"These Are My designs"

The Life Story of John Fullwood

Landscape Artist

Written & Compiled By Paul & David Fullwood

Paul & David Fullwood are John Fullwood's third cousins four times removed

Book cover: Etching by John Fullwood of Old Lichfield Street Wolverhampton

These Are My Designs

The Life Story of John Fullwood Lanscape Artist

Spiderwize
Remus House
Coltsfoot Drive
Woodston
Peterborough
PE2 9BF

www.spiderwize.com

A CIP catalogue record for this book is available from the British Library.

The views expressed in this work are solely those of the author and do not necessarily reflect the views of the publisher, and the publisher hereby disclaims any responsibility for them.

ISBN: 978-1-912694-43-3

"These Are My Designs"

The Life Story of Wolverhampton born John Fullwood,
Landscape Artist (1854-1931) F.R.S.A, R.B.A, F.S.A

**"These are my designs;
I give them birth and they have my soul"**

John Fullwood's life story written and compiled by
Paul & David Fullwood

"Though we are familiar with the impressions from the plates of Rembrandt, Hollar and Van Dyke, their work was done long ago and almost stood alone until Turner transferred to copper some of his landscapes. Turner was followed by Samuel Palmer, Millais, Frith, Cruikshank, and John Ruskin and then etching can be said to have become an English art. Since these days many have essayed etching, but the great majority of those who have attempted this form of artistic expression have been able only to achieve the commonplace. Even today our really accomplished etchers can be numbered by units, Seymour Hayden and J. McNeil Whistler being the most distinguished. One of this small band, however, is undoubtedly Mr. John Fullwood, RBA, of Hastings."

Quoted by Edward J. Shaw in The Walsall Advertiser 27 July 1895

www.fullwood.org.uk

Foreword

Professor Carl Chinn MBE
http://www.carlchinnsbrum.com/

In its report of 1 April 1892 on the spring exhibition of the Royal Society of Artists, the Birmingham Post declared that John Fullwood's contribution, 'The Breadth of Autumn' was "one of the more important," as "it is one of the most successful, drawings of the exhibition." A river scene, it was enhanced by a rich harmony of purple, warm ruddy brown and golden yellow and was a drawing of remarkable power.

Four years later, on 5 December 1896, the Walsall Advertiser quoted in detail a "eulogistic notice" from the Art Journal, the leading authority on art in England. It asserted that Fullwood was one of the most powerful of the younger living artists. Whatever he touched "there is about it the melody of colour and deep music which is only translated by the intense lover of Nature." Despite such recognition, John Fullwood is now but little known and what little is known relates to his landscape work and not necessarily to his recording of old seventeenth and eighteenth-century buildings in and around Wolverhampton during the 1880s.

Indeed, this body of work is not mentioned at all in his obituary in the Birmingham Post on 9 September 1931 which recognised that Fullwood was one of the oldest members of the Birmingham Society of Artists. Praised rightly as a watercolour artist and etcher of repute, he should also be valued for those scenes of old Wolverhampton which provide an historically invaluable and rare visual record of sights that have been swept away but which will never be lost thanks to Fullwood's vision and skill.

Our thanks go to Paul and David for their assiduous research and ability to thrust this vital aspect of Fullwood's work back into full view.

Acknowledgements

A General Thank You

To all those people who have provided advice and information to enable the publication of John Fullwood's life story.

Providers of Help, Information and Pictures

Sir Nicholas Mander.
Wolverhampton Art Gallery.
Wolverhampton Archives.
Wolverhampton History & Heritage Web Site.

Anne Robertson a descendant of John Fullwood's brother Henry.
Gary Wersky – Author of a biography about Albert Henry Fullwood, Anglo-Australian War Artist.
Simon Briercliffe.

Norm Keech for providing John Fullwood's drawings and some photographs.

Birmingham Lives
(http://www.communityarchives.org.uk/content/organisation/birmingham-livescarl-chinn-archive).

Roy Hawthorne and David Mitchell.

A big thank you to Professor Carl Chinn MBE, the well known West Midlands based historian, broadcaster and university professor for all his assistance with writing this book.

Twilight

By John Fullwood

Gay Twilight is tripping downhill,
The Echoes are silent and sleeping,
And the tarn and the pines are still,
And Slumber comes soundlessly creeping,
With his mantle tightly holding,
Swiftly unfolding,
Now Twilight is far down the hill.

"Soul, weary soul, rest at the hill,
The Echoes are silent and sleeping;
In the folds of my shawl I will,
Unconsciously, bear in safe keeping,
Over the dark jagged mountains,
To star-lit fountains,
For Twilight has gone from the hill."

Ah! Twilight will soon quit the hill,
And Slumber has finished his weaving,
In the deep dim gorge at his mill;
He is folding, circling, now leaving;
And already in the dark'ning,
My soul is hark'ning,
To his soothing whisper, "Be still."

As I pace by the deep, deep mere,
I can ne'er hear my own feet falling,
Behind me, beside me comes Fear,
And he leers as he croaks, "Appalling"
But Slumber is now descending,
Over me bending,
To carry me safely, is here.

Contents

List of Photographs & Illustrations

St Michael's Tettenhall Church Yard.
Etching by J Fullwood of Upper St & Old Hill Tettenhall.
Etching by J Fullwood of Cock Street (now Victoria Street) W'ton.

Chapter 7 George B. Mitchell's business premises Lichfield St Wolverhampton.
Etching by J Fullwood of Old Hall Wolverhampton.

Chapter 10 Etching by R. Tremberth of Newlyn Old Harbour.
Paris Salon.

Chapter 11 Etching by J Fullwood of Town End Bank Walsall.
Etching by J Fullwood Old Gateway at Rushall.

Chapter 12 Painting by J Fullwood Hastings From The Pier.
Gilbert White's House Selborne Hampshire.
Selborne Society badge design by John Fullwood.

Chapter 15 Fairlight Glen book cover.
J Fullwood 'Transporting Melody' from 'Fairlight Glen'.
Etching by J Fullwood White Hart Inn Walsall.

Chapter 16 John Fullwood's brother Henry Fullwood.
John Delves wife Mary & daughters in Australia.
Edgar Fullwood & Edith Fullwood (nee Delves).
"Slinfold" Mont Albert Melbourne Australia.
Copper medallion by J Fullwood for Henry B. Tucker.

Chapter 17 Slinfold Church Sussex.
Slinfold village street view in Sussex.
Water colour and drawing of child in picture margin by J Fullwood.
Etching by J Fullwood of St Augustine's Cross.
Westhall Road, Kew London.

Introduction

There has been very little biographical information published about John Fullwood's life story and career other than the most basic of details. His birth in Wolverhampton in 1854, his death in Twickenham in 1931, artistic memberships and the number of times his paintings were exhibited at various galleries are documented. Although these basic facts tell you something about the man, they miss out large parts of his life story and achievements. In addition, photographs of John Fullwood are rare and difficult to find in the popular newspapers of that time.

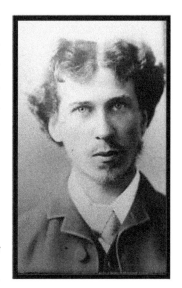

Portrait of John Fullwood, provided with the permission of Gary Werskey.

All of this reflects and even reinforces his current national reputation as a very minor Victorian artist. For subsequent generations of fellow Wulfrunian's (a native of Wolverhampton, named after Lady Wulfruna), who mostly know little about John's work, he is perhaps best remembered for his part in recording for posterity scenes of old 17th and 18th century buildings in and around the Wolverhampton area during the 1880's. Yet John Fullwood had left Wolverhampton as a teenager, as he developed his artistic talent elsewhere. He sought employment and training in Victorian Birmingham before he moved residence to Cornwall, Paris, Sussex and then onto London.

In this book we hope to make the case that an examination of his life and times throws up insights not only into his personal and professional life, but also highlights the changes that shaped and

formed his town of birth, Wolverhampton, and the artistic movements in Birmingham and elsewhere in which he participated.

John Fullwood was well regarded in his heyday as a painter of typical Victorian naturalistic landscapes, an author and illustrator, as well as a skilled and successful etcher. He was a popular artist, commercially flourishing but also critically acclaimed with the 'Art Journal' of 1896 describing him as having the "courage of a man who sees a deeper truth and painted what he saw." A critic stated that one of the keynotes by which to read his work is "peace" and he clearly sought peace in his love of, and depiction of, nature and the countryside.

John's recognition also spread abroad, to Australia and especially America, where his etchings were highly valued. His paintings were subsequently displayed at the Paris Salon and the Royal Academy in London on twenty one occasions. He also exhibited works in Birmingham Art Gallery, at the Walker Art Gallery in Liverpool and Manchester City Art Gallery amongst regional galleries. Ninety-nine of his works were in exhibitions of the Royal Society of British Artists, seven in exhibitions the Royal Institute of Painters in Watercolours and two in the Royal Institute of Oil Painters. John was also a Fellow of the Royal Society of Arts.

Little of John's own writing remains. In attempting to sketch his character we are limited to a few observations of his personality and to draw inferences from his sources, influences and contemporaries. John was clearly a well - read man, influenced by poetry and interested in the scientific advances of his day, but also one who was deeply religious. John formed long lasting friendships and was well connected to many important figures in the art world. His sales, across several forms of media, achieved for him a comfortable standard of living in his middle age but he was to end his days in relative obscurity and "straightened circumstances."

Ultimately, John is not as well recognised today as many of his fellow artists who also began their careers in Victorian

Birmingham. Perhaps his posthumous fame suffers because he had what was described as a "retiring nature", which held him back from the self-publicity that would have raised his profile. Perhaps his move from the Midlands to London has also led him to be overlooked in the canon of artists who are considered of the "Birmingham School" and who remained in that area. In London he was, to use an analogy from the natural world he so loved, a smaller fish swimming in a much larger pool.

However, an artist's enduring reputation cannot be predicted and even in their lifetime the work of artists who were once admired and collected can fall out of fashion. John Fullwood's water colours were described, in his obituary in the *Birmingham Mail*, as "old-world" and his output has now, due to the passage of time and fashion, generally become relegated to the reserve collections of municipal galleries. Out of sight in the archives, they are unseen by the public. The digital age, however, enables these works and the stories behind them, to emerge and once again enchant the observer.

Genealogical research has provided the skeleton for this book and we have sought to flesh out the body from newspaper articles, art magazines, journals and documents stored in the archives of London and the Midlands, including Wolverhampton's Art Gallery, Wolverhampton Archives and Walsall Art Gallery.

During the course of our researches we have been fortunate to have been contacted by people who own examples of Fullwood's works, or who have had family memories of him passed down to them. We are grateful for their interest, and have included their stories in the text. If anyone reading this book can add anything further to the body of knowledge of John Fullwood and his works, then please do contact us.

However, we do not claim to be professional historians and whilst we are grateful for the assistance that has been provided to us in compiling this book, any opinions or conclusions expressed in it are

our own. To the best of our knowledge we have tried to avoid any errors.

This is John Fullwood's story, albeit more than likely incomplete, but one that we hope will entertain and inform the reader.

Chapter 1 Family & Beginning

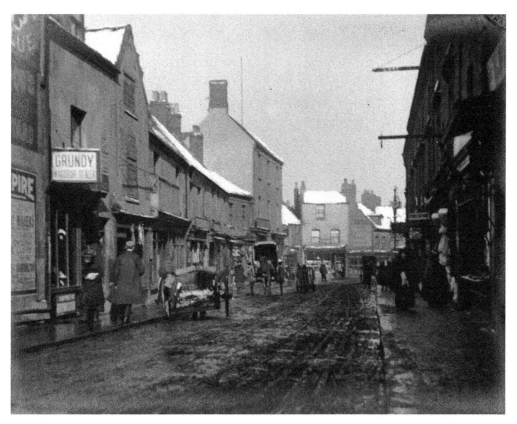

Photograph from the collections of Wolverhampton Archives & Local Studies showing Worcester Street Wolverhampton circa 1890. John Fullwood was born and raised here in the Worcester Street area until the age of 16

The earliest record of John Fullwood's ancestors appears in a 1532 record of property owners at Woodsetton. Co-incidentally, this document shows another John Fullwood and refers to his family.

Woodsetton is a settlement lying halfway between Sedgley and Coseley, in the heart of the Black Country. It used to be in the county of Staffordshire until political boundary changes created the West Midlands County. Nearby lies a worked-out colliery, now grassed over, in an area still named 'Fullwood's End'.

Photograph by David Fullwood shows location of Joseph Fullwood's business premises at 68 Worcester Street Wolverhampton next door to corner shop.

The wider Fullwood family, like many other inhabitants of the Black Country, had moved around and beyond the region as economic circumstances and opportunity dictated. John's direct family ancestry can be traced to an area known as Ettensole (now Ettingshall), which was then in the neighbouring parish of Sedgley in Staffordshire but now lies within boundaries of Wolverhampton.

The Fullwood's had, for generations past, been engaged in typical Black Country primary trades of nail making, coal mining and lime working, but by the time John Fullwood was born on 24th November 1854 his family was settled in Wolverhampton, and had become the owners of a small business.

John Fullwood's parents had their business premises on the corner of Worcester Street and Brickkiln Street, Wolverhampton, then located on the outskirts of the town centre and below a marshy area marking the line of the town's wells. The names of these wells, Pudding well, Horse well and Washing well, reflect their use for

industrial purposes and they are still commemorated in the present day in nearby Townwell Fold.

Wolverhampton Archives hold deeds showing that housing in this area had long been subdivided into workshops, storehouses and retail premises; when sold in 1874 the five properties known as 73-78 Worcester Street were occupied by twelve businesses. Maps of the time show properties crammed together, with the courts in between in-filled with housing, interspersed with manufactories and precious little open space.

Location of 41 Victoria Street Wolverhampton where Joseph Fullwood moved his business. Photograph taken by David Fullwood.

It was in this part of the town that John Fullwood's father, Joseph (born 1814), is recorded at various times as both a cooper and as owning a newsagent's shop, selling confectionery, stationery and the daily papers. This dual occupation may originate in that Joseph's older brother John (born 1806) was also a cooper, as were other members of the extended family.

An article in the *Birmingham Journal* of 27 March 1847 records John Fullwood (born 1806) as being a member of the coopers' society (a fraternity or trade union) and his business, in partnership with a Mr Yates, was recorded in trades directories until 1849. Their business was located in Great Brickkiln Street, which adjoins Worcester Street. However, this business was not to last and the *London Gazette* records the dissolution of their partnership shortly thereafter.

Various Wolverhampton trade directories of this time identify Joseph Fullwood's shop in Worcester Street as being on the corner of Great Brickkiln Street, where he was listed as a confectioner in 1851 and again in subsequent years. Yet Joseph gave his occupation as a cooper when his daughter Sarah was baptised at St Peter's Church, Wolverhampton in May 1836, and a trade directory from 1838 shows him as a cooper in Worcester Street. The 1841, 1851 and 1861 censuses also all show Joseph as a cooper, and another, in 1850, shows him as a cooper, but in Great Brickkiln Street.

Perhaps Joseph Fullwood had simply taken over his brother's business, thus keeping it in the family. It is possible that, whilst Joseph owned both businesses, the newsagents was run by his wife. An article in the *Wolverhampton Chronicle* in July 1862 publicised the trial of a girl who passed counterfeit coins at the Fullwood's newsagents shop whilst being served by John's sister Sarah and his mother. Joseph described himself as a stationer when placing a memorial notice upon Sarah's death in 1865.

The deciding evidence may be that when Joseph Fullwood bought and sold property, he gave his occupation as a cooper. By this time the economic circumstances of the family had evidentially begun to prosper, whatever the source of the income.

As Wolverhampton expanded Joseph Fullwood bought property in the newly developed area of Blakenhall. He bought properties for £28 in 1850 which he sold for £150 in 1865. The Town Council was to name the new road on which these premises were built as

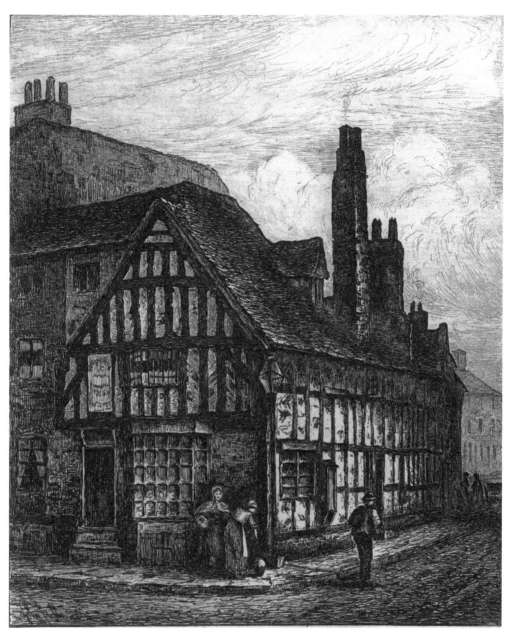

John Fullwood's etching of a 17th century timber frame building known in the 1950's and 1960's as the "Copper Kettle" tea rooms and afterwards as the Lindy Lou shop on Victoria Street. Reproduction by permission of Wolverhampton Art Gallery.

Franchise Street, reflecting the involvement of the Wolverhampton Freehold Land Society in the scheme. Owning a house and therefore becoming a landowner, was the way in which a male adult could become enfranchised, that is, to get the vote.

The family invested this wealth in buying bigger premises, a shop even nearer to the town centre, at 41 Victoria Street.

John himself first appears in official records aged 6, when the 1861 Wolverhampton census showed him living at 68 Worcester Street along with his parents Joseph and Mary Ann (nee Gaunt), and eight other living siblings, Maria, Stephen, Jane, William, Joseph, Henry, Mary and younger sister Emily. Another older sister, Sarah, had already married and left home by then. John's mother, Mary Ann, had been born in nearby Walsall, as was his paternal grandmother and John maintained links to his mother's home town throughout his career.

Despite their increasing prosperity in Wolverhampton and like many other Victorian families, several of the children sought opportunities to advance their economic standing by moving elsewhere. Out of John's eight siblings who survived to adulthood three brothers, Stephen, William and Henry, were to leave Wolverhampton.

Stephen Fullwood moved to Yorkshire where he followed in his father's footsteps and became a shopkeeper, whereas William and Henry moved to Birmingham to find work in the jewellery trade. Eventually William and Henry were to emigrate to Australia, as did John's nephew William (son of brother Stephen). His sister Jane married James Grace in June of 1867 at Wolverhampton and her children were also to emigrate, but this time to New Zealand in 1879.

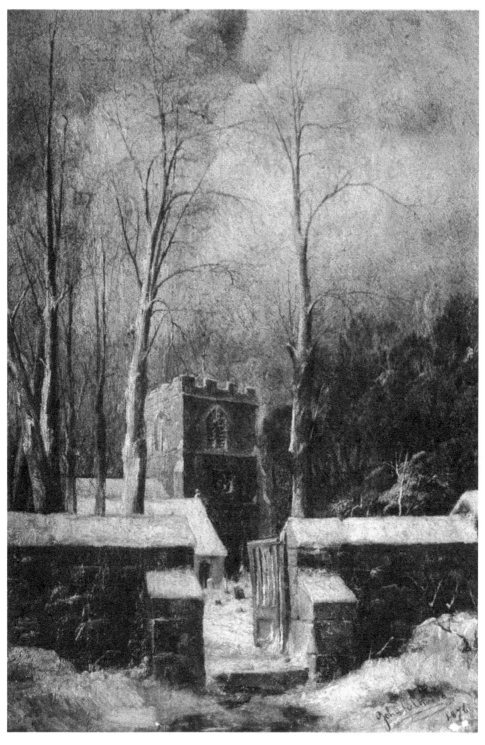

Oil painting by John Fullwood of Tettenhall Church. Reproduction by permission of Wolverhampton Art Gallery.

Joseph Fullwood died in 1893, having moved to Oak Street, in the suburb of Chapel Ash, Wolverhampton. He nominated as his executors his son Joseph and daughter Mary Ann Fullwood who, with her husband Samuel Parkes, had taken over the shop premises at 41 Victoria Street.

The Parkes family had no children and on their death, left a treasured possession to their nephew Samuel Rudge, who lived in Walsall. It was one of John Fullwood's paintings, showing Tettenhall Church St. Michael & All Angels on the previous page.

Samuel Rudge later donated this picture to Wolverhampton Art Gallery in the 1970's, stating in his bequest that as a child he could remember the picture hanging on his aunt's parlour wall.

Little is known of John Fullwood's early years or formal education beyond the fact that he attended the Wesleyan School associated with Darlington Street Methodist Church, Wolverhampton. His education put him in a minority of his peers, as a Government report into the provision of education in industrial towns around this time noted that only one quarter of children in Wolverhampton received two or more years schooling.

In 1865, when he was aged 11 and still a pupil at the Wesleyan school, he received a prize for "Passing examinations in freehand" at the School of Art and Design, also situated in Darlington Street. The prize giver at the Wesleyan School was Henry Loveridge, owner of one of the most successful japanning factories in Wolverhampton, and a key figure in the town. Loveridge later served as President of the Wolverhampton Chamber of Commerce and as a member of the town's first School Board. More importantly for John Fullwood he was a strong proponent of industrial art and design and a driving force behind Wolverhampton's Government School of Practical Art.

John's attendance at the Methodist School reflected that Joseph Fullwood, his father, had been baptised at the Methodist Church in Darlington Street, Wolverhampton, as had several of his siblings.

Despite this, many were also baptised into the Church of England. This practice of non-conformist's baptising their children into the Church of England, as well as their chapel, was due to the requirements of the Poor Relief Act of 1662 which required a person to be "settled" into a parish in order that they may be able to claim poor relief – public assistance – should they fall on hard times.

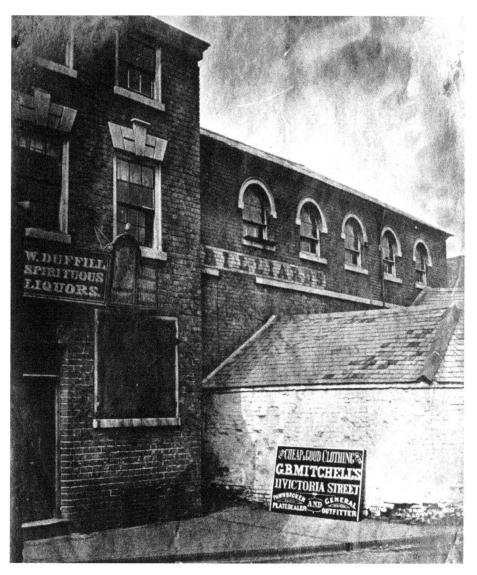

Photograph from the collections of Wolverhampton Archives & Local Studies is of the Noahs Ark Methodist Chapel. Note the advertising board displaying the name of G.B. Mitchell.

John Fullwood's etching of 'Wheeler's Fold' a passageway off Lichfield Street and immediately behind Noah's Ark Methodist Chapel. It was subsequently converted into a public house. Reproduction by permission of Wolverhampton Art Gallery.

The history of this non-conformist region during the Industrial Revolution and of the various branches of the Fullwood family that lived and worked through it, is closely entwined with the differing sects of the non-conformist churches.

The term 'non-conformist' originates from the "Great Ejection" of those who did not accept the discipline of the 1662 Act of Conformity. Non-conformists consisted of Methodists, Congregationalists, Baptists, Unitarians, and Quakers, or was someone who could not be counted as part of the Church of England.

Non-conformists were not a unified body either in terms of social composition or economic strength, as the wide range of chapels in the Black Country and Birmingham show. Despite this, however varied the doctrinal or organisational differences between them were, they did share the same outlook: what mattered was work, faith and duty.

The influence of the non-conformist church and the civic institutions associated with it, was to loom large both in John Fullwood's immediate family as well as other branches of the wider Fullwood family, and the circles within which they moved.

As White's Directory of 1851 stated "Dissenters are as numerous in Wolverhampton as in most other towns of similar population, having no fewer than twelve places of worship."

The 1851 census had asked questions concerning religious affiliation for the first time. In Wolverhampton 53% of the population stated they had attended a religious service in the previous week and of those, 57% declared themselves non-conformist. Thus Wolverhampton was a stronghold of religious dissent from the established church.

John Wesley the founder of Methodism, preached in what he termed "this furious town of Wolverhampton" as early as 1761 and

in 1787 a new chapel was built in Wheeler's Fold, Wolverhampton which was opened by John Wesley himself.

Early Methodist meetings in Wolverhampton had been held in a room behind the Noah's Ark Inn, for which the chapel was named. John Fullwood was to make an etching of Wheelers Fold, which he included in 'Remnants of Old Wolverhampton' book. It begs the question as to whether John decided to make this etching because of this location had some significance to him and his family due to their Wesleyan faith. St Peter's Church is in the back ground.

The Victorian age was undoubtedly an age of faith and the conflict between the established church and the dissenters was fundamental to the national political arena throughout this period. The activities of the adherents of the differing religious affiliations within Wolverhampton both reshaped the town physically as well as politically and drove the development of its cultural institutions. John Fullwood was to benefit from these changes, which were to influence both his life and career.

Wolverhampton was a prosperous and rapidly growing industrial centre in mid-Victorian times, whose manufacturers traded across the globe. It had been given the right to return two Members of Parliament after the passing of the 1832 Reform Act. The need for representation grew out of increasing political awareness in the town.

As a Wolverhampton factory owner later noted "Fifty years ago we were not in that need of Representatives, which we are at present, as we then manufactured nearly exclusively for home consumption, and the commercial and manufacturing districts were then identified with each other; where one flourished the other flourished. But the face of affairs is now changed – we now manufacture for the whole world, and if we have not members to promote and extend our commerce, the era of our commercial greatness is at an end."

This political awareness extended to local government too. The period during which John Fullwood was born, raised, educated and

then finally left Wolverhampton, was a time when civic structures and civic pride reshaped the town. The forty years between its incorporation as a Municipal Borough in 1848 and becoming a County Borough in 1889 were pivotal in the town's development, how it saw itself, and how others saw it.

Until 1848 the town's public infrastructure was built and maintained by the Town Commissioners. The Commissioners were required to be local men, of good standing and possessed at least £1000 in real or personal estate. They were appointed, not elected and the powers they held were limited, as were the funds they could raise through the rates. Even given these limitations, they were averse to spending ratepayer's money on improving the town and tackling the problems that were emerging as a consequence of its rapid growth.

Wolverhampton's first elected Borough Council contained many of the erstwhile Commissioners. At first they governed on a non-party political basis but they still represented the wealthy and elites of the town. However, the opportunities afforded by the granting of powers to the town from 1848 were especially seized by politically engaged leaders of the non-conformist churches, and, as in many other similar industrial towns, this led to the emergence of a philosophy that became known as the "civic gospel."

Most people in the upper echelons of Victorian society were practising Christians, and the leading Churchmen were Tory. Yet the 1851 census had showed that more than half of Wolverhampton's worshipping population declared themselves non-conformist. Amongst the leading dissenters were representatives of factory owners and manufacturers that had emerged as the town industrialised. Because of this strength, non-conformists in Wolverhampton eventually provided a substantial number of the powerful middle-class elites to be found in the town's governance, as well as well as the leaders of many social organisations, clubs and societies. This was not reflected in the first Council chamber where in the same census nearly two thirds of

Wolverhampton's Town Councillors declared themselves to be Anglican and only one third Non-conformist. Even by the 1871 census Anglican's outnumbered non-conformist's but the ratio was nearer parity as the demographic changes in the citizenry fed through into the composition of the town council.

Within the non-conformists, Congregationalists, so called because they elected their minister from within their own congregation, were particularly powerful elite in Wolverhampton and at least ten known Congregationalists were elected as Mayor of Wolverhampton during the Victorian era. The most bourgeois of the larger non-conformist denominations, they were chiefly based at Queen Street Congregational church and the neighbouring Snow Hill Congregational church, at which John Fullwood's cousin's worshipped.

It was not always a chapel for the working class, as "ours", said one Congregationalist Minister, "is not a church of the poor." The Queen Street Congregational chapel was built in 1866 and one third of its £12,000 cost was paid for by just two of its congregation, the Shaw brothers Thomas and Edward, who were local merchants and bankers. Dr Robert Dale was an influential preacher at both Snow Hill and Queen St Congregational Chapels although his own church was in Birmingham. He believed "the public business of state is the private duty of every citizen" and advocated "municipal action, not for the gospels only, to improve the homes of the poor."

Allied with religious non-conformity was usually a distinctive political affiliation and set of values. Non-conformism, by its very nature, did not ally itself with conservatism and therefore its membership was inclined towards liberal political issues, such as the cause of temperance and trade union activity. This, in turn, linked a substantial number of the town's middle classes to Liberalism; non-conformists were Liberal to a man, but of course, not all Liberals were non-conformist. However, Liberalism was perceived by the non-conformist middle classes as the party

agitating for the ending of establishment control and therefore a party dedicated to securing wider opportunity.

Many members of the middle class non-conformist Chapels, finding political expression for the first time as the reform acts enfranchised and empowered them, considered themselves to be the driving force of progress and to represent the conscience of the nation. They perceived themselves to be the moral backbone of the nation with a view which was best expressed as "What was morally wrong could not be politically right." The downside, of course, was the tendency to look down on those they considered to be indolent or unworthy.

Both civic and church institutions were to influence the growth and development of Wolverhampton. The town's political split was exemplified within the Mander family, who were prominent local industrialists. Although divided on political and religious lines, family members from both sides were to provide institutions for the advantage of the town and from which John Fullwood benefitted.

The emerging political landscape was also reflected in the changes to the physical landscape of the town in which John Fullwood grew up. An early guide to Wolverhampton noted that, "The town is on the western borders of the mining district and the neighbourhood consequently abound with mines of ironstone and limestone, with furnaces, gorges and iron works. There is also a corn mill, two worsted mills and chemical works for the manufacture of sulphuric acid and nitric acids. The trade of Wolverhampton is greatly facilitated by its situation on the direct line of the road to Holyhead, Manchester and Liverpool. It also has the advantage of navigable communication to every part of England by means of the Birmingham Canal."

Sitting on the edge of the Black Country, Wolverhampton had grown rapidly in the 100 years before John was born. A population of 7,800 in 1750 had ballooned to 44,000 by 1850. Wolverhampton's percentage rate of population growth at this time

exceeded that of Birmingham, Newcastle, Glasgow and many other towns and cities, albeit from a lower starting figure.

However the stock of houses had not kept pace with the influx of workers attracted to the town's industry. The situation was worst on the eastern side of town, where building land was scarce due to the extensive coal mines. When houses were erected the lack of building regulations enforced by the Town Commissioners meant they were built shoddily and to a very high density.

The industrialization of the area and the concomitant loss of greenery were noted by a German visitor, F. von Raumer in 1835 who wrote; "About Wolverhampton, trees, grass and every trace of verdure disappear. As far as the eye can reach, all is black, with coal mines and ironworks."

A contemporary description of the Black Country was written by Walter White in the book 'All around the Wrekin'. "Blackness everywhere prevails; the ground is black, the atmosphere is black and the underground is honey-combed by mining galleries stretching in utter blackness for many a league....by night... the roaring furnaces are seen for miles around poring forth their throbbing flames like volcanoes.....overhead dense clouds of smoke reflect a lurid light, while the hissing and rushing of steam, the clang and clatter of machinery, the roaring blasts and the shock of ponderous hammer-strokes....vividly excites the imagination, and is not easily forgotten."

Elihu Burritt, the American Consul who reported on Birmingham and the Black Country in the 1860's defined the Black Country for posterity as "Black by day and red by night, (it) cannot be matched for vast and varied production, by any other place of equal radius on the surface of the earth."

He noted that "The iron ore, coal and lime...were all deposited close at hand for the operation. In some, if not in all, parts of this remarkable region the coal and lime are parcelled together in

alternate layers, in almost the very preparation for the furnace requisite to give the proper flux to the molten iron."

The Black Country did not fare better in contemporary literature. Whilst Charles Dickens, in *'A Christmas Carol'*, praised the output of Wolverhampton's industry, describing items placed on a Christmas tree as "eight-day clocks (wonderfully made, in tin, at Wolverhampton) perched among the boughs", he also dammed the town that made them.

In *The Old Curiosity Shop* he described Nell and her grandfather wandering through the nightmare Black Country as by night the "iron-foundries became hell-mouths" and the people who move about through the flames "looked wilder and more savage."

Dickens, whose grandmother was born in Claverley, near Wolverhampton, also described the Black Country in a letter as "a cheerless region" in which "tall chimneys, crowding on each other and presenting that endless repetition of the same dull ugly form poured out their plague of smoke."

Disraeli, the future Tory Prime Minister, also used the familiar "savage" imagery in his novel *"Sybil"* where he first identified the "Two Nations" that made up the United Kingdom – the rich and the poor. He set the part of his story exemplifying poverty, squalor and disease in a town populated by locksmiths, which he named 'Wodgate'. His source material was taken – and often quoted word for word – from a Government report into the conditions of the working class in Willenhall, a town lying midway between Wolverhampton and Walsall.

A key event in John Fullwood's childhood would have been the visit of Queen Victoria to Wolverhampton in 1866. She came to unveil an equestrian statue of her late husband Prince Albert. This was her first public visit since her bereavement and was a source of immense local pride for its inhabitants, but the town and its citizens drew criticism in the national press as a result.

An article in *Punch*, entitled "The Queen in the Black Country" caricatured Wolverhampton as people who slave "from dawn to darkness at nail hammer and nail rod" and had "toil stunted children" and considered the town to be full of "cindery wastes, seamed, scathed and ashy-hoar", that it "knows no seasons" and where Prince Albert would gaze over the town "Betwixt the wealth and wretchedness of this unhallowed place."

This criticism was in part sour grapes; Queen Victoria had turned down invitations from many other towns and cities across her kingdom to unveil monuments to her late consort. As the London *Standard* noted "the citizens of Liverpool and Manchester were unfortunate enough to lose the honour which was frankly accorded to Wolverhampton."

Why she chose Wolverhampton to break her period of mourning is unclear but the visit reinforced local consciousness and pride within the town. The entreaties of larger and more important cities in the country had been spurned in favour of Wolverhampton and the town had demonstrated it could organise a significant civic event.

To commemorate the visit the Council renamed High Green as Queen Square and Cock Street as Victoria Street, complementing the existing King Street, Queen Street and Princess Street in creating a regal town centre. More importantly, it spurred on the council to make plans to reinvent the municipality. Wolverhampton then still had the look of the large market town it had been in previous centuries, but plans were laid to rebuild it to reflect the wealth that the industrial revolution had brought to it and the status that the Council and inhabitants felt it deserved.

However, and despite angry denunciations in subsequent editions of *Punch* by the town's representatives, it is hard to argue that their image of the Black Country as the embodiment of the despoliation of Nature was the one that stuck in the national imagination. This, then, provided the background in which John Fullwood grew up and in which his world view and love of nature coalesced. It was

not for many years that artists began to value and treasure the industrial landscape.

Indeed, it was nearly one hundred years later before the poet W. H. Auden was to write, "Clearer than Scafell Pike, my heart has stamped on. The view from Birmingham to Wolverhampton."

Chapter 2 Emergence Of The Artist

"Every man's concern with the place where he lives has something more in it than the mere amount of rates and taxes that he has to pay."

Joshua Toulmin Smith

The above sentiment is from a theorist most associated with the Victorian development of local self-government. It was quoted approvingly by the local historian James Powell Jones when in 1893 he wrote the 'History of Tettenhall', a village two miles North West of Wolverhampton and the place of his birth.

John Fullwood was to establish links and friendships with many local historians as his career developed, but he was especially close to Jones, for whom he provided the frontispiece of this book, an engraving of a prominent local house in Tettenhall called 'Barnhurst'.

Tettenhall was then a district adjacent to but separate from Wolverhampton. It was subsequently absorbed by its bigger neighbour as local government boundaries changed.

More importantly though, Jones was an early cheerleader for the work with which Fullwood is perhaps most associated with – 'Remnants of Old Wolverhampton and its environs' – which especially demonstrated and illustrated Fullwood's concerns with the town and surrounding area of both their births.

Wolverhampton was a prosperous and rapidly growing industrial centre in Victorian times. It had enough capacity to accommodate the economic, political and social aspirations of the middle-class and especially those, such as the Fullwood's, who aspired to join them. This is demonstrated by the founding of institutions which initiated John Fullwood's education and his career in art.

Wolverhampton School of Practical Art erected 1854. From the collections of Wolverhampton Archives & Local Studies.

On the evening of August 5th 1869, John Fullwood, then aged 14, sat listening to a speech given by the Mayor of Wolverhampton, Moses Ironmonger to an audience of students, teachers and the governors of the Wolverhampton Government School of Practical Art, located in Darlington Street, Wolverhampton.

John had won two prizes that academic year after passing examinations at the School, which taught what was known as the South Kensington curriculum, the name given to the national system of art training originating in the Government School of Design (later renamed the National Art Training School and now known as the Royal College of Art) head quartered in South Kensington, London.

In his speech Moses Ironmonger (whose mayoralty was 1868/69) praised the success of the School, as the 110 pupils had between

them won 49 prizes and certificates of merit and three free studentships in the "South Kensington" examinations.

Moses Ironmonger was a rope manufacturer whose premises, situated in Great Brickkiln Street, was around the corner from where John Fullwood grew up. Ironmonger's speech, however, also recorded the precarious financial situation that the school found itself in.

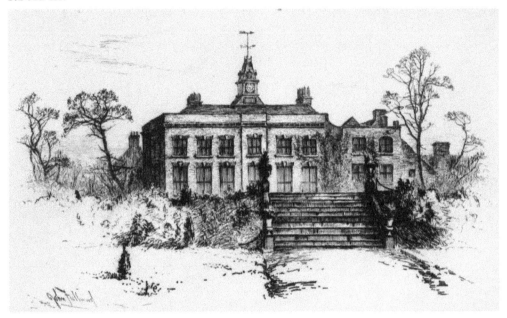

Etching by John Fullwood of Molineux House Wolverhampton. Reproduction by permission of Wolverhampton Art Gallery.

This was a situation that the school governors knew all too well despite, or because of, the fact that they had provided no financial report to the meeting.

The governors and the Mayor hoped a projected surplus from the Art and Industrial Exhibition held in the town that year would raise funds for the school and place it in a better financial position.

The stated aim of the exhibition, held in the grounds of Molineux House (etching by John Fullwood above), was to inspire the local workforce, or as the *Wolverhampton Chronicle* put it at the time: 'The main object of the Exhibition ... is to give the teeming

population an opportunity of witnessing works of an artistic character which, as experience tells, have a powerful effect in elevating the minds and softening the manners of those who are brought under their influence'.

This lofty aim reflected the intentions of those citizens of Wolverhampton who had created the town's School of Art and who were now struggling to sustain the institution at which John Fullwood was studying. Thankfully, by the time the exhibition closed many thousands of people had visited and so it was considered a success. The income it brought enabled the school to continue teaching, for a few more years at least.

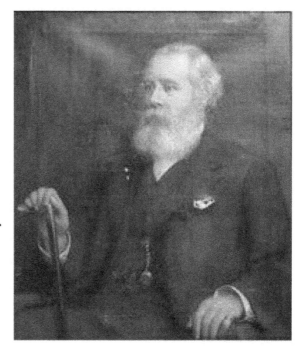

Image of Charles Benjamin Mander provided with the permission of Sir Nicholas Mander. https://owlpen.com/family/mander.

The driving force behind the establishment of Wolverhampton's Government School of Practical Art and its founder and first Secretary, was Charles Benjamin Mander (1819-1878), ably assisted by his fellow local businessman, Henry Loveridge.

Mander's portrait shows him as the embodiment of Victorian values and tastes. His family were prominent local industrialists involved in the manufacturing of varnishes, inks and paints, but who also believed in public service, the family providing several Aldermen and Mayors of the town. Loveridge was the owner of a large firm producing Japan ware.

Like many of their class, they identified with the causes of both providing education for the working man and of the temperance movement, seeing in both the ability to better the conditions of the townsfolk. By improving the craftsmanship of the workers, the design skills they had and by offering places of education as an alternative to public houses, they would improve the moral character of the town and at the same time increase its economic wellbeing.

Charles Benjamin Mander was also a man with his own artistic temperament and a talented artist in his own right. Charles, together with his nephew Samuel Theodore Mander, were both united in increasing the development of art within Wolverhampton. They were divided, however, by politics and religious affiliation; Charles was a Whig and Anglican, worshipping at St Peter's Church whereas Samuel Theodore was a Liberal and non-conformist, who worshiped at the Queen Street Congregational Church. They both built fine houses in Tettenhall, from which they managed their family business in Wolverhampton.

The origins of the School of Art are recorded in the school's 'Minute Book' written at a general meeting held in the original premises in Castle St, Wolverhampton on the 15 December 1851. At the opening ceremony Charles Benjamin Mander prophesied that the school was "destined to confer a solid and long-lasting benefit on the town and neighbourhood."Despite Charles Benjamin Mander being a member of the town council at the time the school was founded, he intended to run it on private lines paid for by fees and subscriptions paid by pupils and local industrialists. He stated that the school would be "supported by subscriptions and donations, and by fees" and "The Government will make an annual grant equal in value to the amount of subscriptions", as was the Government's stated policy of the time.

Methodist Church in Darlington St. Wolverhampton, from the collections of Wolverhampton Archives & Local Studies.

The primary object of the school was "to furnish the means whereby our artisans can acquire, at a small individual expense, knowledge of ornamental art and have the advantage of a complete and systematic course of education in relation to every kind of decorative work."

In 1854 Charles B. Mander funded the School of Art's move to new premises in Darlington St, designed by the Mander family's favourite architect Edward Banks (Senior) and the School was renamed as the Government School of Practical Art (Edward Banks was the Godfather to Charles Benjamin Mander's son, also named Charles).

Although the Art School was nearby to the Methodist Church in Darlington Street, the classroom entrance was on Art Street; the town council following the same prosaic leap of imagination that led to the Methodist school entrance being on School St.

Unfortunately for the Governors the new school didn't attract the support from the Wolverhampton public that Charles Benjamin Mander had expected, who had anticipated that it would be fully paid for by public subscription. From the expected £4,000 cost of the school, only £2,400 was raised and the resulting shortfall of funds necessitated a need for a mortgage. This loan, although bridged by Mander, was to prove the school's downfall.

The new Art School's First Annual Report was produced in 1855, which recorded the opening of the school on the 1 August, 1854 and noted that amongst the many prominent local supporters present were Henry Cole, Secretary to the Department of Art and Science in London and George Wallis, the Deputy Commissioner to the Great Exhibition of 1851, who was later to become Keeper of the South Kensington Museum (now the Victoria & Albert Museum - V&A). More importantly, George Wallis was a proud Wulfrunian.

The art school report noted that the school was "the first (purpose built) building erected in this country in connection with the department of art and science and one of the first efforts to establish a self-supporting school, independent of any pecuniary aid from Government. It was an interesting problem how far it could succeed in its rivalry with those depending mainly for their support upon large annual grants from Government."

By 1859 the Darlington Street art school, under Headmaster William Jabez Muckley (who by the time John Fullwood attended had moved to be head of the Manchester Art School), offered students a number of courses taught by many of the town's influential citizens.

Oscar Rejlander, a pioneer of the newly developed science of photography taught there as did Henry Loveridge himself, and George Bidlake, the architect of Queen Street Congregational Church amongst other Wolverhampton landmarks. Bidlake was a noted local architect who had also written a booklet "Sketches of Churches designed for the use of non-conformists." He was later

engaged by S T Mander to build a Congregational Chapel in Tettenhall.

The character of the Wolverhampton art school and its personnel, can be seen by the fact that alongside Moses Ironmonger as Vice-President of the school was Edward Perry. Perry was another owner of a japanning works, which he had bought from the previous generation of Mander's, as they had left that industry to begin building their varnish and paint factory.

The importance of the japanning trade to Wolverhampton at this time was well recognised; a government report of 1864 noted that the trade supported over 2,000 workers in 14 factories. Henry Loveridge had noted that "Among the japanners a little more special education is desirable; for a man to excel in his art, he should know something of perspective and more of colour" and these were the lessons he expected to be taught. He was also aware that he did not speak for all his fellow industrialists as he noted "The great and invaluable benefits to be obtained from a School of Practical Art are not yet thoroughly understood in this locality."

The school's Eighth Annual Report of 1862 and the final report to be produced by the Subscribers to the School, records the failure of that experiment, resulting in the temporary closure of the school and its re-opening under a new management committee.

The report attributed the failure of the School to being unable to secure funding from the Department of Science and Art, South Kensington, London, noting that; 'the ending of the school is due to the parsimony which the Department of Science and Art appears invariably to pursue in its treatment of all new schools' and the 'non-receipt of aid from government, which was expected'.

As a consequence of the lack of funds the first drawing master, Thomas Chittenden, who had been paid the then considerable annual salary of £200 per annum departed but, despite this, classes continued at the request of students with the "assistance of the

master of the Dudley school" on a "limited basis and apart altogether from the former management."

Despite leasing out part of the building to the Methodist church and other fund-raising initiatives, it continued to be a personal financial drain on Charles Benjamin Mander who had continued to meet the funding shortfall. He saw salvation in the 1850 Public Libraries Act which allowed the town council to raise a penny in the pound on the rates to fund public libraries. Charles proposed that he would gift the school to Wolverhampton Council as a library, to which an art school was attached, in return for the Council taking on the school's existing financial obligations.

Charles Benjamin Mander anticipated that such a precept would raise £500, enough to support the School of Art which now cost £120 per annum to run and a Free Library costing £220 per annum whilst the balance would be used to pay off the mortgage on the school. He also proposed to sell the building itself to the town council for £2,500, which was the amount the school owed to its creditors by this time.

Mander paid for pamphlets in which he attempted to get the other town councillors to recognise his battle for the soul of the working class "to escape the blighting influence of drink and ignorance which has so long demoralised our working population" and echoed John Ruskin, the pre-eminent Victorian art critic and social reformer, on the justified economic merits of enlightened public art education.

Thankfully an amended proposal was made and this won approval; the institutions were saved and for many these institutions were sorely needed. As *The Magazine of Art* stated, in 1889 "In few towns in England was an art-gallery so imperatively required as at Wolverhampton; for speaking frankly, to a stranger at least, it is a dismal place. It contains neither noble streets nor imposing buildings. We even look in vain for the trim villa; and it is evident that the wealthier inhabitants live as far off as possible from the

factory chimneys which obtrude themselves on us everywhere, pouring forth volumes of smoke, veiling the sky and seeming to blacken the surrounding landscape. A picture gallery in the centre of such a town as this is an inexpressible relief, and cannot fail to exercise a beneficial influence on the inhabitants."

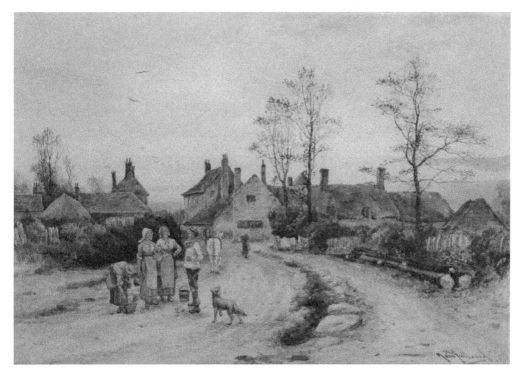

Painting by John Fullwood entitled 'A Village Scene'. Reproduction by permission of Wolverhampton Art Gallery.

Mander also enlisted the support of George Wallis, the Senior Keeper of the South Kensington Museum (now the Victoria & Albert Museum) who stated in the *Wolverhampton Chronicle* of 18 May 1860 that "There were sound practical reasons to support art education for working men in Wolverhampton." Sadly for Mander, the opposition won the day at a public meeting of Wolverhampton ratepayers organised to make the decision. The cry of "We don't want it, and we won't have it" drowned out Mander's arguments, the opposition having persuaded the electorate that Mander's plan was simply a way of saddling the town with the outstanding mortgage debt on the building.

It is ironic that the same Public Library Act was subsequently adopted by Wolverhampton Council to enable a new Central Library to be built in 1879. Alderman Walker, the instigator of the library noted that "the Council took the wise precaution of placing a few respectable working men on the (library) sub-committee." One of those co-opted men was Robert Fullwood, a cousin of John Fullwood.

May 1884 saw the opening of Wolverhampton Art Gallery on a site given by the town council on the newly straightened Lichfield Street. Every available building in the town centre was decorated with bunting for the opening ceremony; masts were erected outside St Peter's church from which were flown flags of crimson cloth upon which were displayed the heraldic shields of the town.

The Art Gallery building was a gift to the town by the prominent local builder, Philip Horsman and he, along with two other local manufacturers, gave bequests from their personal art collections to form the initial permanent exhibits. It was a form of local patriotism that led such men as Horsman to desire that their home towns acquire and display the trappings of Victorian enlightenment, in which galleries were both a place of instruction and entertainment.

Phillip Horsman was a passionate collector of art, who had acquired several works by John Fullwood for his personal collection. After Horsman died in 1890 he left artworks valued at £15,000 to Wolverhampton Art Gallery in his will and they were hung there after his widow's death in 1895. An inventory of the gallery from the time of Councillor Skidmore's Mayoralty identifies at least one painting by John Fullwood, a water colour entitled 'A village scene' (above) as part of the Horsman bequest.

Perhaps taking its cue from the Industrial and Art Exhibition of 1869, Wolverhampton Art Gallery opened with an exhibition of loaned works of art alongside an Industrial Exhibition which was arranged with a view to providing the nucleus of a purchase fund. The "South Staffordshire Industrial and Fine Art Exhibition" of 1884 was a popular success as over 192,000 visitors attended, paying over £5,700 in entrance fees which contributed around £2,000 to the purchase fund for the permanent collection.

In 1885 a new Municipal School of Art was built by the town council at the rear of the Wolverhampton Art Gallery. Photograph taken by David Fullwood in 2015.

When the end of the Exhibition drew near, a number of the town's elite considered that the art exhibition should continue in the newly built Art Gallery and asked for guarantors so that the financial burden should not fall on ratepayers.

The *Birmingham Daily Post* of 15 November 1884 noted that "the necessary guarantee fund of £5,000 was raised without difficulty" from several dozen prominent local citizens who contributed to the fund. The same article noted that "should the patronage of the public be so liberal as to give the Committee a surplus, the money

will be expended in (further) enriching the permanent collection." Amongst the guarantors was a local businessman, Arthur Hellier who had also lent part of his own art collection to the exhibition, including works by John Fullwood, with who by then he had entered into a business partnership.

The art school premises existing at that time in Darlington Street were sold for £2,000, which contributed to the £8,000 cost of the new premises. It was opened by Samuel Theodore Mander, the nephew of Charles Benjamin Mander, but who represented the other half of the town as a non-conformist and supporter of the Liberal Party. However, despite Wolverhampton now possessing an art gallery and newly built school of art, permanently financing both of these institutions depended on a poll of the inhabitants of the town agreeing to the cost of this being put onto the rates.

The initial proposal was once again rejected and as the *Birmingham Daily Post* of 16 August 1887 stated, the real prospect that both institutions would have to close "will have been unspeakably discreditable to the town."

The annual meeting and prize giving ceremony at the Art School that year was presided over by Mayor Jackson, who noted a successful academic year and hoped that the applause generated as prizes were distributed would "ring into the ears of the ratepayers." However, in response, the speech by Samuel Theodore Mander warned that the school's prospects were "not pleasant or hopeful" and regretted that it may be said that "the ratepayers had chosen the jubilee year of the Queen as the year to be marked in posterity by the closing of the School of Art and the Art Gallery."

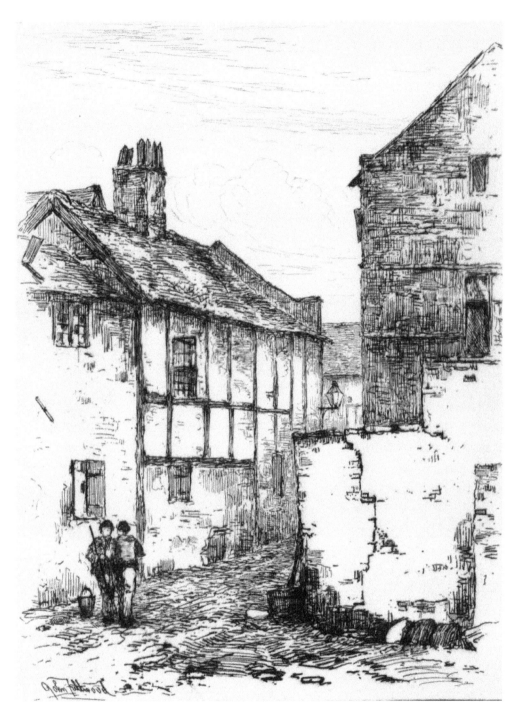

John Fullwood's etching of Cat Yard Court, Berry Street, Wolverhampton. Reproduction by permission of Wolverhampton Art Gallery.

Thankfully an amended proposal was made and this won approval; the institutions were saved and for many these institutions were sorely needed. As *The Magazine of Art* stated, in 1889 "In few towns in England was an art-gallery so imperatively required as at Wolverhampton; for speaking frankly, to a stranger at least, it is a dismal place. It contains neither noble streets nor imposing buildings. We even look in vain for the trim villa; and it is evident that the wealthier inhabitants live as far off as possible from the factory chimneys which obtrude themselves on us everywhere, pouring forth volumes of smoke, veiling the sky and seeming to blacken the surrounding landscape. A picture gallery in the centre of such a town as this is an inexpressible relief, and cannot fail to exercise a beneficial influence on the inhabitants."

George Wallis had proved to be a significant influence upon the artistic development of Wolverhampton and also played a part in John Fullwood's subsequent career. Wallis was born in Wolverhampton on June 8, 1811 and was educated at Wolverhampton Grammar School. He worked as an artist in Manchester between 1832 and 1837, and then returned to Wolverhampton where he worked in the japanware trade for the Perry family at their premises in the Old Hall (Turton Hall). After taking an interest in art education as applied to "designs for art manufacturers and decoration", he joined the Government School of Design at Somerset House London in 1841.

George Wallis became the headmaster of the Spitalfields School, London, in 1843 and was promoted in the same year to the headmastership of Manchester School of Art, a position from which he resigned in 1846.

The Royal Commission for the Great Exhibition of 1851 appointed George Wallis as a deputy commissioner. During the exhibition he was superintendent of the British textile division and a deputy commissionaire of juries. After the exhibition closed he accepted a headmastership of the Birmingham School of Design which he left in 1858 to join the South Kensington Museum (Victoria & Albert

Museum). During the Great International Exhibition of 1862 George Wallis acted in the same capacity as he had in 1851.

Despite moving away from his home town George Wallis had kept a keen interest in the establishment of the Wolverhampton School of Art. Its first annual report had noted, "Mr. George Wallis, head master of the Birmingham School of Art, had offered advice on how to award prizes to students of the school."

The Staffordshire Advertiser reported, in April 1869, George Wallis' claim that "he was one of two persons who originated the Free Libraries' Act" and congratulated his fellow townsmen upon its adoption.

George Wallis was also one of the first to sign the rules of the Wolverhampton Athenaeum, first established as a mechanics institute and library in Queen Street, and which held in 1838 what is believed to be the first technical exhibition in Britain where prizes were given out for manufacture and for industry.

George Wallis stated at the time "that a good museum was much needed (in Wolverhampton) in addition to the local Public Library because a time was coming when commerce would need skilled artisans."

In his later years George resigned his post as senior keeper of art collections at the South Kensington Museum, apparently due to ill health, to take up residency in the Royal Crescent at Bath in 1891 but died a fortnight later.

During his life George donated several art works to Wolverhampton Gallery including a bust of the Wolverhampton born artist Edward Bird whose birthplace, in Cat Yard, had formed one of the earlier etchings in John Fullwood's book 'Remnants of Old Wolverhampton'.

Although George Wallis' religious affiliation is unclear, he published a book in 1875 entitled "Swedenborg and modern

culture" – Swedenborgism being a non-conformist church – which may indicate his views.

Chapter 3 Move To Birmingham

"By the gains of Industry we promote Art"

The entrance to the Gas Hall of Birmingham's art gallery bears the inscription "By the gains of industry we promote art", funded as it was by the profits of Birmingham Corporation's gas department and with this entire institution benefiting from the bounty of the Mayor Joseph Chamberlain's "gas and water socialism."

This display of civic pride reflected the economic strength of the town and this strength in turn fuelled further population growth as people came to share in its prosperity. At some point between 1870 and the capture of the national population census in 1871, John Fullwood became part of that growth as he moved from Wolverhampton to live and find work in Birmingham.

John had moved in with his elder brother William and William's wife Ann Elizabeth Parkes, who had made the move to Birmingham around the same time, although it is not certain whether John moved with them or joined them later in their new home. They all lived at 55 George Street West, Hockley, an area now known as the "Jewellery Quarter", in a row of "back-to-back" houses. This move was not unusual, as members of the extended Fullwood family had pursued economic opportunities in moving back and forth between the Black Country and Birmingham for many years.

In nineteenth century Birmingham's four staple trades of brass, guns, jewellery and buttons, jewellery was the newest and arguably the most consistently prosperous. It had slowly but surely emerged from the declining "toy" and buckle trades (which had pre-dated the industrial revolution in Birmingham) and through the early years of Queen Victoria's reign, as the wealth of the nation grew, it developed to satisfy the rising middle-class demand for personal and household adornment.

This gave rise to a period of advantageous economic conditions both for the trade as a whole but also for the workers, which were amongst the best paid artisans in Birmingham. The numbers engaged in the manufacture of jewellery, silverware, tableware and electroplating grew from approximately 7,000 workers in 1860 to not far short of 10,000 in the following decade.

Photograph provided by 'Birmingham Lives', shows the centre of the Birmingham Jewellery Quarter.

It was partly the profound emphasis on skilled craftsmanship rather than heavy machinery that had caused the numbers to expand so quickly. Graduates of art schools would have been in particular demand; as George Wallis had noted the primary purpose of their education had been "to teach art as applied to manufacture."

John Fullwood had uncles, aunts and cousins all living either in or not too far away from Hockley, many of whom were already

employed in the jewellery trade, and this may have afforded their Wolverhampton born relatives an easier entry into employment.

John's second cousin, Frederick John Fullwood, had been a "Factor" in the jewellery trade, which is one who commissions work from self-employed craftsmen to sell on wholesale. Frederick later ran his own workshop, situated on Vyse Street in the heart of the Jewellery Quarter, employing five men and four boys.

Whether or not Frederick John Fullwood employed his cousins from Wolverhampton is unknown, but they would surely have been acquainted, if not through work then through the non-conformist church to which Frederick John's family also attended. These chapels maintained a strong presence in the area and established a network of clubs, societies and institutions to provide a supporting network for their adherents.

According to the 1861 population census more than one in ten of the worshipping population of Birmingham was considered non-conformist, three times the national average. All across England there was a special connection between the non-conformists and the newly expanding industrial towns but in Birmingham the non-conformists, even though they were not in the majority, knew that they had a special strength. That strength was especially reflected in Hockley. In1851 the various churches and chapels there provided seating accommodation for 61,554 people, representing a quarter of the population of the whole town. The Church of England provided almost half of these pew spaces but whilst there were three Church of England churches in Hockley, they were outnumbered by the six non-conformist chapels. The largest of the non-conformist sects were the Wesleyans, followed by the Congregationalists.

William Fullwood, with whom John was lodging, was aged 26 in 1871. He was ten years older than his brother and is shown in that year's census as working as 'electro-plate maker'. This had become a vital part of the jewellery trade since the process of coating base

metals with a thin layer of silver was patented by George Elkington in Birmingham during the 1840's.

Whilst John Fullwood's motivation in relocating may have been to further his artistic career, in the meantime he also had to earn a living and he gave his occupation in 1871 as a 'Chaser & Embosser'; that is one who engraves or embosses metals, usually precious metals such as gold or silver. It was an occupation that would allow him to develop and further the artistic skills he had acquired at art school in Wolverhampton, but also reflected his increased social status now he was working in Birmingham.

A report into working conditions in Birmingham at this time noted; "As a rule, the working jeweller occupies a higher social position that the other artisans. They reside in comfortable dwellings; their clothes are generally good, and do not betray the working man. This may be attributed to the cleanly nature of their work. They are not given so much to dissipation as some classes. Quiet and continued application, rather than muscular strength, is necessary (a steady hand being indispensable) and all tend to the formation of steady habits." These steady habits were to bode John Fullwood well in later life.

John Fullwood's further education as a craftsman and an artist in Birmingham benefitted from the same factors that had driven the development of the cultural institutions in Wolverhampton, the civic gospel, or municipal socialism, which were 'writ large' in Birmingham and had become more deeply embedded over time. These institutions were driven by the same religious impetus, but allied with a confident and effective political organisation.

The civic gospel has become closely associated with Joseph Chamberlain, the radical and liberal Mayor of Birmingham from 1873, but had its origins with the local leadership offered by a range of non-conformist Ministers and advocates such as George Dawson (Baptist), R. W. Dale (Congregationalist), Charles Vince (Baptist) and H. W. Crosskey (Unitarian). They supported a range of

institutions not all of which were funded by the ratepayer, although many were.

These men had a vision and together with the powerful and influential middle class non-conformist community they led, they articulated a call for municipal regeneration that encompassed more than merely shops and housing. The energy, commitment, zeal and idealism of the members of these chapels, when combined with the wider political ambitions of local politicians, produced a utopian vision of duty built on a moral, social and also an intellectual framework.

Above all they were determined to show that Birmingham had the cultural capital to match its commercial success and were justifiably proud of their town's artistic institutions and the artists that they produced.

Many of the ideas the local elite proposed were discussed at the Birmingham and Edgbaston Debating Society, which flourished from the 1860's and where the architect John Henry Chamberlain (no relation to Mayor Joseph Chamberlain), was elected President of the Society in 1861. Numerous similar industrial conurbations across the country had also formed debating societies and John Fullwood was to be a member of a number of these, especially whilst he lived in the London area.

What concerned the members of the society, in addition to the social, physical, health and moral issues that might be expected, were the cultural and pleasure amenities necessary in expanding towns such as Birmingham. They wished to develop their citizens' pleasure of experiencing gardens, music, literature, art, the sciences and history and in doing so create a cultural climate the equivalent of the Italian renaissance. Henry Crosskey, who like John Fullwood lived for a time in Sussex and had a passion for geology, would "excite his audience by dwelling on the glories of Florence and the cities of Italy in the Middle Ages and suggested that Birmingham too might become the home of a noble literature and art."

Crosskey followed keenly the teachings of George Dawson that "urban man does not live by bread alone." One of the first acts of the Dawson circle was to persuade the Council to establish a free library and art gallery so that Birmingham "might even become the most artistic town in England."

The Corporation Art Gallery opened on 1 August 1867. It consisted of only one room measuring 70 by 30 feet but it nevertheless attracted over 35,000 visitors in five months. In 1871 glass manufacturer Thomas Clarkson Osler gifted £3,000 to establish a Public Picture Gallery Fund. Thus civic resources and philanthropic generosity combined to form and fund public life in Birmingham.

Photograph of Lea Bank Road Birmingham kindly provided with the permission of 'Birmingham Lives'.

John Fullwood's personal circumstance was also to change as he became an established artist in Birmingham. In 1876 he moved address to Grafton Place, Ellen Street, Hockley and in the following July, aged twenty three, he got married.

John Fullwood's bride was Kate Rooker and she was eighteen years old. Kate had been born in Aston, Birmingham where her father, George Rooker, worked in the jewellery trade. He had been baptised at the Congregational Union Chapel in Handsworth. Although the location of Kate's own baptism is unknown, it is likely that John and Kate met through either chapel or work. Kate had been, with her family, a member of Henry Crosskey's congregation, and undoubtedly had absorbed his rhetoric about Birmingham's future.

John Fullwood and Kate's first child, daughter Lillian Mary Fullwood, was born seven months later in February 1879. Her middle name reflected that both John and Kate's' mothers were called Mary. Lillian's birth was registered in Wolverhampton and not Birmingham where they were living. Had John taken Kate back to his family to assist with the early birth? Shortly after this John, Kate and the new baby moved again, to 82 Albion Street, Hockley, only a few streets away from their previous home in Ellen Street and still in the heart of Birmingham's Jewellery Quarter. John obviously still needed to live close to the source of his work.

Birmingham's art and industry, intertwined as they were and with their synthesis reflected in Chamberlain's gallery, offered larger artistic institutions and constituted a stronger market for art than Wolverhampton. This also demanded a greater supply of artistic craftsmen to service the town's expanding trades. Both fine and applied arts supported one another in a virtuous circle of growth that resulted in the establishment of the largest market for art in Victorian Britain outside of London. Victorian writers acknowledged this, stating that the town "could support a considerable number of professional painters who would make a very good living there." The autumn exhibitions held by the Royal Birmingham Society of Artists regularly displayed between six and seven hundred works of art each year.

Despite Birmingham's population more than doubling in the period from 1831 to the time that John Fullwood moved there around

1870, the town still lagged behind that of London, Glasgow, Manchester and Liverpool in numbers of inhabitants. Its economic development, however, reflected Birmingham's unique circumstances; it was a city whose growth was relatively recent and where employment practices had developed free from the restrictive charters, guilds and corporations that regulated workers in other cities. Birmingham's long established tradition of metal working meant that it had attracted many artisans, craftsmen and smiths to the city prior to the industrial revolution and these skilled workers had individually handed down their skills and tradition to succeeding generations.

All of these factors had contributed to the proliferation of small businesses and workshops rather than the large factories found in northern towns. Birmingham's growth, culminating in it becoming known as the "city of a thousand trades," was not primarily built on heavy engineering, even if most trades involved metal manufacturing of some sort. Both geography and geology had meant that Birmingham left iron smelting and metal bashing to other places, notably the nearby Black Country and places even further afield.

Those inhabitants of Birmingham who did not manufacture the goods sold them instead, throughout Britain and its Empire. Birmingham depended upon the large-scale production of finished manufactured goods primarily intended for export, a state of affairs captured in the stone pediment above the entrance to the Council House, erected in 1879, where a frieze showed Britannia receiving the products of the manufacturers of Birmingham.

However, local businessmen recognised that, if this approach were to be successful it meant that these products had to be of a higher-quality design in order to distinguish them from what was disparagingly called "brummagem", a term used to indicate "rubbish from Birmingham." If Birmingham was to develop as an industrial city, then professional expertise and thoroughness were demanded; the teaching of art and design could not remain

dependent upon individuals and amateurs. As Britain's continental competitors modernised and professionalised their artistic training schools George Wallis, amongst others, highlighted the value of the visual arts in supporting industrial progress.

Outside of Birmingham though a world trade depression had begun around 1876 and this, combined with a decline in the fashion to wear so much personal jewellery, the "lockets, rings, bracelets, pins and necklaces" that were the mainstay of the jewellery trade in Birmingham, led to a severe decline in employment.

All of these factors must have influenced John Fullwood's thinking as shortly afterwards he took the decision that he would no longer be a chaser and embosser, but would concentrate on becoming a full-time artist.

Chapter 4
Education, Education, Education!

A poet's eye into nature

As John Fullwood furthered his education as an artist in Birmingham during the 1870's he had attended two institutions: the Birmingham Municipal School of Art and Design and the Birmingham School of Landscape Art. The natural conclusion of his education was his later membership of the Royal Birmingham Society of Artists (R.B.S.A.).

These institutions grew out of the existing, and distinctive, local art market. One of the Birmingham based artists who can be said to have initiated the town's fine art institutions was Joseph Barber, who had established his own academy of drawing in Great Charles Street by 1780 and which was continued after his death in 1811 by his son Vincent Barber.

One of Barber's pupils was Samuel Lines, who had established another academy in nearby Newhall Street in 1807. In 1809, these two artists, together with six others, opened an academy of life drawing in Peck Lane. This group held its first exhibition of members work in 1814 as the *Birmingham Academy of Arts*. It was from this beginning that *The Birmingham Society of Artists* was established. The Society soon realised that a means of teaching the next generation of Birmingham artists was required if the art market was to be sustained.

Lines and Barber were part of the 'Midlands Enlightenment' which had been heavily influenced by the Birmingham Lunar Society, a philosophical group emerging in the 1750's that later included Mathew Boulton and Erasmus Darwin, amongst many other local luminaries. This group had contributed to a climate of innovation, with scientific enquiry leading to technological implementation in an entrepreneurial environment. All this it has been argued, grew

out of Birmingham's long history of non-conformist religious freedom.

Another key figure in the development of the arts in Birmingham was the painter David Cox. John Fullwood would not only have seen his works on display at the Art Gallery but would also have read his influential guides for those studying the practice of art. Elihu Buritt, the American Consul, was also appreciative of Cox, describing his approach as how; "He looked with the loving rapture of a poet's eye into nature, and then he dipped his pencil into the rainbow, and caught and fixed on canvas her sunniest gleams."

As well as the landscapes for which Cox is best known, he also produced a considerable quantity of topographic views of Birmingham. A number of these were collected and bound in a volume, republished many times, and which was subsequently used as a teaching aid in many Birmingham institutions. One of the best known of these was a southwards view from the Bull Ring, with St. Martin's Church in the background.

Various other artists produced a large number of such topographic views which were published in Birmingham at this time. As the town and its population grew, local publishers realised that there was a market for such work.

These views were produced as individual art works but also as both book and newspaper illustrations, many of which were copied again and republished. All this must have resulted in what would now be termed a huge picture 'database' of topographic views made in and around Birmingham during 1780-c.1850 showing the newly-built buildings, such as the Town Hall, St Philip's Church, Christ Church, both the Grand Junction Railway and the London and Birmingham Railway stations, the main Post Office, the botanic or pleasure gardens, various manufactories, suburban rail stations and various shops. These became an existing resource, as well as an inspiration, to the artists studying in Birmingham at that time.

In 1821 Samuel Galton chaired a meeting of the Lunar Society, and noted "It appears to this meeting that the due cultivation of Fine Art is essential to the prosperity of manufacturers of this town and neighbourhood, and that no facility at present exists for this specific purpose. It is considered to be extremely desirable that such an institution be now formed", and eventually its members founded the *Birmingham Government School of Design* in 1843. This anticipated the reasoning deployed by Charles Mander years later in Wolverhampton and was the debate that George Wallis fostered when he became head of the Birmingham's Government School of Design.

Wallis expanded on his ideas in 1884 when he wrote the introduction to the catalogue of an exhibition gathering the works of students of Government Schools of Art from across the country. He wrote concerning the status of the designer in Great Britain where "the want of public recognition of his position as an artist" contrasted with the status in France, Germany and Belgium. This led to the "ablest and most original" student to leave industrial design for the practice of pictorial art or to leave Britain altogether and go to work in the United States or the Australian Colonies. He gave two examples of designers who had attended the Birmingham School of Art and gone on to South Kensington to study but could not make a living in this country. They had gone abroad and subsequently been feted in America for their designs.

The Birmingham Government School of Design was renamed Birmingham Municipal School of Art in the 1870's, when it became the United Kingdom's first municipal college of art. This institution was known as the "Queen of the Midlands." The professionalism, the regulation and investment that followed George Wallis's leadership bore fruit in many ways, including the identification of a distinctive local scene - the "Birmingham Art School Scene" - according to the *Art Journal,* with a focus on landscape painting. Some of the founders of this so-called "scene" may have been the descendants of the craftsmen first drawn to the

city to work in industry but the scene's origin should also be seen in the context of the much earlier 'Midlands Enlightenment'.

Although the description "Birmingham Art School Scene" was a collective name, the *Art Journal* said it to be full of "individuality" due to the style and the various methods used by the young artists comprising it. Although John Fullwood's name has been associated with the scene, he had furthered his art education and joined Birmingham's artistic institutions sometime after the scene started and had left Birmingham long before it was decided it had finished. Anyway, the scene was named by later generations.

The Birmingham Society of Artists received its Royal Charter in 1868 and became the Royal Birmingham Society of Artists (R.B.S.A.) in that year. It is through these networks of teaching that the Birmingham tradition of landscape painting was developed and sustained. John Fullwood was to be a proud member of the R.B.S.A. later in his life.

He was not alone in this regard. Writing in *"The History of the Royal Birmingham Society of Artists"*, Edward Harper, President of the R.B.S.A. into the 1930's, recollected the origins of a group of young artists in Birmingham in the 1870's, including John Fullwood, who were to learn together, exhibit together and finally achieve success together.

Harper wrote, "The Birmingham Society of Artists (as the Royal Birmingham Society of Artists was then called) and the School of Design held their evening classes in the upper story of the Midland Institute, classes to which I was sent from the Edward St. Branch of King Edward School at the age of 12. This was an unappreciated privilege accorded to 8 boys who drew less badly than the others, and it must have been six years later before I entered the advanced classes. The classes also included William J., Wainwright, Walter Langley, John Wilkins, Thomas Spall, Edwin Harris, W. A. Breakspeare, John Fullwood and W. B. Fortescue." Of these artists

Fullwood, Wainwright and Langley had all begun their working life in the jewellery trade, and all three were to become lifelong friends.

As Harper was the same age as John Fullwood, this would indicate that this group first met in 1872, not long after Fullwood had moved to Birmingham. John's older brother William was also attending classes at the Birmingham School of Design at this time.

The School minute books show that John Fullwood was awarded a Third grade prize in the 1875 national examination in the Artisan and Modelling classes, and William his brother gaining a school Second grade prize in applied design. The national examination was of the South Kensington curriculum. Both awards were reported in the *Birmingham Daily Post* of 3 August 1875.

Harper continues by saying, "One of our number, I think it was Langley, brought us news of some classes which were held on 3 evenings a week at the R.S.A. for the study of figures and costumes, and having secured admission by submitting drawings, we migrated as a body and worked in these classes, then under the direction of Jonathan Pratt and H.T. Munns, until under the revivifying figure of Edward Taylor, the School of Art provided us with more and better opportunities of study."

Edward R. Taylor was recruited to become Headmaster of the Birmingham Municipal School of Art in 1877, by the school's chairman, the architect John Henry Chamberlain, having previously been head of the Lincoln School of Art. It was his appointment that was to lead to the ideology and aesthetic of the Arts and Crafts movement becoming the dominant feature in Birmingham's visual culture, which proved to be a perfect fit with the Civic Gospel.

As a result Birmingham's artists and craftsmen would benefit from extensive patronage, as the Arts and Crafts style became the semi-official taste of Birmingham's governing elite. Chamberlain and Edward Taylor persuaded the artist, designer and social reformer William Morris to accept the appointment as the school's President for two years from 1878. This was fitting, as Morris had been one

of the founders of the "Birmingham Set" at Oxford University in the 1850's out of which the 'Arts and Crafts' movement had developed.

This appointment proved to be the start of a 20-year relationship between Morris and the school that saw him act as lecturer and examiner and as a commissioner of work from the school's students, many of whom would go onto become members of the R.B.S.A.

Addressing a meeting of the Society in 1879, William Morris stated "if these hours be dark as, in many ways they are, at least do not let us sit headless like fools and fine gentlemen thinking the common toil not good enough for us and beaten by the muddle, but rather let us work like good fellows trying by some dim candlelight to set our workshop ready against tomorrows daylight–that tomorrow when the civilised world, no longer greedy, straightful and destructive, shall have a new art, a glorious art, made by the people and for the people, as happiness to the maker and the user."

The Municipal School of Art had a thriving department teaching book illustration at this time, which was to produce many nationally acclaimed figures. As early as 1896 the *Magazine of Art* was able to identify the "Birmingham School" of illustrators as a distinct and important style. Whether Fullwood attended these classes is unknown but work in book illustration was to provide an income for him for many years.

As part of this progression, in 1883 the Municipal School of Art broke completely from the control of the national system of art education, with its rigidly prescribed systems of theoretical instruction controlled from South Kensington and became the first British art school to establish itself fully under local municipal control.

One of the criticisms made of the "South Kensington" school of art training was that it had encouraged minituristic skills and fine detail, but at the expense of breadth and large scale design. The tight control, precision and grasp of detail that John Fullwood later

displayed in some of his finest etchings show the technical skill he acquired during his training. He is less remembered now for his large scale oil paintings.

An essay on the art scene in Birmingham printed in 1887 by *The Magazine of Art*, a review of the art world published monthly by Cassell & Co, noted that "The Municipal School of Art, for completeness and excellence of teaching, is not to be equalled throughout the country" and where "it is one of the chief endeavours of the management to make an artist of the workman before he is taught to be a designer in his own special branch" as "the chief fault of designers – artisan designers - is that they cannot draw, hence in Birmingham they are taught to study first from the cast and later in the life class."

The essay was clear that "this immense improvement is chiefly due to the admirable teaching and organisation of Mr E.R. Taylor" (Headmaster).

A family portrait of John Fullwood.

In addition to the training offered at the Municipal School of Art, John Fullwood, still then working full time in the jewellery trade, continued his art studies in the evenings and weekends at another, private, academy; the Birmingham School of Landscape Art.

This School originated within the Young Men's Mental Improvement and Mutual Aid Society, a society associated with the non-conformist churches in Birmingham and their desire to promote self-help and self-education for their congregations.

The *Birmingham Daily Post* reviewed an exhibition of works by artists taught in these classes on 15 September 1873. This is the first

review where John Fullwood's art is identified; his water colours were described as "creditable."

One aspect of the exhibition that the critic particularly enjoyed was the "time sketches" which the critic described as "one of the most enjoyable features of the exhibition…..they derive their interest from the fact they are done within a given time – one hour or two hours – at the class, the teacher naming the subject and each student forming his own conception of it, and working it out in the time stated…..John Fullwood excels in this department."

At the time of this exhibition 600 pupils were attending 20 classes led by Edward Watson and other teachers. The article goes on to describe John's work as having links with the pre-Raphaelite Brotherhood, although he was never a member of that movement.

The art classes were originally taught at the school's premises in Clarendon Chambers, situated in Temple St, Birmingham and which were led by Edward Watson, a teacher and skilled artist in his own right who had studied with Samuel Barber and sketched with David Cox. Watson was also a non-conformist preacher.

Watson, in contrast to the syllabus at the Birmingham Municipal School of Art and Design, had no interest in design as applied to the needs of manufacturers, as his sole aim was to teach landscape painting. Watson noted that "The eye of the artist should not only be trained to see and imitate but also to select and arrange forms, so as to serve an agreeable composition" *(his emphasis).*

A year before his death, Watson lamented that "in nearly all pictorial works of Art painted during the last thirty years, there is a marked verging towards the realistic, to the neglect of the poetic aspect of Nature: or….should I say that there is an ignoring of the poetic sentiment in Nature, in an enthusiastic endeavour to represent even the minutist details with great correctness. Our painters have become *naturalists* rather than *artists.* "

This school was later to merge with the Birmingham branch of the Young Men's Christian Association (Y.M.C.A.) and, partly through Watson's efforts, the Y.M.C.A. decided to acquire larger premises to accommodate their expanding range of activities.

They acquired the "Sultan Divan" a public house notorious for bad behaviour located in nearby Needless Alley, for £7,500. This was then rebuilt, including adding a new third storey with large windows suitable to house classrooms for the teaching of art.

The Y.M.C.A. relocated to their new premises later in 1875. As the Birmingham School of Landscape Art continued to grow and hold exhibitions of its works, it gained critical acclaim outside of the city. Through this exposure, John Fullwood began to establish his reputation.

A review in the *Artist* magazine highlighted the works of fellow scholars Stanier, Evans and Mercer but "perhaps Mr John Fullwood should be assigned the first place for the variety, power and poetical feeling which pervades his works. Great things may be expected from this artist."

The School of Landscape Art continued for some years after John Fullwood had left but, although its annual exhibitions continued to be held, the impact of competition from the better funded Birmingham Municipal Art School was apparent to the reviewer of the *Birmingham Daily Post* of 28 September 1886.

The reviewer noted, "The art classes have suffered somewhat from the development of the Municipal School of Art, but still retain considerable vitality, while the open-air sketching department enjoys undiminished popularity…the display is helped out by a few specimens of the work of former students among them being pictures by John Fullwood, Fred Mercer, Henry Pope, John Keeley and others."

Open-air sketching was taught in order to connect these aspiring artists with nature, whatever the weather. As the pre-eminent

Victorian art theorist John Ruskin said "Sunshine is delicious, rain is refreshing, wind braces us up, snow is exhilarating; there is really no such thing as bad weather, only different kinds of good weather."

Despite the competition with the Municipal School, the School of Landscape Art continued to hold exhibitions until the Second World War and received and retained the patronage of the influential Birmingham Quaker family of Cadbury.

The *Birmingham Daily Gazette* reported on a prize giving ceremony attended by Mrs Barrow Cadbury on 11 January 1937 where the Director (George Leigh) claimed that many students of the school had achieved high distinction in the world of art, citing John Fullwood, Fred Mercer and John Keeley as examples.

A result of John's emerging success as an artist throughout this period was his decision to move his family to a private rented property away from Hockley, further afield in the expanding suburbs of Birmingham.

The 1881 census reports, and this is the first census return in which John Fullwood gives his occupation as a "Landscape Artist", his family, including their newly born daughter Maybell Gaunt Fullwood, born in July 1880, living at Lea Bank Road, Edgbaston. Maybell's middle name, Gaunt, was no doubt chosen in honour of John's mother's maiden name, as she also passed away in 1880. There was one other occupant of that address, a nineteen year old domestic servant. John Fullwood had now truly joined the middle classes.

The joy at the birth of their first child soon after their marriage turned to tragedy when John's first born daughter Lillian, died. As the *Birmingham Daily Post* of 13 April 1881 noted "a verdict of accidental death was returned on Lillian Fullwood, of 195 Lea Bank Road, Birmingham aged two years and two months....who was severely burned as a result of playing with fire."

John's brother, William, with whom he had first moved to live in Birmingham, had by now established himself as a modeller and designer within the jewellery trade, and had premises on Ludgate Hill, deep in the centre of Hockley.

In attempting to raise the profile of John Fullwood, the authors of this book have frequently been contacted by people who possess his works but who have an incomplete knowledge of his art and career.

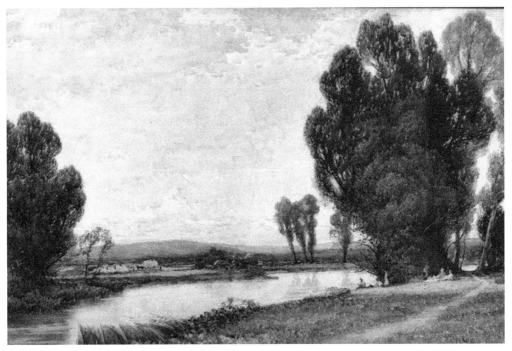

Photograph of a river scene painted by John Fullwood. Provided by the owner in connection with an intriguing family anecdote.

One such curious case concerns the painting shown above. The current owner, who makes cakes for a living, relates a family anecdote suggesting John Fullwood had a relationship with a relative of hers (a great grandaunt) and the painting has been handed down within the family through succeeding generations via another great grandaunt called Gertrude.

The story, also handed down within the family, was that John Fullwood had given the painting to a great grandaunt as a parting

gift at the end of their relationship before he left for Paris to study in 1881. Whether that gift was made prior to, or after John's marriage to Kate Rooker is not remembered, but the story within the family is that the couple had an affair.

There is obviously a kernel of truth within the story told as, pre the internet age, how else would the fact of John's trip to Paris be known in this family except through direct contact between the parties?

However, John Fullwood had a well documented track record (as recorded in contemporary newspaper accounts) of giving his paintings away as marriage gifts to family and friends he was close to. At this time one of Gertrude's siblings Evelina was living not far from John's former Birmingham address so perhaps rather than a parting gift at the end of a relationship, the painting may have been a wedding gift to either Gertrude or to one of Gertrude's siblings, remembering an earlier friendship in Birmingham.

This explanation is further supported by the fact that the painting is signed by John Fullwood with the suffix R.B.A. and thus dating it to after 1890, long after John's marriage and sojourn in Paris. Further, the setting seems to be Sussex or the South Downs, the area in which John was living in the 1890's, not the 1870's when the relationship was suggested to have happened.

Unfortunately, we will probably never know who John Fullwood gave this picture to and whether it was a wedding present or indeed a parting gift between lovers.

Chapter 5 Origins Of 'Remnants of Old Wolverhampton & Its Environs'

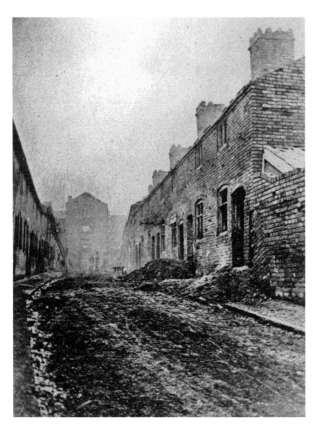

As the prosperity of Wolverhampton grew in the 19th century so had the population of the town and the newly arrived townsfolk were often crammed into overcrowded and unsanitary housing, which in turn led to the outbreak and spread of disease.

An early photograph from the collections of Wolverhampton Archives & Local Studies showing the housing in Caribee Island, Wolverhampton.

The poorer quality housing was concentrated on the eastern side of the town, especially in the area known as "Caribee Island", which occupied the area now bounded by Broad Street (formerly Canal Street), Stafford Street and the present ring road. At this time it consisted of a warren of courts and alleys between the thoroughfares as every space was in-filled with housing by landlords eager to accommodate the influx of predominantly Irish workers.

According to the 1871 census the Irish made up more than 17% of the town's population. The name "Caribee Island" is probably a

corruption of the names of the Irish counties (Cork, Clare, Kerry etc) where the workers had come from.

The problems that poor housing created had been identified many years before a solution was implemented.

An early photograph from the collections of Wolverhampton Archives & Local Studies, of Canal Street (now Broad St.) showing reputedly the last thatched roof cottage in Wolverhampton. George Bradney Mitchell it is claimed owned this plot of land.

Wolverhampton's Town Commissioners, the civic body responsible for the infrastructure of the town prior to 1848, had planned a number of schemes intended to improve the town, but progress had been slow as they were unwilling to put the costs of the schemes onto the ratepayers.

In 1843 Richard Henry Horne, a poet and an acquaintance of Charles Dickens, was employed by the *Royal Commission of Inquiry into Children's Employment* to report on the condition of children working in mines and factories.

Horne visited the Black Country and in Wolverhampton he described the housing in which many of these children and their families lived. "The great majority of these courts and blind alleys contain only two to four houses, one or two of which are workshops, or have a room in them for a workshop. In one of the hovels off Stafford Street it appeared that a man, his wife and child and a donkey all slept together. The hovel had but one room: the man was seated upon the threshold of the door as I was passing one evening. The woman and child were in bed on the ground and the donkey was standing upon some straw beside her."

In 1849 a further report, addressed to the General Board of Health, noted "In Colcs Croft, off Stafford Street, there are 41 houses, containing 283 inhabitants, 94 of whom were adult lodgers. The place was very filthy…Caribee Island is a congregation of ruinous cottages to which there are no sewers or drains."

These conditions encouraged the spread of disease such as Cholera and Typhus and after one such outbreak in 1871 the town's ex-Medical Officer of Health, Dr Manby, was questioned about the contribution the housing stock had made to the death toll. He was asked "Are these streets such as they are in the present time, very tortuous and badly situated for the ventilation of the houses generally?" To which he replied "I think so, especially Lichfield Street that goes out of Queen Square into the unhealthy area, being a particularly narrow and tortuous old street."

The granting of municipal powers to the Town Council had not provided an immediate response and the notorious situation in Wolverhampton warranted a report to the Local Government Board *"On the Sanitary Conditions of the Municipal Borough of Wolverhampton"* in 1874, written by a Doctor Ballard. He

identified the area's poor quality housing "In St Peter's ward (*amongst many wards listed in the report*) the courts passing out of Stafford street on the west side; North Street and especially the courts out of it, Horsefair, Berry Street and the courts out of it especially Cat Yard and Lichfield Street."

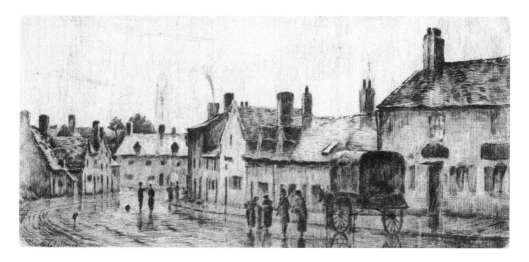

John Fullwood's etching of Horsefair, Wolverhampton now renamed Wulfruna Street. Reproduction by permission of Wolverhampton Art Gallery.

A physician at the Wolverhampton Dispensary, Mr T. Ogier-Wood, described the area known as Caribee Island in a report as "a filthy narrow alley or cul-de-sac inhabited chiefly by the lowest Irish, with an open stagnant ditch down the middle....within a few yards of the backs of these houses runs a ditch, the main sewer of that side of town, which is dammed up and diverted into several large cesspools which in warm weather emit such offensive exhalations as to be almost intolerable."

An article in *'The Builder'* magazine in August 1872 stated "In Peel Street and its neighbourhood and in what is called Caribee Island, the condition of things is frightful: if the latter were really the settlement of a tribe of wild Indians, it would be an object of wonder to the civilized upper classes of Wolverhampton. These are places which fight against the general salubrity of the town, and out

of which will one day come some frightful epidemic to dispel the security at present indulged in, and rouse to salutary action." Wolverhampton was not unique in having slums and similar conditions existed right across the Black Country.

However, Ballard's report did prompt Wolverhampton Town Council into making a response. This outlined the various measures which they had already put in place to tackle these issues and to develop further more ambitious plans.

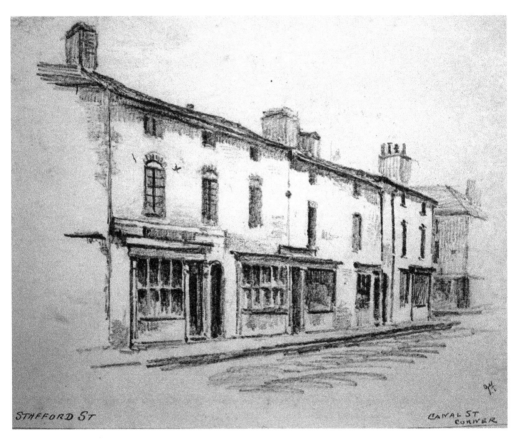

A previously unpublished drawing by John Fullwood and included here with the permission of Norm Keech, showing the corner of Stafford St and Canal St (Broad St) Wolverhampton on the boundary of Caribee Island district.

As result of these plans many of Wolverhampton's old buildings in those blighted areas were to be demolished and replaced. In total 12

acres of Wolverhampton town were to be redeveloped on which stood 686 premises housing 3,385 inhabitants. As Ballard's report had identified "The only improvement of which some of them are capable is such as would improve them away altogether. Many are residences in which no human should be lodged."

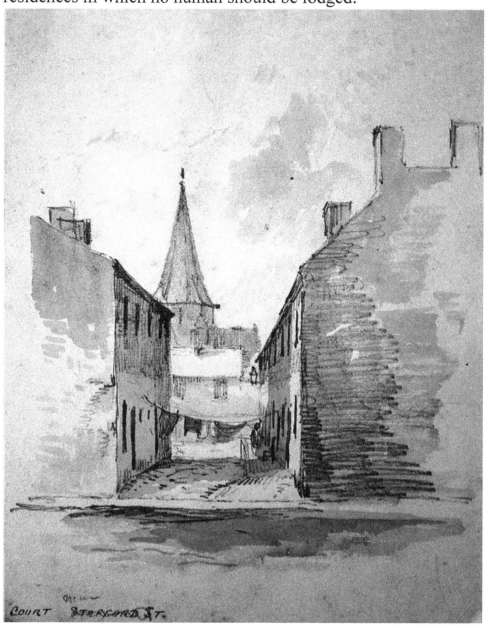

A previously unpublished drawing of Stafford St. area of Wolverhampton by John Fullwood. Published here with the kind permission of Norm Keech.

The mechanism by which Wolverhampton Town Council funded public works was by sponsoring private Acts of Parliament. Two such Wolverhampton Improvement Acts, as they were called, had already been passed, in 1853 and then in 1869. The next Improvement Act was on a much larger scale and was proposed to take advantage of the Artisans Dwelling Act of 1875.

In total Wolverhampton was to spend over £228,000 on these Improvement Acts. The original estimate was that it would cost £162,000. The new scheme was intended to demolish and replace the Caribee Island slums and lay out a new road system, thereby reclaiming marshy ground and creating new areas for development.

A new commercial district was to be built along Lichfield Street, which was straightened out and widened to accommodate new business properties. It was hoped that the sale of development plots on these new streets would offset the cost and make a profit for the town council. Indeed, the Council advertised the results of its improvements in a way designed to maximise commercial potential.

An advert they placed describing a plot of land on North Street stated it was "the best business situation in Wolverhampton, being in immediate proximity to the New Town Hall and intended Police station, market hall and Corn Exchange and fronting two of the principal thoroughfares of the town."

But in truth there were other, equally squalid areas of the town that could have been re-developed. Perhaps the reason behind the choice of this area for flattening reflected the fact that most of the inhabitants were recently arrived immigrants, predominantly Irish, who were blamed for many of the town's problems.

In their ambition, Wolverhampton Council was copying the pattern already established in many towns and cities, most notably in Birmingham's laying out of Corporation Street. As the *Wolverhampton Chronicle* noted on 21 April 1869, Birmingham was where "little sister Wolverhampton looked habitually for comparison and guidance in all aspects of civic conduct."

The driving force behind Birmingham's much larger scheme was the Mayor, Joseph Chamberlain but the architect and designer masterminding it was John Henry Chamberlain. Despite the similar surname the two were not related, however they shared the non-conformist faith from which Mayor Joseph Chamberlain had implemented the 'Civic Gospel'.

Joseph Henry Chamberlain was a partner in the architectural practice of Chamberlain & Martin. His partner, William Martin, was engaged by Wolverhampton Council as a Surveyor and Valuer when the Council began to compulsorily purchase properties in the area of the Improvement Act in order to demolish them.

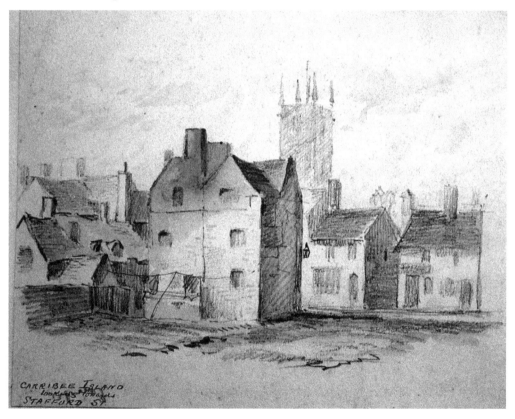

A previously unpublished drawing of Stafford St. area of Wolverhampton with St. Peter's Church in the background by John Fullwood. Published here with the kind permission of Norm Keech.

Connections between the architect William Martin and the wider Fullwood family already existed. Frederick Fullwood, a second cousin of John Fullwood, was an employee of Chamberlain & Martin. Frederick's father, Frederick John Fullwood, was a jeweller employed by a firm whose owner's daughter became William Martin's wife; she had been a witness to the marriage of Frederick John Fullwood.

Another of Frederick John Fullwood's sons was Albert Henry Fullwood, a talented artist, who was eventually to move and make his name in Australia, becoming a war artist during the First World War. Before that both John Fullwood and Albert Henry Fullwood had links through their membership of the Birmingham School of Landscape Art.

Frederick Fullwood emigrated to Australia in the late 1880's along with his family. Before this, however, he had obviously held a position of trust at Chamberlain & Martin as he was noted as a mourner when the press reported on John Henry Chamberlain's funeral in 1883.

In a letter written to the *Sydney Morning Herald* in 1890, Frederick Fullwood remembered his involvement in property development in the UK. He was trying to promote a similar scheme in Sydney and noted that the British Government had advanced cheap loans to local councils to facilitate a number of commercial developments which had resulted in "the carrying out of improvements in several cities, two of which – Birmingham and Wolverhampton – I have been personally associated with."

Perhaps this memory merely reflects what John Betjemen, writing fifty years later, reflected on when he said that "an absence from England can lead the traveller to be selective in his recall" and "even a town like Wolverhampton looks splendid through memories of a telescope."

Nonetheless, these connections suggest that Frederick and John Fullwood, second cousins, knew each other through a combination

of shared artistic, familial and religious networks; perhaps that they travelled together from Birmingham back to Wolverhampton to note, value, and sketch the buildings that would be torn down as the Corporation of Wolverhampton sought to improve its townscape.

Many of the unpublished sketches that John Fullwood drew and still survive, are of the Caribee Island area. Scenes from Horsefair, Berry Street, Lichfield Street and the courts that emanated from them all appear in John's 'Remnants of Old Wolverhampton' book. These sketches and etchings do not attempt to beautify or make picturesque the slums that he saw; rather they capture the urban squalor that existed only a short distance from where he had been brought up.

The outcome of the Improvement Act itself though, was not as successful for the people of Wolverhampton, especially those living in Caribee Island, as those promoting it had hoped. The Corporation obtained approval from the Government to abandon that part of the scheme made under the Artisan's Dwelling Act that had required it build as many homes as it tore down.

As the *Wolverhampton Chronicle* of December 1881 noted, the first sale of the plots of development land cleared by the Improvement Act was not a success. The paper's correspondent noted that "many of the lots put up having to be subsequently withdrawn for want of sufficient biddings" and of the ones sold "the prices realised were much below general expectation."

It pointedly quoted Alderman Fowler speaking to the Council in September that year as stating "if the Council were not going to make £10 per yard of the land in the vicinity of the new street…it would be a very losing business", as it noted the average price of the land sold in the sale as being only £4 15s 10d per yard.

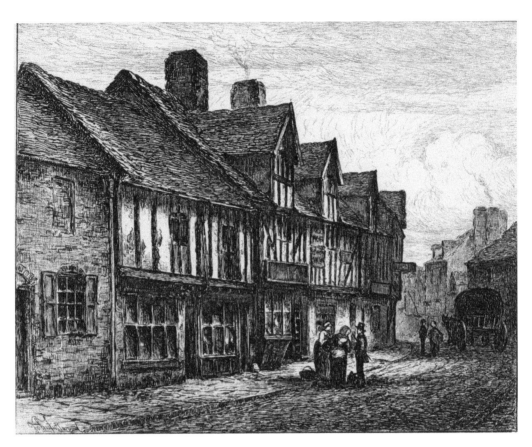

John Fullwood's etching of old Lichfield St Wolverhampton before the demolition work began. Reproduction by permission of Wolverhampton Art Gallery.

It was from these unpromising beginnings that John Fullwood, by now an established artist of some local repute, had begun work on the book that is perhaps most associated with his name – 'Remnants of Old Wolverhampton and its Environs'.

Chapter 6 The Book & It's Artistic Connections in Wolverhampton

"A real local artistic treasure"

In 1879 Arthur Frederick Hellier, a land agent and surveyor living in Wolverhampton, saw in the town's planned developments an opportunity to publish a part-work collecting images and text about the changing face of his adopted town.

Hellier had been born in 1858, in Chatham, Kent, where his father had been a clerk and another part of Arthur Hellier's childhood had been spent in Hampshire, when his father worked at Parkhurst Prison on the Isle of Wight. In 1881 Arthur was living in Bradmore Lane, Wolverhampton, with his wife Amy and son, also Arthur and giving his occupation as a Land Agent, Surveyor and Valuer.

Why Hellier chose John Fullwood to be his artist for the project to record the changes taking place to Wolverhampton is not clear, as by this time Fullwood had already moved from Wolverhampton to live and work in Birmingham. However, by the time he was recruited John Fullwood had already begun to make his name in the local art scene, showing his work at exhibitions of the Royal Birmingham Society of Artists, and belonging to several Birmingham artistic groups.

Despite his local prominence it seems unlikely that Fullwood had, by 1879, acquired sufficient capital to become an equal financial partner with Hellier, so it is likely John's role was probably limited to providing the art work. They formed a contractual partnership to pursue their project, working from Hellier's offices at St Stephen's Chambers, 1 Waterloo Rd South, Wolverhampton.

One of their first reviews of a part-work of Wolverhampton images, published in the *Wolverhampton Chronicle,* identified "Mr John

Fullwood is the artist, and his name ensures an able treatment of every subject."

That Arthur Hellier was an established collector of art is confirmed by a report in the 15 November 1884 *Birmingham Daily Post* of the exhibition of paintings shown at the South Staffordshire Industrial and Fine Arts Exhibition. The report notes that Hellier had lent the exhibition a painting by the Birmingham artist Ernest Thompson, but also noted that "Two pictures by John Fullwood, namely '*A Cornish Glenn*' and a study of a hoary and mutilated Oak in Edgbaston Park …were lent by Mr A. F. Hellier."

The painting of '*A harvest for the hearth - A Cornish Glenn*' was first exhibited in 1881 in Birmingham, thus indicating the purchase of these pictures post-dates the start of their partnership, if it is assumed that this work is from the first of John Fullwood's subsequent trips to Cornwall.

The review also states that the study of the oak was done in less than three hours. This remark indicates that the reviewer spoke to the artist, given that by now John Fullwood had some recognition in Birmingham and that it is likely that this study was completed as part of one of the Birmingham School of Landscape Art field trips under the supervision of Edward Watson, whose technique of "time sketches" was well known. The title of the painting of 'the oak tree' is not stated in the review but from the description it may have been the painting inspired by the lines from Cowper, "Thine arms have been wrent off…."

It is likely that John Fullwood had begun to produce the work that was to form part of 'Remnants' book (shorthand for 'Remnants of Old Wolverhampton and its Environment') by faithfully recording buildings in the town as part of his studies at the Wolverhampton School of Art and many of these buildings may have been those eventually subject to demolition.

Perhaps John Fullwood had taken inspiration from the Birmingham artist David Cox in his instruction book '*A Treatise*' in which, as

one publisher's review noted "Picturesque bits of Old England abound in these books — rustic bridges, cottages, and quaint old houses, such as scarcely exist in these latter times, when so much that was endeared to the artist has been swept away by the hands of modern improvers." Either way, the idea behind the publication was praised in the *Art Journal's* review of the first edition "It is a wise and patriotic scheme that preserves their portraiture before they are gone."

Hellier and Fullwood's 'Remnants' book was originally published as a part-work containing four etchings of Imperial Quarto – 15 inches by 11 inches - in each, and sold on a subscription basis at 2s 6d per edition.

A leaflet advertising the 'Remnants' work, dated January 1880, gave the reasoning behind the publication; "Wolverhampton, ancient in its name and history, possesses many buildings long since old fashioned and out of date. Some of these are carefully preserved, others are gradually, but surely, perishing by process of natural decay; others again, situated within the area devoted to our most necessary street improvements must soon disappear. It has seemed therefore, to the promoters of this work, that an artistic record of the relics of an early time in the town and its neighbourhood might prove, perhaps, generally acceptable; and they have thus allowed their idea to assume a definite shape."

The 'Remnants' promotion leaflet also stated that it was intended to comprise of 25 parts with upwards of 100 original etchings, appearing at intervals varying from one to two months and that the number of copies published would be strictly limited to 1500. It was printed locally, and distributed in London by Virtue & Co. At the time of publication of this biography, between 50 to 60 etchings ascribed to 'Remnants' are known to exist.

The first edition contained the four etchings, 'Boscobel', 'The Collegiate Church', 'The Deanery', and 'Wheelers Fold', and was

described favourably in the *Art Journal* "Seldom have we seen the introductory number of a publication so entirely satisfactory."

The *Birmingham Daily Post* noted it as "Admirably illustrated with etchings on copper. The work is got up in first rate style, the illustrations being truthful and vigorous and the letterpress being as remarkable for its excellent typography as for its interest."

Another review, in the *Wolverhampton Chronicle* considered that it "promises to stand unequalled amongst books relating to Wolverhampton…The size is Imperial Quarto, the paper is of fine quality and the printing leaves absolutely nothing to be desired. The drawings in the first part of the work are charming in themselves and accurate reproductions of the views they promise to depict. The work promises to be a real local artistic treasure."

A review in the *London Daily News* of 5 February 1880 noted that the publication "furnishes a noteworthy indication of the increasing interest in the architectural and other relics of our old towns." Whereas, the reviewer noted, a similar London publication used the "legal evidence of permanent photography" the Wolverhampton publishers "take an art-view" with every picture an etching on copper.

By the 24 May 1881 the *Walsall Advertiser was* noting that 'The Old Buildings, Digbeth, Walsall' (below) had appeared in the third edition to be issued of the 'Remnants' part sets and the critic described the etchings as being "perfect gems" and of being "rich in 'Rembrandtesque freedom', brightness and fidelity."

In May 1882, the *Staffordshire Advertiser* announced they had received the fifth edition, quoting the subjects as 'Dunstall Hall'; 'Cat-yard Berry Street'; 'Old House in the High Street' and the 'White Hart' in Walsall. The etching 'Codsall Church' appeared in the eighth edition.

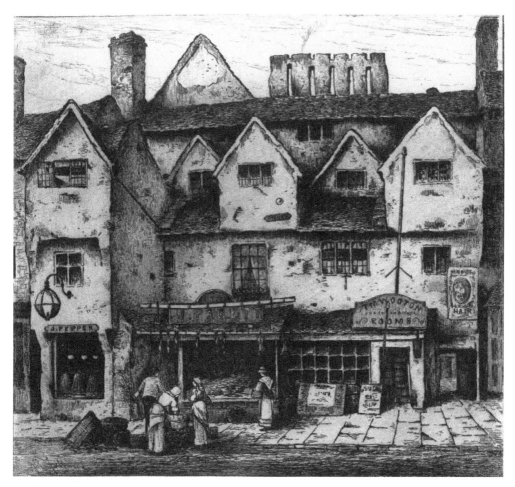

Etching by John Fullwood of 'the Old Buildings Digbeth Walsall'. Reproduction by permission of Wolverhampton Art Gallery.

These etchings show how John Fullwood's technique and expertise developed over a period of time. The etching of Wolverhampton's St Peter's Collegiate Church, as seen from the site of the art gallery, is almost architectural as straight, spare lines pick out the spire and chancel end of the building. Limited use of foliage and with no human figures to indicate scale, no cloudscape or birds in the sky and other buildings to anchor the church in its surroundings, mark this etching as unique in the set.

Not surprisingly, St Peter's Church, the "proud Parish church of a prosperous town", according to Pevsner, figures in several of the Wolverhampton etchings. It can be seen in the background of

'Wheelers Fold', of 'Berry Street', the 'Birthplace of Edward Bird' and of 'Horsefair', amongst others, as any faithful recording of the town centre of the time would automatically note its tallest building.

John's etchings showed not only buildings that were threatened with demolition but casting wider afield, more picturesque subjects including churches, two different windmills and notable local residences.

Etching by John Fullwood of 'Tong Castle' near Cosford Shropshire. Reproduction by permission of Wolverhampton Art Gallery.

One such notable residence, an etching by John Fullwood of Tong Castle (above), set in grounds landscaped by Capability Brown, was part of a later part issue of 'Remnants'.

Although Norman in origin, this castle had been extensively remodelled in the 1700's and has been described as the first real

"gothic" building in Shropshire. The etching shows the house nestled into the landscape, dominated by two trees in the foreground, stylistically in complete contrast to the etching of St Peter's. However, apart from its picturesque qualities, the reason for the etching's inclusion may have reflected its ownership at the time.

John Hartley, one time Mayor of Wolverhampton and an owner of collieries, ironworks and glassworks in the area, had leased the estate from the Earl of Bradford. His family had connections through marriage with both the Fowlers and Thorneycrofts, all members of the town's liberal non-conformist elite and therefore potential patrons of the project.

John Fullwood's accurate eye for nature did not prevent his sketch of 'Northycote farmhouse' being misidentified with the nearby Moseley Old Hall in the book's (Remnant's) letterpress.

Although the part work had continued to be issued to subscribers for at least three years, by 1884 Hellier had to abandon the project. The set of forty-eight etchings that had been supplied by John Fullwood by that date and which originally comprised the part-work that had been issued, were bound and printed together in a book. This book was published by Virtue & Co and was enthusiastically reviewed by *The Art Journal*. This review has been attributed to George Wallis, a regular contributor to that magazine. It starts: "'Old Wolverhampton!' - The sound is suggestive; the 'remnants' of the old town are of deep interest to the antiquary and the historian; many of them have succumbed to time and others are in the course of rapid decay; the 'effacing fingers' are leaving little of them but their memory. It is a wise and patriotic scheme that preserves their portraiture before they are gone."

The reviewer then suggests, perhaps with local pride, that other cities and boroughs should do the same "although it may be that there are few localities that yield so fruitful a harvest." The review concludes "the etchings display much artistic ability, skill and judgement in selection" and that this is "an assemblage of

meritorious etchings by an artist who understands his work and evidently loves it."

Perhaps this book was produced as a way for Hellier to recoup some of his investment as, by the time it was issued, the working relationship between John Fullwood and Arthur Hellier had dissolved acrimoniously and the projected series of one hundred etchings was never to be completed. Perhaps also Hellier saw an opportunity to rebuild his finances on the back of the publicity, offloading unsold prints, as many unbound copies of these etchings remain in circulation even now and are still offered to Wolverhampton Art Gallery.

The Crockers Directory for Wolverhampton, in 1884, shows Hellier still working out of St Stephen's Chambers, 1 Waterloo Rd South, but not in a partnership with Fullwood. The *Wolverhampton Chronicle* of 27 October 1886 describes the resulting court case:

> "At the Wolverhampton County Court on Tuesday morning before His Honour Judge Griffiths, an action was brought by Mr Arthur F Hellier, Surveyor, Darlington St, against Mr John Fullwood, artist, residing at Twickenham and formerly of Birmingham, to dissolve the partnership formed between them in 1879 to publish a work called 'Remnants of Old Wolverhampton', which consisted of etchings, with letterpress descriptions.
>
> The work was to consist of twenty five parts and was to be published periodically, the defendant to produce the etchings and the plaintiff to look after and manage the publication. Twelve parts were issued, and defendant declined to supply any more for the publication for the thirteenth and remaining portions, notwithstanding the numerous applications for them on behalf of the plaintiff. The consequence was that the publication had to be discontinued, and hence the present action. Points of law arising out of the case were argued at great length and

ultimately His Honour granted a decree of dissolution, with costs on the higher scale".

Another report of the case, in the *Birmingham Daily Post*, noted that John Fullwood had declined to supply further etchings as the project was not making any money. The collected set of 'Remnants' part-works contained forty-eight etchings. There were twenty-four scenes of the town centre of Wolverhampton, four scenes of Walsall town centre and twenty of scenes in the surrounding area. Given that John Fullwood had left not only Wolverhampton but also the Midlands, moving between Cornwall, Paris and Twickenham in this time, did he simply lack the time to return and capture further sites?

As well as John's relocation, other money making opportunities arose and he was by now a married man with a family to support. In an interview with John Fullwood which formed the basis of an article in the 'Art Journal' in 1896, the author stated that Fullwood had gone to Paris in 1883 to improve his skills as an artist but whilst there contact had been made with the American firm of Keppel & Co., New York, which was to establish a long and productive relationship between them. It seems likely then that John Fullwood saw the opportunity to use his time more profitably in selling his work elsewhere than in honouring his partnership contract with Arthur Hellier.

Hellier was well known enough in Conservative Party circles to be invited to attend a banquet in the Wolverhampton Agricultural Hall, as reported by the *Birmingham Daily Post* of June 1886. Hellier apparently sat near to Charles Mander at the function, amongst other members of the local elite. Whether this influence had a bearing on the lack of connection Fullwood had with Wolverhampton after this date is not certain, but Fullwood was to have a much higher profile in Walsall in the following years. But the court case against Fullwood may have had more serious consequences for Hellier.

Hellier's last known occupation was as a cattle food manufacturer trading as Champneys, Son & Co, in Wolverhampton. However, the *London Gazette* of 21 January 1888 records that a public examination was to be held at the Official Receiver's Office in Wolverhampton into Hellier's finances, indicating that he had gone bankrupt. Hellier moved from Wolverhampton to Milverton, near Leamington Spa, where the 1891 population census records him living on his own means. Hellier died in 1938, at Battle, Sussex.

Hellier's role in the 'Remnants' publication, however, did not seem to have included writing the text accompanying John Fullwood's etchings. Although one principal author has been identified, it is probable that more than one author contributed to the work.

Hellier and John's book contained descriptive notes credited to an author known simply as 'E.B.', and using the archaic term "Letterpress." This term indicated that the publishers considered the text and illustrations to be of equal worth; the artwork did not merely illustrate the words, and the descriptions of the locale did not depend on the illustrations to bring out the imagery.

Many notable books published at the time (such as reviewed in the *Art Journal*) only provide initials at the end of articles, so this practice was not unusual but it does create an air of mystery, raising the question who was 'E.B.'?

Speculation, which is still open to confirmation, has identified the Mander family's favourite architect, the Wolverhampton-born Edward Banks as a possible candidate as the author. However, as there were two Edward Banks, a father and son, with the senior passing away in October 1866, the author is most likely to be Edward Banks (junior) as it is unlikely the text was written by the senior Banks in advance of the illustrations being commissioned.

John Fullwood's etching of the top of Old Hill Tettenhall, which shows the 'Rose & Crown' public house (now called 'The Rock') and still trades to this day. Included here with the permission of Norm Keech.

Edward Banks (senior) was married at St. Peter's Church Wolverhampton in September 1848. His bride was Harriet Catherine Walker, the second daughter of Joseph Walker of North Street Wolverhampton. Although married in St Peter's church, Wolverhampton, the celebrant of the ceremony was the Reverend Woodhouse, Vicar of St Mary's, Albrighton, a church that was another subject of an etching included in 'Remnants of Old Wolverhampton' by John Fullwood.

Edward Banks' obituary was published in the *Wolverhampton Chronicle* of May 1866 and lists the buildings in Wolverhampton he was responsible for as an architect. It includes the School of Art in Darlington Street, the Public Library in Waterloo Road and the Cattle Market on Cleveland Road.

Edward Banks (junior) was also active in the public life of Wolverhampton, having been appointed to the post of Overseer of the Poor for the Board of Guardians, whose new offices were built in Horsefair (now Wulfuna Street), when the old buildings were torn down - another subject of an etching in the 'Remnants' book.

In the 1881 population census, aged 31, Edward Banks was living at "Woodfield" on Old Hill in Tettenhall, Wolverhampton with his widowed mother Harriett. Edward clearly had an interest in fine art and his wide knowledge was demonstrated in letters to the local press where he commented on an article by John Ruskin concerning the works of J.M.W. Turner. Edward died, aged 34, in 1884 and was buried in St Michael & All Angels Church Tettenhall near to his parent's home.

A possible second candidate for author of 'Remnants' book may have been disclosed in an exchange of letters between Hellier & Fullwood, on notepaper headed with Hellier's business address of Waterloo Road and George Wallis in June 1883.

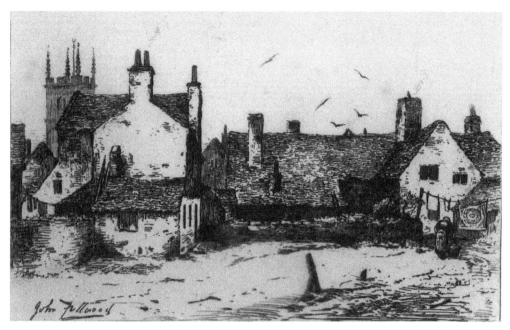

John Fullwood's etching of Edward Bird's birthplace. It was intended to be published in part 10 of the 'Remnants' part-work sometime after July 1883. Reproduction by permission of Wolverhampton Art Gallery.

Hellier had asked Wallis's opinion on the accuracy of Fullwood's etching showing the house in which the Wolverhampton artist Edward Bird had been born. This etching was to have been included in the tenth part of the 'Remnants' to be issued in autumn 1883. Wallis provided a favourable reply. Hellier wrote back, "We are obliged to you for your letter, and glad that you recognize the proof we send you as the correct house in which Bird was born. Mr Edwards, who is writing the descriptions for the work, will send you proof of description of Bird's direct in the course of a day or two. Be good enough to return it as quickly as possible."

Reading this note from Hellier, does it lead the reader into thinking the author is 'Mr Edwards' in the literal sense using 'Edwards' as his family name, not his first name or does the 'Mr Edwards' indicate a form of informal endearment used between colleagues or partners whereby 'Mr' is placed in front of someone's first name?

This interpretation would confirm that it was Edward Banks (junior) who supplied the letterpress writing.

In the exchange of correspondence George Wallis had stated that he had been a visitor to this house in his own youth. John Fullwood must have sketched Bird's birthplace before its likely demolition circa 1880.

The Wolverhampton *Express & Star* published an article in 1935, giving an account of Bird's life story. Edward Bird had been born in Wolverhampton in 1772, the son of a carpenter, and died in 1819 in Bristol. His birthplace has been variously described as being in Wheeler's Fold, Old Lichfield Street, North Street and the Old Horse Fair (now Wulfruna Street). Bird had developed his artistic skills through his apprenticeship as a japanning artist working in premises converted from the Old Hall (Turton Hall), as did Wallis at a later date (and John Fullwood was to complete an etching of Old Hall which was included in 'Remnants').

Bird had moved to Bristol by 1794 where his career flourished, but his legacy remained in Wolverhampton as an inspiration to fellow artists. Even today, examples of his works are to be found in Wolverhampton Art Gallery. The article pointed out that Bird's father "had a timber yard on the site of the present Education offices in North Street. It was one of two houses removed a long time ago which stood at the left hand corner of the Old Horse Fair turning out of North Street in close proximity to the Chequer Hall which was stated to have been Bird's birthplace."

Two views of Edward Banks' home on Old Hill, Tettenhall, near Wolverhampton, now converted into a residential Home with superb views overlooking Wolverhampton. Photographs taken in September 2015 by David Fullwood.

Another letter in this chain between Arthur Hellier and George Wallis identifies a possible later and second author of the 'Remnants' text. Hellier told Wallis to expect a letter from a Charles Edwards, of St Marks Road, Chapel Ash, Wolverhampton, who was seeking further information from Wallis for the text. Edwards later wrote to Wallis to introduce himself and indicates that he (Wallis) had known the writer's uncle George when Wallis was living in Wolverhampton. Perhaps Edward Banks (Junior) had become incapacitated by illness prior to his death and this may have been the reason why Charles Edwards was invited to complete the text for the book.

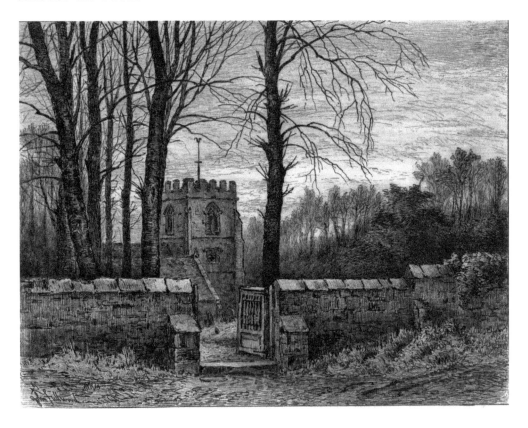

John Fullwood's etching of St. Michael's & All Angels Church. Reproduction by permission of Wolverhampton Art Gallery.

View of Tettenhall Church taken by David Fullwood in 2015.

It is unlikely that John Fullwood had moved in the same social circles as Edward Banks (junior), but if he had, or perhaps whilst visiting friends or acquaintances in Tettenhall, he used the opportunity to sketch two more views, both of which appeared in 'Remnants' book. The first etching was of the old bridge across Smestow Brook, which is located a short distance from the Banks' residence of "Woodfield" in Tettenhall, in the area known counter-intuitively as Newbridge and carried the road from London to Holyhead passing through Wolverhampton to Tettenhall.

John Fullwood's other sketch is of the Parish Church of Tettenhall, St Michael's & All Angels, taken not from the more picturesque front view of the church, but of an unremarkable entrance on the north side. John Fullwood's framing adjusts the view to capture more of the surroundings, the trees above the surrounding stone wall and a gate into the church graveyard, rather than the church itself, showing only the top half of the church tower.

There is one copy of the book of the published etchings, in which the artist has signed just one of the 48 etchings it contained; that of St Michael's Church. Does this indicate that this particular etching had some special significance for the book's owner?

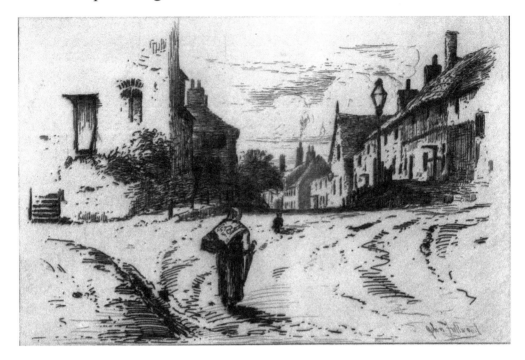

John Fullwood's etching of the junction between Upper Street and Old Hill Tettenhall near Wolverhampton. Reproduction by permission of Wolverhampton Art Gallery.

One other person is also stated as having contributed to the text of 'Remnants of Old Wolverhampton' book and he is credited within the page describing the 'Churchyard Cross, Pattingham'. As the wording notes "we are indebted to the Rev J W Kenworthy who has kindly supplied us with much of the following (description)."

The Rev James Wright Kenworthy, the Vicar of Braintree, Essex, was a noted antiquarian and his contribution indicates the wider circles that Hellier was able to access for the project in addition to the interest amongst local antiquarians as the new townscape of Wolverhampton emerged, from the old buildings that were being lost.

Prominent amongst these local historians was James Powell Jones, who was later to write one of the first histories of the town and ran the Wolverhampton Naturalist and Archaeological Society. Jones together with other like-minded individuals began to gather and publicise knowledge concerning the local history and folklore of the town and surrounding area.

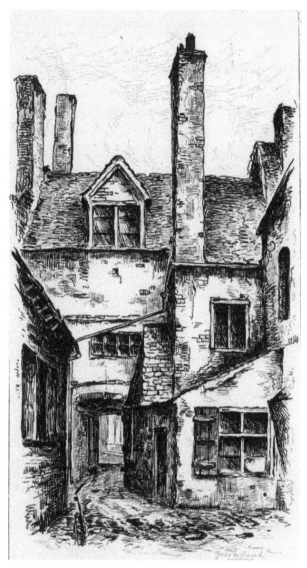

John Fullwood's etching of a passageway leading from Cock St (now Victoria St) into John's St. (now the Mander Centre) where the Mander's factory was located in Wolverhampton. Reproduction by permission of Wolverhampton Art Gallery.

Jones had been born across the county border in Worfield, Shropshire, a village just a few miles away from Wolverhampton. As a child he had moved to Tettenhall, where he grew up and

helped in his uncle's shop on Upper Street (a road which in turn leads into Old Hill, where the Mander's favourite architect Edward Banks lived) before taking up a job as a glass fittings salesman in Walsall. Jones later returned to live permanently in Tettenhall.

The correspondence that had occurred between Hellier & Fullwood and Wallis had in fact originated in several letters to the *Wolverhampton Evening Express* from James Powell Jones.

At this time Jones was living in Rowley Street Walsall, a town to which John Fullwood kept close links throughout his career. On 24 January 1883, Jones wrote to the *Wolverhampton Evening Express* paper "Another and more modern artist, who is also a credit to the town, has in preparation a tribute to Bird's memory. I allude to John Fullwood, who intends the house in which Bird was born to form the subject of one of his plates in his work on 'Old Wolverhampton'."

Jones wrote again on 10 February 1883 to the same paper noting "As regards a sketch of the wrong house appearing in Old Wolverhampton I may at once allay all fears on that score, for I find that Mr Fullwood has a sketch of that particular corner of the Horsefair made by him previous to its demolition for town improvements". As late as 1923, Jones was still citing this etching as evidence of Bird's birthplace at a meeting of the Wolverhampton Archaeological Society.

Jones later wrote '*A History of the Parish of Tettenhall',* which was previewed in the *Birmingham Daily Post* of 26 October 1893. The reviewer noted that the book would be "published by subscription" and "there will be numerous illustrations, and the frontispiece will be a charming etching of 'Barnhurst' by that brilliant etcher, Mr John Fullwood, R.B.A. We have seen a proof of this etching, the execution of which is masterly."

Barnhurst, near Pendeford was a fine old farmhouse on whose land Wolverhampton town council eventually built the municipal sewage works, and which was later to become the site of the town's

airport. In his foreword, Jones specifically thanked George Wallis for the help he had received in preparing the book.

Chapter 7
The Book & It's Supporting Cast

Another member of Victorian Wolverhampton society figures significantly in the genesis of the 'Remnants' book: George Bradney Mitchell provides several key linkages in the story.

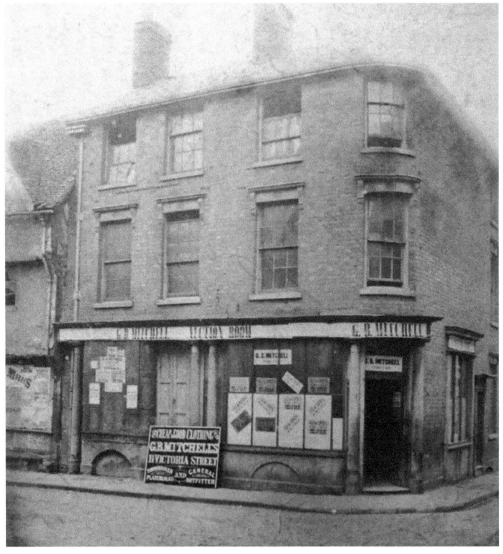

George Bradney Mitchell's business premises located on Lichfield Street, Wolverhampton. Published with the permission of Norm Keech.

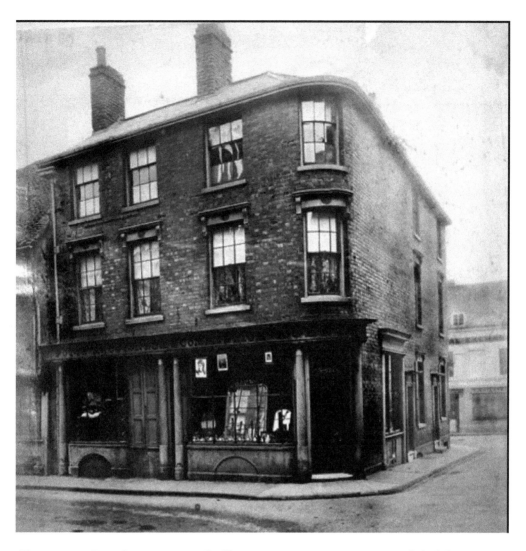

George Bradney Mitchell's premises in Lichfield Street Wolverhampton. This photograph confirms its location due to the 'Royal Exchange Hotel' being in the background on Little Berry Street. Photograph provided with the permission of Norm Keech.

George Bradney Mitchell was a business man, who owned a pawn broker's shop in Lichfield Street Wolverhampton and also had interests in auctioneering and printing. He had political ambitions as well, standing for election to the Board of Guardians and for Wolverhampton Council at different times. But more importantly for John Fullwood, he was also someone with a passion for local history and had the means to facilitate it. George Bradney Mitchell

was member of the Naturalist and Archaeological Society of Wolverhampton alongside James Powell Jones and his scrapbooks, which were later donated to Wolverhampton Archives, show the keen interest he had in the history, folklore and customs of the town and surrounding area.

Mitchell considered himself to be an antiquarian; that is one who studies, collects or deals in antiquities, at a time when the local and social history of areas like the Black Country would not often appear in the standard historical texts.

Mitchell also had some artistic talent of his own as he researched, wrote, illustrated and printed material concerning the historical matters of his home town. He forged links with antiquarians in surrounding areas, and his papers include correspondence with a fellow antiquarian, W. H. Duignan of Walsall, another friend of John Fullwood, concerning the history of Wolverhampton.

Crucially, George Bradney Mitchell also had a vested interest in the Wolverhampton Council improvement scheme, as his family owned some of the properties that were being cleared as the new streets were being laid out.

The sign in front of his premises in Lichfield Street indicates George Mitchell had a second property in Victoria Street, Wolverhampton as it says *"For cheap and good clothing go to 11 Victoria Street."*

In the background of this second photograph of George Mitchell's business, the name 'Royal Exchange Hotel' can just be made out.

As this hotel was located on Little Berry Street, it also establishes Mitchell's business was on Lichfield Street. Little Berry Street, ran from Stafford Street into what is now called Princess Square.

The *Wolverhampton Chronicle* in 1880 records Mitchell making a case at the Land Tribunal. George Mitchell stated that his property on the corner of Railway Street and Canal Street (now Broad

Street), which he said his family had owned for 60 years, was worth £2,000 whereas the council had only offered him £1,260. Mitchell also owned other property on Canal St, including what turned out to be the last thatched property in Wolverhampton town centre.

Perhaps it was a combination of all these interests that motivated George Bradney Mitchell to commission a number of artists and photographers, including John Fullwood, to illustrate the changing face of Wolverhampton. Paperwork retained by the Mitchell family details the artwork that he acquired illustrating the redevelopment of Wolverhampton as the old buildings were cleared.

John Fullwood worked in partnership with another artist, James Tibbitts, on a sequence of paintings to capture the disappearing townscape for Mitchell, who also engaged another artist, John Reid, to provide similar images. Both artists used photographs taken by Wolverhampton based photographer Edwin Haseler as a basis of a number of their works and these images too were retained by Mitchell, who was a keen amateur photographer himself.

Both Reid and Fullwood, at least once, portrayed the same location; an oil-painting by John Fullwood of Bessie's Fold compares almost exactly with a water colour by Reid. Bessie's Fold was a thoroughfare dating from Wolverhampton's ancient woollen industry. It was located off North Street, and was demolished as part of the Improvement Scheme.

John Fullwood's oil-painting of Bessie's Fold, in a palette of various browns, shows ramshackle houses with barely a straight line between them. It also displays a small, huddled group of on-lookers in the foreground and conveys well the squalor of the area. Reid's painting shows the same scene but uses a much brighter, cleaner palate of colours, making the hovels look implausibly picturesque. John Fullwood's painting of 'Bessie's Fold', currently resides in the collection of Wolverhampton's Art Gallery and has the wording "Painted for G B Mitchell by John Fullwood" on the stretcher frame.

Both Tibbitts and Reid had originally moved to Wolverhampton from Birmingham, and Haseler from Wales, but all three lived near Wolverhampton town centre at the time Mitchell knew them. Together, their work for George Bradney Mitchell was extensive.

George Bradney Mitchell, it is said, intended to publish a book of the 'old face' of his home town (Wolverhampton) using the art work and photographs he had collected to illustrate it.

An undated inventory records that 61 wash drawings by Reid and 5 by Fullwood, together with a further 29 pencil drawings by Fullwood were amongst the 140 art works in Mitchell's collection, although Fullwood's paintings with Tibbitts are not listed separately.

A catalogue page in Mitchell's papers, believed to be from the 1884 South Staffordshire Industrial and Fine Arts exhibition held in Wolverhampton, shows that George Bradney Mitchell had lent 18 oil paintings of old houses in Wolverhampton, by Fullwood and Tibbitts, to be hung there.

Perhaps the painting of Bessie's fold was one of those 18 exhibited in Wolverhampton, although it does not contain the name of Tibbetts and the Art Gallery's accession book shows that it was donated later by John Fullwood. George Bradney Mitchell, alongside Arthur Hellier, was one of the public guarantors of the 1884 exhibition.

It is unclear whether George Bradney Mitchell knew of John Fullwood before he made the acquaintance of Arthur Hellier but there were many connections between these artists, the antiquaries and the businessmen. The links that entwined all these families can be illustrated by the fact that one of Mitchell's sons, James, was living in Limes Road, Tettenhall in 1901, the next door neighbour but one to James Powell Jones and James Mitchell's wife was the sister of John Fullwood's nephew's wife.

Mitchell, who was aged 59 in 1901, was living not far away at 396/7 Newhampton Road West, Whitmore Reans, then a newly developed suburb of Wolverhampton, near to the junction with Tettenhall Road.

Shortly before he died in 1915, George Bradney Mitchell attempted to sell thirteen paintings of old Wolverhampton, described as "by J. Fullwood and Tibbitts" to the Art Gallery Committee. The Curator wrote back on behalf of the Committee, stating that they did not think the pictures were of a standard suitable for hanging amongst the permanent collection but "a few of them could be shown at times when holding a show of Old Wolverhampton."

The gallery went on to make an offer for seven of the paintings at one guinea each, or ten guinea's for all thirteen, noting that the price reflected the condition of the paintings as "they would require expert cleaning and suitable framing" before they could be hung. The letter concluded with a dismissive comment that "of course, as time wears on and the present generation dies out the paintings will lose a certain amount of value, as those to come will not appreciate them so fully as those who have seen the actual buildings and places."

Amongst the seven paintings that the Committee wished to purchase was that of Bessie's Fold, North Street. Perhaps Mitchell did not think the Committee had offered enough money to buy them as Wolverhampton Art Gallery does not possess any of the other paintings that were offered and their accession book shows that the only one they do possess, *Bessie's Fold*, was donated by John Fullwood himself in the 1920's.

Both Fullwood and Reid used Edwin Haseler's photographs as source material for some of their works. Edwin Haseler was born in Pontypool in 1812 but his family originated from Aston, Birmingham. His place of birth was most likely due to his father's employment in the japanning trade, which at the time was prominent in Pontypool. However the Midlands, and in particular Wolverhampton, soon became the centre of the industry and the family moved back to their roots arriving in Wolverhampton sometime before 1832.

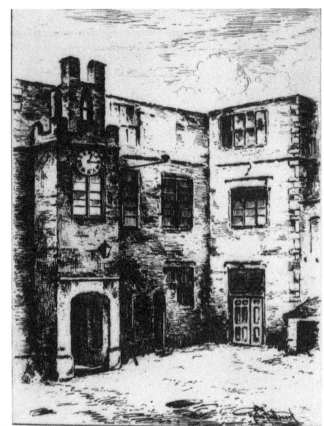

John Fullwood's etching of Old Hall Wolverhampton. Reproduction by permission of Wolverhampton Art Gallery.

Japanning is a decorative style using, usually, a thick black lacquer applied to either papier-mâché or tin plate and then decorated in an imitation of oriental style and forms.

Several of Haseler's family were well regarded artists of their day but Edwin Haseler entered his working life as an apprentice for Jennens and Betteridge, a manufacturer of japanned ware patterns in their 'Old Hall' factory in Wolverhampton.

The 'Old Hall' or 'Turton's Hall', was an Elizabethan mansion in Wolverhampton which housed a number of manufacturers. The

Hall itself was demolished in 1883 and the site, now simply Old Hall Street, is home to the Wolverhampton Adult Education College. The Old Hall was regarded as the cradle of the japanware trade in Wolverhampton but also had several wider artistic claims to fame.

One of Wolverhampton's most well regarded artists, Edward Bird, was born in 1772 and was to eventually become a member of the Royal Academy. He too started his career at the Old Hall, apprenticed to Walton & Company, makers of papier-mâché products.

George Wallis was another apprentice of Walton's who began painting papier-mâché then worked up to pictures and became a recognised art educationalist and authority on art.

In another quirk of history, working on a japanner's bench at the 'Old Hall' was Joseph Booth, an excellent artist in his own right. He was the father of John Wilkes Booth who went on to assassinate President Lincoln in the USA.

Haseler's talent for design was soon recognised as he rose through the ranks. By 1851 he had become principal painter at Walton & Co and as such he decorated their prime exhibit at the 1851 Great Exhibition, a large table.

Haseler started using an improved style of flower painting: up until that point flowers were not painted as an imitation of nature, but in a Chinese stylised form. Haseler painted naturalistic flowers upon the centre of the items, with a border of light ornamental gold. The rest of the trade considered this a very bold arrangement but the public liked these items, which continued to sell for nearly thirty years.

There was an arrangement by which working artists got a royalty on copies of their designs which were sold. As he had six apprentices working for him in a separate shop in the Old Hall, he clearly had some financial success. Haseler was regarded as something of a

dandy by his contemporaries, riding to and from work on a big white horse and it was noted that he "was consequential in manner and took himself very seriously." His patterns and designs for japanned ware for various manufacturers in the town still exist and are kept in Wolverhampton Art Gallery's archives in Lichfield Street.

In 1852 Haseler patented the "Negative Process" which enabled japanned-ware to be decorated with ornate designs in burnished gold, and in 1862 he paid the then considerable sum of £100 in stamp duty to protect his patent. This "Negative Process" involved the use of chemicals and it is perhaps through a combination of his artistic background, eye for business and scientific acumen that Haseler began his next career, that of a photographer.

The evolution of that profession can be shown through the various trade directories that listed the earliest photographers in the town. In 1851 Edwin Haseler is listed in the Wolverhampton Trade Directory as an artist, although he had by then almost certainly begun his photographic experiments.

In the 1858 Birmingham Directory, which included a section on Wolverhampton, the classification is still shown as "Artists" but with the annotation 'photographic'.

By 1861 Haseler is listed as an "Artist & Photographer" and had established his studio in Queen Street, Wolverhampton. As well as portraiture of the local citizenry and photographing the output of local industrial production, Haseler also captured scenes of his locality and especially the changing face of Wolverhampton, including the Caribee Island area. He was a Freemason and like many others in this circle, a member of the prominent Wolverhampton St Peter's Lodge.

George Bradney Mitchell was certainly aware of the Haseler family's artistic capabilities. The *Birmingham Daily Post* of 1st May 1882 reports on the auction of a late Mr Horace Woodward's pictures. Mitchell bought several pictures from this collection,

including one by a "Mr Haseler" called "a group of poppies", for which he paid 15 guineas. This "Mr Haseler" was probably Edwin Haseler's older brother but Mitchell, as he began experimenting with photography, would not have been unaware of Edwin's studio on Queen Street, Wolverhampton.

Photography provided artists with an alternative to preparatory sketching and a fresh way of capturing scenes. As such Haseler's relationship with George Bradney Mitchell and their shared association with John Fullwood and John Reid, is expressed through the shared likeness of the images that were produced and used in the production of 'Remnants of Old Wolverhampton' book.

Perhaps by 1859, Edwin Haseler had found the competition for his photography services in Wolverhampton had become too intense because an advertisement appeared in the *Sheffield Independent* of 6 August 1859, showing Haseler had added a further studio, at 23 High Street, Sheffield.

Haseler stated in the advertisement that he was a photographic artist and had "rooms open for every purpose of the photographic art." However, as he was only available on Tuesdays, Wednesdays and Thursdays, we can assume that on the other two days he was working from his Queen Street, Wolverhampton premises.

Intriguingly, Edwin Haseler is also referenced in an advertisement published in the *Hastings & St Leonard's Observer* dated 22 September 1883, proudly stating that he is a prize medallist from various exhibitions and that, along with his business partner Mrs Nicholson-Addie, they were offering to teach students about the contemporary photographic processes of Crystoleum, Chromo-Gluph printing as well as Oil, Water Colour, Terra-Cotta or China Painting. They had a studio in Havelock Road Hastings, around the corner from where John Fullwood was also living in 1883.

Crystoleum, from "crystal" + "oleum" (oil), process was a method of applying colour to an albumen print, popular from 1880–1910. An albumen print was pasted face down to the inside of a concave

piece of glass. Once the adhesive (usually starch paste or gelatine) was dry, the paper backing of the print was rubbed away, leaving only the transparent emulsion on the glass. The image was then coloured by hand, using oil paints. Another piece of glass was added to the back and this could also be coloured by hand. Both pieces of glass were bound together creating a detailed, albeit fragile, image. The technique was derived from the way mezzotint engravings were produced in the 18th century.

It is quite possible that Edwin Haseler's business career did not continue successfully. By 1885 Haseler was no longer living and working in Hastings, as a notice was published in the *London Evening Standard* in July 1885 on behalf of Wolverhampton solicitors Underhill & Lawrence, who offered a reward of 10 shillings for information about the whereabouts of Edwin Haseler, "formerly of Wolverhampton and Hastings."

Edwin Haseler had married Rebecca Hayes in Aston Birmingham in 1877, when he was 63. His wife died aged 71 in 1890 and the following year's population census shows him, aged 77, as a widower, living as a lodger with his sister in High Street, Aston, Birmingham. Edwin passed away in 1901. He is buried at Key Hill cemetery, Hockley, Birmingham along with his wife.

John Reid, the second artist connected with John Fullwood through George Bradney Mitchell, was born in 1838 in the North Warwickshire village of Austrey. His parents had moved there from Bridport in Devon, where his family had been baptised in non-conformist chapels. By the 1860's the Reid family had moved to Birmingham where John was living in Hockley and working as a pen tool maker. The production of steel pen nibs was then a significant part of the industry of the Jewellery Quarter. John Reid married Elizabeth Freeth and by 1867 was living in Whitmore Reans, Wolverhampton with his first born daughter.

Reid then changed his occupation as the 1871 census recorded him as a Lithographer and artist. He lived in Wolverhampton for at least

twenty four years, giving his occupation in the 1891 census as "Lithographic Draughtsman", before moving back to Birmingham. It is tempting to assume, although remains unproven, that he had met George Bradney Mitchell through their contacts in the printing industry.

George Bradney Mitchell's records show that he owned Reid's paintings and sketches at the same time as he bought similar works from John Fullwood. Reid's works, however, are less distinguished, his figure work is not in the correct proportions and his palette is surely too bright and sunny to accurately reflect the drab conditions of Caribee Island, in Wolverhampton.

The third artist of this triumvirate, James Tibbitts, was the eldest, being born in 1827, in Birmingham. After his marriage to Ellen Cooper, their first four children were born in Birmingham where he worked as a japanner. However his fifth child was born in Wolverhampton. By 1861 Tibbitts gave his occupation as a greengrocer and fruiterer living in Newhampton Road, Whitmore Reans a newly developed suburb of Wolverhampton. By the following census he described himself as an artist and oil painter. Tibbitts died in the spring of 1881 aged only 54, and was still living in Wolverhampton and describing himself as an artist.

There is no definitive record of how Tibbitts was introduced to John Fullwood but there is one possible explanation; they both attended Wolverhampton Art School, albeit at different times. Tibbitts was rather old by comparison when, aged 40, he had his work selected by Wolverhampton Art School in March 1867 for entry into the National Competition at South Kensington.

Whatever the origin of the paintings commissioned by Mitchell, when the South Staffordshire Industrial and Fine Arts Exhibition was held in Wolverhampton in 1884, it contained a display of etchings of local scenes by John Fullwood, probably the same sequence of drawings that formed part of 'Remnants' book.

After the end of the exhibition the Wolverhampton Art Gallery accessions book records that forty-one of these etchings were purchased from Arthur Hellier for 10 shillings and sixpence each and they remain part of the collection to this date.

Chapter 8 Establishing A Presence

By the early 1880's John Fullwood was settled into married life and was making his living as a professional artist with his own studio in Birmingham. He was a member of a myriad of social societies belonging to the artistic set in Victorian Birmingham. Within a few years his life was to change significantly. His first child died tragically and his first contact is recorded with the town of Richmond in Surrey, where he was to make his home in later years. John then embarked upon travels to Cornwall and Paris to further his education and career and whilst abroad he met a dealer who was to make his name in America. Upon returning to Britain, he moved away from the Midlands forever.

Between July and September 1881 John Fullwood placed adverts in the *Walsall Advertiser* offering "Landscape painting in Oil and Water Colour. Mr John Fullwood receives private pupils, at his Studio, Grosvenor Chambers, Broad Street Corner, Birmingham."

Sales of John's 'Remnants' book had not proved as high as either he or Hellier had hoped and it was obviously necessary to supplement his income from picture sales with instructing private pupils in art. Walter Langley, John Fullwood's friend and fellow art student, was another artist based at Grosvenor Chambers at this time as were the Thompson brothers, Ernest and Harry.

John Fullwood had established his presence as an artist after he began exhibiting regularly at the Royal Birmingham Society of Artists (R.B.S.A.). The Society has held from 1814 in an almost unbroken sequence. The first exhibitions were held in temporary accommodation until the Society had a new permanent gallery erected in 1829. Behind an imposing portico fronting onto New Street, the building had much improved gallery space including a circular exhibition room with a diameter of 52ft. Annual exhibitions of water colours were held here from the spring of 1866, the first such exhibitions held outside of London.

The first record of John's work is in the 11th 'Spring Exhibition' of the R.B.S.A. catalogue in 1876. He was 21, and exhibited pictures called *The Old Sheds, Kings Heath* and *Bridge, near Yardley.*

In the R.B.S.A. 'Autumn' show later that year John exhibited the paintings *'Bewdley-on-Severn'* and *'Near Wenlock'*. The sale price of these paintings was £5. John gave his address as Grafton Place, Ellen Street, Birmingham – a location near to Hockley and this address was hand written on the back of another water colour, that of a bridge at Tettenhall near Wolverhampton, a copy of which is now held at Wolverhampton Art Gallery. Perhaps this picture is another exhibition entry, but one that was not accepted? For the next few years John showed his increased confidence in asking for and presumably receiving, higher prices for his works.

In 1877, John displayed pictures from North Wales, which had been established as a favoured scenic location for Birmingham artists since the landscape artist David Cox had travelled there in the 1820's. John Fullwood's paintings of *'On the Ogwen', North Wales* and *'Near Aber', North Wale*s attracted the higher price of £10. This latter picture became part of a private collection in the USA.

John had moved home again by this time as a newly married man living in 82 Albion Street, Hockley, Birmingham. By 1878, whilst still living in Albion Street, he exhibited *'Compton Pool – Evening'* and *'Sherwood Forest'* and asking £25 for his paintings (Compton Pool in Wolverhampton was nearby to where his elder sister Sarah was living at the time). The spring 1879 exhibition saw John display *'Skirts of the Forest'* and *'Sherwood'* asking £30 for them.

In the R.B.S.A. 'Spring 1880 Exhibition' John Fullwood displayed *'Thine Arms have left thee; Winds have Rent Them Off – Cowper'* giving the Grosvenor Chambers address. The use of these lines of William Cowper's poetry indicates both John Fullwood's love of nature and the influence of religion on his upbringing and training. Cowper's final and unfinished poem "Yardley Oak" depicts a mighty, ancient tree now disfigured by wind and lightening and is

rumination on the various stages of life. The tree is "A shattered veteran, hollow-trunked perhaps as now, and with excoriate forks deformed." Confusingly, the actual Yardley Oak is in Northamptonshire, not the Birmingham suburb of Yardley.

Perhaps the title was suggested by Edward Watson, John's teacher at the Birmingham School of Landscape Art and a lay preacher in Birmingham on one of their sketching trips. Cowper wrote many of the hymns that John Fullwood would have been familiar with when they were sung in the non-conformist chapels.

George Leonard Leigh, a fellow student of John Fullwood, also used some of Cowper's poetry as an inspiration for one of his paintings; "When all the leafless groves that skirt the horizon" (from the poem *The Task*) which was exhibited at the Birmingham School of Landscape Art exhibition of 1882. Leigh was to become President of the Clarendon Arts Fellowship in the 1890's and wrote a biography of Edward Watson in 1899.

John Fullwood's work had started being more regularly identified in newspaper reports of local exhibitions from around 1880. The critics' response to exhibitions in the local press was very important to emerging artists in the Victorian period. Newspaper circulation was high at this period as the effects of educational reforms fed through to the population and local art exhibitions were regularly covered. The success or failure of many careers hinged on favourable reviews and John Fullwood was fortunate that his name became regularly mentioned in Midland's newspapers.

In a review of the exhibition held at the Birmingham Fine Arts Guild in February 1881, the *Birmingham Daily Post* remarked that John's paintings were especially noted. However, a review in the same paper of the R.S.B.A 'Spring 1881 Exhibition', in which John had exhibited 6 works asking up to £30 each, criticised one of his paintings as "one of those fanciful formal landscapes in the style of Martin's 'Plain's of Heaven' which belongs to an obsolete school."

This criticism is surprising given Fullwood's training in the *en-plein-air* style of less formal outdoor painting: perhaps he had tried to copy a more established style in an attempt to generate sales. However, this criticism may have had other consequences for it was around this time he left Grosvenor Chambers and travelled with Walter Langley and William Wainwright to Newlyn, in Cornwall. He was later to travel further afield, to Paris, as he sought to further the art education he had received in Wolverhampton and Birmingham

In the 1882 the R.B.S.A. 'Spring Exhibition' for the first time gave his address as c/o Mr Chamberlain, 19 Temple Row, Birmingham. John presented two works for which he was asking £50 each and in the 'Autumn' exhibition that year he exhibited two more works, including *'Penzance',* at £65 each. In 1882 John was living in Penzance, with William Wainwright and Walter Langley. There is no record that Kate and Maybell accompanied him.

This catalogue entry is the first recognition of Edwin Chamberlain as John Fullwood's agent and dealer. Edwin Chamberlain (no close relative, despite the name, to Joseph or John Henry Chamberlain) had already established a good reputation as an art dealer in Birmingham. He was known as a lover of art as well as a dealer and he was instrumental in the careers of a group of young Birmingham artists from the 1880's onwards.

It was said of him in his obituary in the *Birmingham Mail* that he keenly sympathized with "the struggles of the men at that time engaged in the pursuit of a precarious profession, his generous spirit, by his direct encouragement of their work, materially helped them on their way to achievement." It seems that Edwin Chamberlain retired in 1917, as the contents of his premises at Holborn Chambers, on Broad Street were auctioned, including Fullwood's painting *'In the Vale of Kent'.*

Edwin Chamberlain died in 1929 and as his obituary noted, "he played a considerable part in the emergence of young artists some

forty years ago." More importantly "As an art dealer he had established a good reputation, and there are several artists still living who are largely indebted to him for their early chance of success."

Whilst Chamberlain's foresight and patronage was to play a noteworthy part in the development of the market for art in Victorian Birmingham, his standing was not unusual. As the '*Art Journal*' noted in 1871 "the influence of the dealer is one of the chief characteristics of modern art. He has taken the place of the patron and to him has owed, to a great extent, the immense increase in the price of modern pictures."

This comment indicates the change in how art was bought and sold at this time. The art dealer was once a marginal figure but now was the core of the new arrangements. The dealer financially supported the artists and inspired them to produce new works which they were able to do, in part, because the dealer had stimulated an appreciation in the public for the art they were producing. The accompanying technological progress in printing produced a wealth of illustrated books, magazines and periodicals which informed and educated those already interested in art, and in turn created new consumers; local papers would contain extensive, and informed, criticism of exhibitions, attending which, in turn became part of the social scene.

This reflected the new form of patronage in this era of industrial capitalism, which both separated and freed artists from the demands of an aristocratic patron but which also bound them more closely to the fashions of a more impersonal art market.

In 1887 *The Magazine of Art* had stated "The Birmingham of today is perhaps the most artistic town in England…it may be that all this progress is of a comparatively recent date, but that does not alter the truth of our statement." The town was outstripping Manchester and Liverpool in the exhibitions, societies and galleries it supported, all of which infrastructure allowed the profession of being an artist to

grow, both in city itself but also in the surrounding conurbation. Birmingham, of course, commercialised this artistic outpouring and it was considered to be the busiest art market in England, outside of London.

According to the *Art Journal*, the R.B.S.A. was "one of the most prosperous and most useful institutions in Birmingham…artists and the public should know that the sale of work in these rooms very far exceeds those of any exhibitions in the provinces" with as many as 40,000 visitors a year.

Edward Harper was a teacher at Birmingham School of Art under E R Taylor, and latterly President of the R.B.S.A. In an article in the *Birmingham Daily Gazette* of 17 Nov 1938, reflecting on the previous fifty years, he remarked on how profitable the Birmingham art market had been at that time and how it had since declined.

Whereas £5,500 was paid for pictures in 1878 in connection with the R.B.S.A.'s exhibition, Harper stated, the figure for 1938 showed a combined yield of little more than £500. Harper remembered "many men in Birmingham earning a good living from art fifty years ago. Some had several commissions awaiting attention at one time"; mentioning Walter Langley, William Wainwright, Edwin Harris and John Fullwood amongst others. Harper ended by stating that in his opinion Birmingham never received the attention that it deserved as a cradle of artists. Near the height of his success John Fullwood was able to ask £200 for one painting at the R.B.S.A. '*A repose of slanting rays*', equivalent to over £15,000 in 2018 values.

The new wealth and prosperity enjoyed by the newly enfranchised middle-class, and the leisure time they now had to enjoy it, was reflected in the art that they bought and displayed. The taste of the emerging collector embedded those middle-class values so dear to the newly arrived bourgeoisie; self-improvement not self-indulgence, prosperity, respectability hard work and the sanctity of family life.

They bought art that told a story, which reflected their ideals and world view, which had a purpose and which was "recognisable art." Although some of the new collectors were philanthropists who bought large paintings to hang in the newly created municipal art galleries, just as the landed aristocracy had displayed art in their private galleries, many more bought smaller scale pictures suitable for hanging in the drawing rooms of their new suburban homes. Added to this democratisation of art was the development of printing techniques that allowed many fine quality copies of etchings to be produced for sale to an even wider audience who had perhaps seen an original painting in a gallery.

Edwin Chamberlain hosted regular exhibitions at his galleries, firstly in Temple Row then in Bennetts Hill and finally in Broad Street, Birmingham. All of these locations were clustered around the Cathedral, the financial district and the Council House. As these were all sites where the prosperous masses would pass in the daily business, Chamberlain no doubt hoped they would stop and linger at his gallery.

Among that group of artists helped by Edwin Chamberlain and which enabled them to establish themselves was Walter Langley. Langley received a commission for twenty watercolours of Newlyn from Chamberlain. This security enabled him to move there in 1881 and thus began the long association between Birmingham and that Cornish town.

Press adverts indicate how art from this group of Birmingham artists was being bought, sold and collected by the time John Fullwood was establishing himself within the public gaze. An auction in 1884, of the estate of a Mr Joseph Atkins, of Balsall Heath, Birmingham, highlighted works of art by, amongst others, John Fullwood and Pope. The following year a "private collection" of art was sold containing "amongst others worthy of note will be found works by John Fullwood." George Henry Rooker, John's brother-in-law, was an established auctioneer with premises on the

prestigious Colmore Row in Birmingham; perhaps he may have had some role in these sales.

In 1883, John Fullwood had entered four etchings at the spring exhibition at the R.B.S.A. The *Birmingham Daily Post* praised his work as "A series of etchings by John Fullwood, illustrating points of local interest, are brilliant and effective, and show a just appreciation of the limitations of the etcher's art." It can safely be assumed that these etchings were part of the series forming 'Remnants of Old Wolverhampton and its environs'.

In 1881 the R.B.S.A. decided to copy the model of the Royal Academy by creating a body of Associate Members, from which full Members would be drawn as their careers progressed. Six young artists were made associates that year, including Fullwood's contemporaries and friends Walter Langley, William Wainwright and William Breakspeare. John Fullwood's success was recognised when he became an Associate of the R.B.S.A. in 1884 and a full member in 1891. John Fullwood was to become a regular exhibitor at the R.B.S.A, eventually displaying no less than sixty-seven paintings in R.B.S.A. exhibitions and becoming one of its longest standing members and continued to exhibit at the R.B.S.A. long after he had left Birmingham.

At the 'Spring 1888 Exhibition', John Fullwood submitted the etching *'Beyond the Noise of Busy Man'* a line from the poem 'Grongar Hill' by the Welsh poet John Dyer. This was another reflection on the rural idyll and as Dyer was a painter as well as a poet, his words describe the countryside principally in terms of classical landscape and offers art as a source of peace:

Grongar Hill invites my song,

Draw the landskip fair and strong,

Beyond the noise of busy man,

Painting fair the form of things.

At the same time as exhibiting at the R.B.S.A., John Fullwood was supplementing his income by providing black and white illustrations for a number of publishers. John illustrated, with others, a sequence of guide books for Cornish and Co, Booksellers, etc of New Street, Birmingham, including guides to the New Forest and the Isle of Wight. Cornish Brothers also produced a magazine, "The Art Student: An Illustrated Magazine conducted by Members of the Birmingham School of Art" between 1885 and 1887 to which John Fullwood contributed art works as well as articles.

The March 1887 edition had as its frontispiece a reproduction of the painting '*When the trees are bare*' which was described as "nature seen through eyes swift to recognise her mysterious charms" according to the *Birmingham Daily Post* of 3 March 1887. By this time John was also a regular contributor to '*The Art Journal*' which printed '*The Minnow Catcher*' on the cover of its November 1886 edition.

Chapter 9
'The Young Birmingham Artists'

"Arts and Fraternity"

Birmingham's art institutions were now producing a whole new set of artists and craftsmen each year ready to enter the world of fine and applied art in their growing and vibrant city. John Fullwood soon began to make a name for himself, and was on his way to eventually becoming a member of the prestigious R.B.S.A. Before that honour, however, he was also a member of three Birmingham institutions which contributed to the development of the burgeoning artistic movement in late Victorian Birmingham: the Art Circle, the Clarendon Arts Fellowship, and the Easel Club. The overlapping membership of these comprised a core group of young artists who, having received their art training in the city started socialising together and exhibiting together as they began their professional careers.

The motto of the Birmingham Art Circle, *arts et fraternitas* or Arts and Fraternity, reflected the social as well as artistic nature of this group of artists. Charles Whitworth was one of the first to join and wrote a history of the Art Circle in 1903 in which he recalled that the initial meetings were of a musical, literary or artistic character. Nevertheless, their constitution stated that it was founded "to promote unity among the workers in the Arts and to hold Exhibitions when convenient."

The Art Circle was proposed by Ernest Thompson at the Broad Street Chambers he shared with his brother Harry in winter 1878, when he met with five other artists including Walter Langley, Charles Whitworth and William Wainwright. The founders of the Birmingham Art Circle came from that group of students who had first met in 1872 and had stayed in contact with each other.

Langley, Fullwood and Wainwright were not only linked artistically; according to Fullwood's obituary they were to be lifelong friends. Although they were to eventually settle in different parts of England, for the next few years their friendship was cemented by joint membership of these groups. According to Whitworth's later account Thompson wished to encourage unity and friendship amongst the younger artists of the town and so they decided to invite other artists to join them. The first membership list totalled fifteen, including John Fullwood. Ernest Thompson was the first President and Walter Langley was the first Secretary.

Although individual members had exhibited their works before, these shows tended to be held in their own studios and the public attended by personal invitation only. But the group decided that they should mount a joint show and the first 'Birmingham Art Circle' exhibition was held on the 17 May 1879. This first show comprised work from five artists of the group and was held in a member's studio, reputed to be that of Edwin Harris. It was judged a success and plans were laid for a larger exhibition in 1881. Ernest Thompson was not however to see the fruit of his success, dying in 1879.

Between its inception in 1879 and 1881 the minutes of this group show that John Fullwood was a regular attendee at its meetings, whilst not standing for any position on the Committee. This reticence was repeated at the other organisations he joined at this time, perhaps reflecting the shy nature ascribed by others. At these meetings members showed their works to each other for criticism and encouragement. A flavour of the proceedings at these meetings is given in the minutes. On February 26th 1881 those present included Langley, Fullwood, and Wainwright amongst others; on 9th March John Fullwood showed pictures etc under theme 'Winter', Langley was also present. The meeting of 30th March took the theme "War" and that of 23rd April "Solitude." Most of the attendees were regulars, indicating the social and supportive nature of the group.

Despite this seemingly contented pattern the group still had ambitions to "hold Exhibitions when convenient" and Walter Langley later wrote that the group determined the next exhibition would consist 'only of works by the members - young Birmingham artists - they will possess a character and an interest peculiarly their own'. The membership had grown further by then and this exhibition of works by all eighteen members of the 'Art Circle', including John Fullwood, was held in the gallery of the dealer Edwin Chamberlain, located in Temple Row, Birmingham.

The *Birmingham Daily Post* of 24 November 1881 reviewed the exhibition and confidently stated that "several of the young men whose works hang here are evidentially determined to make their mark in the art world, and the very modest prices they have put on their work will probably in futures years be chronicled with the trivial sums received by a Turner and a Cox."

One of the pictures exhibited by John Fullwood was '*Marazion Marshes',* painted in Cornwall. He was asking £30 for it. It was described as "a very large picture and a difficult subject (which is) bold and effective, without losing the delicacy of the pearly gray's so characteristic of our humid clime." Paired with it was another Cornish scene '*A Cornish Glenn*', later to be owned by Arthur Hellier.

One outcome of the positive reception to this exhibition was the relationship it established between the Art Circle and Edwin Chamberlain. At a "Special Meeting" held on 8th October 1881 at Edwin Chamberlain's house, it was agreed that further public exhibitions would be held and that Chamberlain would be entitled to a charge of 15% on works sold. Although Walter Langley was present, John Fullwood was not. On December 9th 1881 another meeting was held at Edwin Chamberlain's rooms on Temple Row, Birmingham. The meeting agreed that "the Art Circle pledges itself to continue its present connection with Mr E Chamberlain in respect to exhibitions."

The pattern of 'Summer' and 'Winter' exhibitions was now set. The original membership was well represented; alongside John Fullwood was Charles Whitworth, Edward Harper, John Keeley and many others. Thus a long and initially fruitful relationship between Chamberlain and the Art Circle was established. Edwin Chamberlain promoted the 'Art Circle' exhibitions for many years and became an agent for many of the new wave of artists emerging in Birmingham. Beyond that, on 27th March 1882 he was appointed as permanent secretary of the Birmingham Art Circle

The *Artist and Journal of Home Culture,* in its June 1882 issue had noted "The Association of Young Artists calling themselves the Art Circle have again ventured before the public with an exhibition exclusively of their own works. It was opened during the past month at the rooms of Mr E Chamberlain, Fine Art dealer, Temple Row. Though small, the number of works being not quite fifty, it is an exhibition of much interest and promise."

The reviewer noted that the exhibition was now supported by an illustrated catalogue with an entry for each artist and reflected on the summer exhibition "The visitor will find abundant evidence that Birmingham is producing some remarkably talented young men. This is not by any means a new thing, for very many who are now eminent as painters, engravers and medallists have sprung from this hardware metropolis. But they drift away and know Birmingham no more. Indications of this drifting process may be found in the admirable little catalogue which the "Circle" have produced. Looking at the addresses of the eighteen members I find that the circle is distending in a remarkable manner. Two live in London, one in Paris, two in Cornwall, two in North Wales and one in Britain."

John Fullwood exhibited more Cornish scenes at this exhibition; a watercolour *'The Sands of Lelant'* and *'A Study of Old Buildings – Penzance'*.

The November 1882 edition of the *"Building News and Engineering Journal"* reviewed the Winter 'Art Circle' exhibition, stating "The band of Young Birmingham Artists (Y.B.A.), associated together under the name of the 'Art Circle' opens today an exhibition consisting of about forty paintings in oil and water-colour. The artists represented are Messrs Wainwright, Langley, Harris, Breakspeare, Fullwood, Whitworth, Harper, Fortescue, Currie C and WJ, Morgan, Keeley, Pope etc" and noted "Mr Fullwood's *'Once with the Fleet'*, is a stretch of rugged, stone strewn coast beyond a deep blue sea and a soft warm sky", referencing another of his Newlyn paintings.

The constitution of the Art Circle required that "No works are admissible that have been publically exhibited before in Birmingham" thus precluding Fullwood from re-exhibiting works he had submitted to the R.B.S A or B.S.L.A. shows.

In 1883 John Fullwood submitted *'When the trees are bare'* to the Art Circle's summer exhibition and *'From labour returning'* to the winter exhibition, by which time Chamberlain had moved to "a new and more commodious gallery", in Birmingham, the Athenaeum. By this time Whitworth Wallis, son of George Wallis, had joined the group. In its review of the winter exhibition the *Birmingham Daily Post* noted "The treasures of the exhibition belong to Messrs Wainwright, Langley, Fullwood, Breakspeare, Harris and Whitworth. Fullwood's *'From Labour returning'* was quiet and subdued in tone but rich in form and harmony of colour – the more one looks at this landscape the more grace and truth he will find in it."

It seems that John Fullwood did not exhibit with the *'Art Circle'* for many years after this. Indeed, the *Birmingham Daily Post*, in reviewing the winter 1888 exhibition, noted "we regret to see so many of the brotherhood represented only in the list of members." As a contemporary review in the Artist noted "Birmingham is producing some remarkably talented young men…..but they drift away and know Birmingham no more. And doubtless that will

continue to be the case." The paper went on to list nine prominent local artists, including John Fullwood, whose absence it regretted.

The minutes of the *'Art Circle'* confirm that in this period, although John Fullwood paid his subscriptions he did not attend its meetings. By this time of course he had moved down south, to Sussex and London. The minutes though reflect the Birmingham based members frustration at the impact of his and other absent members had on the quality of the exhibitions by not submitting works to them. A note in the minutes for the 1887 Annual General Meeting reflected on the last two public exhibitions held; it stated "These exhibitions have not resulted as satisfactorily as might have been wished owing presumably to the continued depression in trade, and to the laxity of several members in either not contributing at all or in only sending works of secondary importance."

Two years later, the situation not having improved, the minutes noted that "after a long and animated discussion –various views being expressed- but the general opinion was that something must be done to get more members involved in the exhibition." The following amendment was proposed – that after January 1890 each member of the *'Art Circle'* to be requested to contribute at least one picture during the year. "Any member not having contributed to either of the exhibitions during the year, sufficient reason not being given, his name to be removed from the list of members." John Fullwood was present at the December 30th 1889 meeting, his first attendance in a long time.

John's presence amongst the list of exhibitors was not reported again until the summer 1891 exhibition when he submitted two drawings, *'Softened Whispers'*, and *'Vespers of the Gloaming'*. The following year John submitted "Four bold, vigorous and patently veracious sketches" to the water-colour room, according to a review in the *Birmingham Daily Post* of 4 May 1892, which noted that 24 out of the 32 artists in the *'Art Circle'* contributed works to the exhibition. John exhibited the following year but only one painting, a landscape depicting *'A Road through a Kentish Vale'* on a hot,

luminous day and described as "sound, masculine work" in the *Birmingham Daily Post* of 10 May 1893.

John Fullwood's work had by now fallen down in the order of works highlighted by the reviewer, with other artists such as Wainwright and Langley attracting greater prominence as well as the work of newer members of 'Art Circle' such as E. Gabriel Mitchell.

However the "depression in trade" noted by the Art Circle as a reason for the lack of sales had one other side effect. Edwin Chamberlain had decided that he no longer wanted to promote the Art Circle, declining the post of Secretary in 1894 and no longer hosting the groups' exhibitions. The next summer exhibition was then moved to the R.B.S.A. premises in New Street, Birmingham. A total of 132 works were submitted by 25 members; only one small work was sold. An internal debate developed about whether the Art Circle should continue as an exhibiting society. "In view of the depleted state of the Art Circle exchequer and the sparse attendance of members it was not thought advisable to hold a winter meeting" that year. In fact the Art Circle was in abeyance for the next few years.

The subsequent phase of the Art Circle's life was reported in *The Studio* magazine when it noted that the 27th exhibition of the 'Art Circle' in September 1897 had moved to the Graves & Co Gallery in Cherry Street, Birmingham. As the magazine stated, it had been three years since the 'Art Circle' had held a show and "this reticence is to be admired; the work exhibited seems better in many ways than one's recollection of the pictures of three years past. The members are all young Birmingham artists and among them will be found a number of men whose work will be known outside our city; some of them are also members of the Royal Society of Artists. Collectively they represent the best painting that is now being accomplished in the midlands." Alongside John Fullwood were listed prominent local artists such as Langley, Wainwright, Jelley, Mercer, Harper and Davies.

John Fullwood did not exhibit with the Art Circle again. Nor did he have much to do with the group, although he continued to be shown as a member. Despite this his reputation stayed intact. In Whitchurch's history of the Art Circle, written in 1903, he noted "That the Birmingham Art Circle has contributed not a little to the artistic life of the city is evidenced by the long list of names now known to fame far beyond its borders. Of those gentlemen who are or have been closely associated with the Birmingham Art Circle, many of whom are foundation members and to whose guiding care the early years of the establishment and organisation of the society is largely due, the majority of whom are now members of the Royal Society of Artists, the premier society." Among those Whitchurch identifies are Fullwood, Langley and Wainwright.

In 1907 John Fullwood's participation declined further. The minutes of that year's Annual General Meeting (A.G.M.) noted that a number of members had resigned; two however would be afforded lifelong Honorary Membership. John Fullwood was one of those. In a final mark of respect the 1931 A.G.M. notes with sorrow the passing of John Fullwood and William Wainwright in the same year.

From 1914 until the mid-1930s, The Art Circle shared its exhibitions with that of another local group, the Clarendon Art Fellowship. This group had also begun in the winter of 1878. The idea of a fellowship to "Promote in Birmingham the study and interest in Art" was propounded by the founder of the Birmingham School of Landscape Art (B.S.L.A.), Edward Watson. Watson gathered a small group of professional artists associated with the B.S.L.A. and they developed his idea until they gained the approval of the Committee of the Birmingham Y.M.C.A., in whose premises the B.S.L.A. held their classes.

By the following year the Clarendon Arts Fellowship was established. It was named after Clarendon Chambers where the B.S.L.A. was originally formed. They adopted their motto "Go search for Nature and arrive at Art" from *The Artists* by the German

poet and philosopher Friedrich von Schiller, although the quote also perfectly sums up the philosophy and teachings of Edward Watson.

Membership was to be limited to twenty artists and the constitution of the Fellowship required its members to have all attended classes at the B.S.L.A. Letters were sent out inviting ex-members of the school who had attained some professional standing to join the Fellowship and John Fullwood was one of the original eighteen who formed the group.

Other members included Charles T Cox and John Keeley, teachers at the B.S.L.A. but also artists in their own right, as well as others such as Henry Pope, who was to take over as President of the Fellowship after the death of Edward Watson.

John Fullwood attended the first general meeting of the Fellowship in December 1879 but did not attend the next annual general meeting, nor the subsequent social meetings which also formed part of the Fellowship's calendar, although he sent his apologies pointing out that he, at that time, no longer lived in Birmingham.

The minutes of the annual general meeting in 1884 noted that John Fullwood (and others) had not replied to the invitations requesting his attendance at that meeting. The minutes of 1889 show that he was still a member, paying his subscriptions and giving his address as 4 Bank Buildings, Hastings, Sussex.

However, at the following meeting, on February 6th 1890, the Committee decided that a letter should be sent to two members, including John Fullwood, drawing their attention to the fact that "they had shown no sympathy with the Fellowship for some time past" and inviting them "to renew their interest in the future." In the event of the replies being unfavourable, "that they be dealt with" under the rules. Presumably his reply was negative as his membership was subsequently lapsed.

One way that the Clarendon Arts Fellowship promoted art in Birmingham was to award scholarships and bursaries to promising

young talent, allowing them to attend classes at the Birmingham School of Landscape Art and hopefully follow on to have successful professional careers.

One such scholarship was awarded to Albert Henry Fullwood, John Fullwood's third cousin who had similarly started his working life in the Birmingham jewellery trade; the 1881 population census records him as "jeweller and artist", the same census in which John first described his occupation as a landscape artist. Albert Henry Fullwood emigrated to Australia in 1883 and became a significant figure in the New South Wales art world. He returned to live in England in 1901 and it is tempting to think that he visited John Fullwood later to repay his debt, as he exhibited two paintings executed near where John was living at that time; 1907's *'Twickenham Ferry'* and 1912's *'Richmond Bridge'*.

Another group, 'The Easel Club', was formed in 1883 and shared much with the Clarendon Art Fellowship and the Art Circle, including the patronage of Edwin Chamberlain. Given that he was the dealer for many of these artists, this is unsurprising. It was formed to showcase and critique the work of practising artists and it still meets and exhibits in Birmingham today.

Twelve members formed the original group. John Fullwood's work was clearly sufficiently well known for his membership of the 'Easel Club' to be proposed on February 20th 1886 by Frank Richards and seconded by Frederick Brueton; these artists were two of the original founders of the Easel Club and in whose studio the group had first met.

John Fullwood contributed *'The Minnow Catcher'* to their exhibition in June 1886 when the *Birmingham Daily Post* reported "Coincident with the wider study and closer appreciation of art in recent years there has been, as was only to be expected, a considerable enthusiasm among the many for what is called "Black & White", a term of wide meaning covering all processes by which the thoughts of the artist are expressed in monochrome, whether in

oils, water-colours, chalk, charcoal, pen-and-ink or whatever medium may be employed…….we are glad to see that in the capital little exhibition which opens today in the Holbein Gallery, 25 Bennetts Hill, a dainty banquet of good things has been prepared for them. The list of members of the club, thirty-four in that number, includes the names of nearly all the young artists…..when we say that the exhibition includes drawings by Wainwright, Langley, Gaskin, E. S. Harper, Brice, Mason, Oliver Barker and Fullwood…..The honours of the exhibition are carried by Messrs Wainwright and Walter Langley although among the eighty five works that the exhibition comprises there are many meritorious drawings…..”

It considered *The Minnow Catcher* to be "a very beautiful etching of a river scene." The *Art Journal* review simply asked "How many memories of rural enjoyment does not a picture like this recall?"

John Fullwood's active participation in the group was to be limited. The minutes of the Annual General Meeting held on January 22, 1887 show that he did not attend any of the 18 meetings held, or show any work at them, during that year, his entry showing 'out of town'.

John Fullwood was not the only one of the thirty five members listed, Messrs Harris, Morgan and Breakspeare were also absent. The minute book of the Club notes that on 29 January 1887 the "First Annual Smoker" was held, with Walter Langley presiding. It states "This very successful gathering took place at Holbein Gallery, 25 Bennett's Hill, kindly lent for the occasion by Mr Chamberlain. Members representative of the Royal Society of Artists, The Art Circle and a few others were invited and attended. The musical programme was contributed by Messrs Taylor (pianoforte), Hunt (clarinet), Whitworth (violin), Long and J Pratt (vocalists) and Harrison (recitation). Refreshments were provided by Messrs Lisether and Miller in ante-rooms at the back and smoking of "Ye fragrant weed" was freely indulged in. About 50

members and friends were present and the gathering was an immensely successful one."

Whether John Fullwood attended this soiree is uncertain as no individual names are listed. The following year's Annual General Meeting, however, shows that he again did not attend any of the fifteen meetings held during that year, noting that he was "out of town."

John Fullwood did contribute to the 1888 exhibition, held at Chamberlain's gallery, with the *Birmingham Daily Post* noting "it is now two years since the public was last invited to inspect the drawings of its members, owing, as we understand it, to the difficulty of finding a suitable gallery." John Fullwood contributed *'End of a winter's day'* and the paper noted "The productions of Mr Langley and Mr Wainwright and the poetical landscape of Mr Fullwood are the cream of the exhibition."

In 1889, at the third exhibition of the 'Easel Club', most of the exhibits were in black & white and monochrome. The *Birmingham Daily Post* of 29 January 1889 noted "Mr Fullwood, whose great mastery in black & white is familiar to us in his fine etchings, sends *'Silver Aspen'*, a very vigorous and effective drawing."

Although the 'Easel Club' continued to hold exhibitions in the succeeding three years, John Fullwood did not contribute to any of them. The 'Easel Club' then folded, only to be revived a few years later. It still continues in Birmingham to this day (2018).

Chapter 10 Spreading His Wings - Newlyn and Paris

Newlyn, a fishing village adjacent to Penzance, Cornwall lies on the south coast of the Penwith peninsula, ten miles east of Lands End. The railway had reached Penzance by 1850 and the area, although remote, was not inaccessible; as the political reformer Samuel Smiles noted, the locomotive had "virtually reduced England to a sixth of its size."

Newlyn's combination of fantastic light, cheap accommodation and picturesque subjects proved attractive to artists influenced by the French Barbizon School of outdoor painting, a technique known as *en-plein-air*. The *Magazine of Art claimed* in 1898 that, "It was Birmingham that first discovered Newlyn", and the 'Newlyn artists' colony and school was particularly associated with Birmingham trained artists from the 1880s until the early twentieth century, which reflects the influence of landscape painting in that school.

One man's name in particular is associated with Newlyn, that of Walter Langley. In the *Cornishman*, of 10 October 1889, a correspondent wrote "If Mr Walter Langley did not exactly invent Newlyn, he was the first to make it famous when he migrated from the Midlands." Yet there are many references to the Birmingham Art Circle, the Royal Society of Birmingham Artists and to the *Edgebastonia*, the newsletter-cum-journal of the Birmingham community of artists, in material associated with Newlyn and the focus on Langley undermines the contribution of others.

John Fullwood was a member of many of those Birmingham groups and was a resident of Newlyn, albeit for a short time, making him one of the earliest known of the Birmingham artists to live and work in the area. Indeed, John Fullwood is identified as a one of the first members of the Birmingham Art Circle to have been in Penzance, according to Roger Langley's book of his grand-father

Walter's life and work. But despite his early association with the area, John Fullwood's contribution to the development of the Newlyn colony and school generally goes largely unrecognised in the public eye.

Newlyn Old Harbour by R. Tremberth.

Etching by R. Tremberth showing the old harbour at Newlyn. Reproduction by permission of Wolverhampton Art Gallery.

It is possible that the first Birmingham artist to visit Newlyn was Henry Martin Pope in the 1870's but if he was alone he soon alerted fellow Birmingham alumni to the location's attractions. In the summer of 1880 Walter Langley accompanied Pope on a sketching holiday to Newlyn. He returned to Cornwall in July 1881 with a sizeable commission from Edwin Chamberlain to produce twenty paintings of Newlyn, accompanied by another Birmingham artist, Edwin Harris.

It may be that John Fullwood's personal friendship with Walter Langley and Edwin Harris brought him to Newlyn too, or it may be through the influence of their shared contact with Edwin Chamberlain. Yet another artist has been identified as part of this early group, William Wainwright. In the *Cornishman* obituary of John Fullwood it was said that "Fullwood, along with Walter Langley and W. J. Wainwright, were inseparable at their painting quarters at Newlyn."

John Fullwood found inspiration at Newlyn, exhibiting Cornish watercolours at the Birmingham Art Circle in the winter of 1881, including *'A Cornish Glen'* and *'Marazion Marshes'*. The following year he gave his address as the hamlet of Paul, one mile south of Newlyn, when he exhibited in Birmingham.

The *Artist* magazine noted that *'Cornish Lane'* is a picture of "sterling merit and he (John Fullwood) has a good drawing of *Newlyn Sands."* John also travelled around the county as *'Descending Noon'* is described as a North Cornish scene. He contributed three Cornish paintings to the Easel Club exhibition of 1882, *'An Old Street'*, *'St Ives'*; *'Marazion Marshes'* and *'An Old Building, St Ives'* (also described as *Study of Old Buildings, St Ives).*

The same year Walter Langley received a £500 commission from another Birmingham dealer, J W Thrupp, which was sufficiently large to enable him to base himself permanently in Newlyn, moving down with his wife and children. The 1882 minute book of the Art Circle, capturing members' addresses, show that both Fullwood and Langley were recorded as 'Country' members, their Grosvenor Chambers, Broad Street addresses being crossed out and replaced with that of Paul, Newlyn. In Langley's case the house name was also given, Pembroke Lodge. This was a substantial Georgian property, able to accommodate Langley's growing family. Whether Langley shared this property with Fullwood and Wainwright at this time is unclear.

At the 1883 Royal Academy exhibition John exhibited '*Haymakers Returning*' and gave his address as Tal Carney, Penzance, probably a mis-spelling of Tolcarne, a nearby hamlet. Roger Langley states that John Fullwood left Cornwall by late 1882 or early in 1883, although he made at least one other brief visit to Newlyn in 1885. John Fullwood submitted two West Cornwall paintings for the 'Spring 1886 Exhibition' of the R.B.S.A. including '*At Newlyn, Cornwall*'.

By this time the R.B.S.A. was accepting and exhibiting the work of many of the younger Birmingham artists, including those who had been to Cornwall and those who were simply influenced by the social realism of the Newlyn school artists. The naturalism of the established members was challenged by the draughtsmanship and moral tone imported from Cornwall.

The popularity of the works of the artists associated with the schools at Newlyn and nearby St Ives was not limited to Birmingham. The *Art Journal*, in an article published in 1883 entitled "The Moorlands and Glenn's of Cornwall", noted the increase in the numbers of Cornish scenes exhibited at the Royal Academy. This prominence influenced taste nationwide and these scenes were popular with gallery goers throughout the late Victorian period and sold well. The Wolverhampton Municipal Art Exhibition of 1888 attracted submissions by several well-known artists depicting Cornwall, including Walter Langley, whose work was also represented in the Birmingham Art Gallery.

The zenith of the Newlyn colony's achievements is held to be an exhibition at Nottingham Castle Art Museum in October 1894 entitled "Pictures from the Newlyn School", showing more than 220 examples from these painters of Cornish scenes. The organiser and curator of the exhibition was George Henry Wallis, the son of Wolverhampton born George Wallis, who had grouped together the works of artists such as Frank Bramley, Walter Langley, Stanhope Forbes, Adrian Stoke, A.C. Tayler, Alfred East, T.C. Gotch, Fred Hall, C. Napier Hemy, Louis Grier and many others. The *Aberdeen*

Free Press, in its report, claimed that this was the first time there had been an exhibition just of works from this distinctive school.

However, artistic movements wax and wane, sometimes within short timescales and often within the lifetime of an artist. In 1896 the *Art Journal* magazine profiled John Fullwood and it noted that a number of Birmingham artists, John Fullwood included, had "settled in Cornwall early in the last decade and showed their individuality so strikingly that it was at one time thought by many that Newlyn was going to mark a new departure in English Art. But the method was so easily copied and so readily exaggerated too, that it very soon became the distinction not to be a Newlynite."

Nevertheless, the article did confirm that John Fullwood was one of the first group of artists to settle there and noted that "he did such good work there that there are those who think it would have been best for him to have continued in that locality…there is no question as to the fact that some of his most characteristic work bears the stamp of Cornwall", referencing the works *'To Meet the Fleet'* and *'What the Morning Revealed'*. The latter was painted after a bad storm which had swept Mount's Bay and the Cornish coast and was also made into an etching which formed part of the group of works displayed in and then given to, Wolverhampton Art Gallery in 1884.

By this time, and certainly since the writing of William Cobbett in the 1830's, there had been an awareness by some commentators that the countryside, particularly during the great depression in agriculture occasioned by the dramatic fall in grain prices due to overseas imports from the 1870's, was becoming a wasteland. In leaving the midlands it could be argued that John Fullwood had chosen not to represent the industrial way of life. Similarly by not reflecting rural poverty, neither did he accurately portray the pastoral. Indeed, in a review of his painting '*The Winding Lyre of the Vale*', exhibited in Birmingham, the critic of the *Dart* magazine highlighted Fullwood's "very presentment of rural English Life."

The human figure is noticeably absent from many of John Fullwood's rural realisations and when present is often insignificant within the landscape. Nature, not humanity, takes precedence. Yet John's contemporary at Newlyn, Walter Langley, did try to encompass a moral perspective when portraying the lives of the fisher folk by showing them in contemporary dress in a more or less contemporary setting which depicted a story, or idea. The workers in Langley's art are usually portrayed as honest rustics labouring against the elements and are usually clean and decent.

The *Magazine of Art* however, reflecting on the status and influence of the Newlyn School in 1910 and especially of the artist Stanhope Forbes with whom, by then, it had become particularly associated, had a different view. It noted the "new, clear notes in British Art struck by painters of the Newlyn School" and the magazine claimed to have played a significant part in bringing the works of the colony's artists to the greater British public.

It claimed that "it was the *Magazine of Art* that first acknowledged the remarkable achievement of the Newlyn School. In 1889 the Editor asked for two articles on the group of painters worthy of Newlyn." Fourteen artists were listed in the 1889 article, but John Fullwood was not amongst them as he had left Cornwall the year before Stanhope Forbes arrived. Forbes had arrived at Newlyn in 1884 and the following year his '*A Fish Sale on a Cornish Beach*' was accepted by the Royal Academy, which established his reputation.

Stanhope Forbes soon became a leading figure in the artistic colony and the School of Painting that he founded in 1899, with his wife Elizabeth, revitalised the colony and was to attract a whole new generation of artists to the area in the following years. Around 120 artists are recorded as working at Newlyn in the twenty years from the 1880's, mainly white, male and middle class.

The *Cornishman* newspaper, in its obituary of John Fullwood published on 17 September 1931 noted his status, alongside Walter

Langley, as one of the founders of the Newlyn School. However, an exhibition devoted to the output of the School mounted in 1943 and curated by Stanhope Forbes, chose 1890 as the starting point of the golden Age of the Colony; after Forbes had arrived, but also after Fullwood had left.

John Fullwood, it seems, had been there at the instigation of the movement but had moved on to further his talent elsewhere before the recognition and reward became awarded to Langley, Forbes and other artists and so the part John played is now overlooked.

The Paris Salon by Jean-André Rixens (1846-1925) [Public domain], via Wikimedia Commons

When John Fullwood exhibited at the R.B.S.A. in May 1883 he gave Tolcarne, Penzance as his address, but in that year's November show he gave a different address, 2 Rue Odessa in Paris. This perhaps offers an explanation as to why Arthur Hellier had found it difficult to contact Fullwood when trying to get him to fulfil his obligations in supplying more etchings for future issues of 'Remnants of Old Wolverhampton'.

148

John Fullwood may have felt that he had to leave England to develop his talent elsewhere. The works exhibited at the R.B.S.A. at this time were influenced both by the ideas of social realism being developed in Cornwall but also by a lighter colour palette, which reflected an awareness of new ideas coming from Paris.

The Paris Salon, which had set the style and standard for French art since 1667, had lost the financial support of the French government in 1881. This was the period now called "The Belle Epoque" and a new Salon was established by the Societe des Artistes Francais (S.A.F.) to promote younger artists.

The Salon was the premier annual art exhibition in France at the time and Paris largely defined the world of art, so the importance of being shown at the Salon cannot be overestimated. Indeed, as Renoir later wrote "There are fifteen art lovers in Paris capable of appreciating a painter without the Salon. There are eighty thousand who wouldn't buy a thing from a painter not exhibited at the Salon. That's why I send my paintings there."

As Paris was the artistic centre of the world throughout the nineteenth century it offered artists both an opportunity to further their training and also gain work. John Fullwood's relocation to France was not unusual; of his immediate Birmingham contemporaries William Breakspeare, Frederick Davis and William Wainwright, future fellow members of the Easel Club and Art Circle, also trained there.

Wainwright, with whom he had just shared lodgings in Cornwall, was living a short distance away from John Fullwood across the Boulevard du Montparnasse. As with his stay in Newlyn, there is no evidence that Fullwood was accompanied by his wife and daughter.

After initially giving his address in the Rue Odessa, by May 1884 John Fullwood had changed his contact address to 13 Rue du Montparnasse, the business address of Libraire Artheme Fayard. Fayard was a French publishing house established in 1857 which published popular and classic novels, often illustrated, in cheap

editions. If providing illustrations for these books was the "day job" for John in Paris whilst he struggled to establish himself as an artist, then it was one that he done before and one that he was to continue doing throughout his career.

In an appreciation of his career to date, printed in *The Art Journal* in 1897, it was said that his French contemporaries had recognised his talent and that his work in France was exhibited at the Salon organised by the S.A.F. It stated that it was placed at eyesight level, which situation indicated a considerable honour.

Given John Fullwood's relative inexperience and lack of profile, for his art to have such a placement would indeed have been an honour. Perhaps his profiler gave him retrospective promotion as surviving S.A.F. catalogues do not record any paintings being exhibited by him. There is though one other indication that he painted in Paris. John's painting *'The Charcoal Burners'* now hangs in Walsall Art Gallery, a gift of Edward Shaw to the town at the turn of the twentieth century. The colourist's stamp on the back of the canvas reads "Paul Foinet (Van Eycky) 34 rue Notre Dames de Champs, Paris."

Paul Foinet was a well-known figure in late nineteenth century Paris, making colours, canvases and brushes and was used by many British artists as a contact when exhibiting at the Paris Salon. His soubriquet Van Eycky referred to a supposed likeness to the artist van Eyck. Looking at the painting, John Fullwood's depiction of thick, intertwined branches and billowing smoke make this unusual amongst his works and could be said to reflect the influence of the Impressionists, who were exhibiting in Paris around this time. Was this painted, if not hung, in Paris?

John did however exhibit two engravings at the 1885 Salon, held in the Palais de Champs Elysee, but after he had returned to England. These were *'Tiges d'Argent'* and *'Trembles Chanteurs'* and he gave as his French agent a M. Clemant, resident at the quai de la Tournelle. *'Silver stems'* (in French *'Tiges d'Argent'*) was

exhibited at the Birmingham Art Circle exhibition in May 1885 together with two sketches of the Oise River, which flows into the Seine in Paris.

In a digest of artist engravers published in Paris at the turn of the twentieth century, John Fullwood is described as an artist whose 'oeuvre' comprised about 180 published engravings. His work, according to the book, was mainly available in America. In an intriguing aside, it suggests that Fullwood's engraving '*The Gypsy Camp*' was of a scene just outside Paris.

The technique of engraving, or as Ruskin termed it, "The art of the scratch", had become highly regarded in Paris from the mid-nineteenth century. This was partly as a reaction against the mass production of prints following the invention of lithography. Before the supremacy of photography in the printed press, this was the medium through which most of humanity communicated visually.

The line engraver uses a sharp point, a burin, to compose a network of lines, cutting the design into metal, usually copper. These lines are then filled with ink and printed onto paper. The engraver works from light (no lines) to dark (an ink filled line – and the deeper the line the more ink was held and therefore the darker the image).

In mezzo-tint, the opposite is true. The artists "roughs up" the plate by using a rocker, which would print totally black, areas of this are then removed so that less ink would adhere and a lighter tone prevail. A skilled artist could create more subtle painterly and textural effects using this process. It was also much quicker. The engraver William Sharpe, writing in 1810, described mezzo-tint as, "almost as quick as drawing."

Etching, the process through which an image is created by sketching on a malleable wax ground, then washed away with acid to reveal the image, was seen as more closely resembling drawing; the artists hand was directly connected to an individual work and the artist often controlled the print through choice of paper and ink.

John Fullwood was to master all of these techniques across his career. The culmination of his acquisition of these skills was demonstrated in his Parisian etchings. At least six of the etchings John Fullwood made there at this time, representing two views each of three rivers have survived. The prints, '*On the Seine, from Sevres*', '*On the Oise, France*', and '*The winding of the Marne*' were subsequently advertised for sale in a catalogue of Fullwood's work issued by the Fine Art Guild.

The most important outcome of his Paris sojourn however, was the contact he made with the dealer Frederick Keppel, which was to make Fullwood's reputation in America. The 1896 *Art Journal* biography of Fullwood, remarking on his time in Paris, noted "It is thought, if he had stayed in the French capital longer, he may have won wider acceptance in the art community. His time in France did teach him how better to put paint on canvas, but more importantly it served to introduce him to American patrons through whom his etchings became very popular in America."

Chapter 11 Walsall –
"A Town Of Close Links".

Etching of 'Old Buildings, Town End Bank, Walsall' by John Fullwood. Reproduction by permission of Wolverhampton Art Gallery.

Whilst transatlantic fame was to beckon, John Fullwood never forgot his midlands roots. The quote above comes from a letter to the *Walsall Advertiser* in the 1890's, acknowledging the presence of a number of Fullwood's paintings and etchings in the town's Art Gallery. The same paper, when reporting the opening of an exhibition of John Fullwood's works in Birmingham in December 1890, noted that the artist "is well known in Walsall, counting many excellent friends here." Indeed, his association with Walsall in the public eye was such that the *Birmingham Daily Gazette*, when noting the donation of a number of his works to the Birmingham Art Gallery in 1927, described him as a Walsall artist.

The origin of John Fullwood's links to Walsall may have been familial, or might have been forged through shared friendships, religious persuasion, or cultural interests; whatever they were, they were certainly also artistic.

John Fullwood's mother is recorded in the 1851 and 1871 population censuses as having been born in Walsall, but the 1841 census records her parish of birth as the same of her husband Joseph, that is, St John's Wolverhampton.

Perhaps greater weight could be placed on the more detailed 1851 and 1871 censuses but other corroborative detail is lacking. Certainly, John had relatives living in the Walsall area at other times. What adds weight to the likelihood that John Fullwood would have visited Walsall prior to the commencement of his partnership with Arthur Hellier. With a commitment to publishing 100 etchings, we know that of the forty eight etchings which were published in 'Remnants of Old Wolverhampton', five were actually of Walsall and the surrounding area.

In its 24 May 1881 review, the *Walsall Advertiser* was noting that an etching of '*The Old Buildings, Digbeth, Walsall*', had appeared in the third edition of the 'Remnants' part work to be issued, but regretted that the title, in not referencing that town (Walsall), may have restricted sales in Walsall.

John Fullwood's etching of '*Town End Bank*' faithfully records a number of houses and commercial buildings in that street, including possibly the Oddfellows Arms or Waterloo Tavern and a pawnbroker's shop front. These old buildings were being demolished as part of Walsall's own improvement scheme and the motivation to record them must have been similar to that of the buildings around Caribee Island in Wolverhampton. The scale of Walsall's scheme was smaller in comparison, with Walsall Council borrowing less than one tenth of the development sum that Wolverhampton spent.

The houses to be demolished were described as being "peopled by the lowest and most depraved of the community" with town's medical officer of health concluding that the area had "the worst conglomeration of abominations" in the town. The Mayor of Walsall at the time, most likely to be William Bayliss, was quoted as saying; "Many of the tenants have been for generations the sloth of the idle and the profligate and abounded in associations which are disgusting to public morality and common decency." Another contemporary description described the area as "smoke and lime-kiln, gas works and Irish hordes", which gives an indication that the same motivations were at work when "improving" both Walsall and Wolverhampton.

In contrast another of John Fullwood's etchings in 'Remnants' was that of '*Old Gateway at Rushall*'. Rushall is by now a suburb of Walsall. The subject was of the remains of the fifteenth century gatehouse of old Rushall Hall, which by then had been incorporated into the garden of New Rushall Hall. This house was occupied by William Henry Duignan, a local solicitor, but more importantly for John Fullwood, also an antiquarian, writer, historian and prime mover in the development of artistic institutions in Walsall.

William H Duignan's interest in art had meant that he had also loaned works of art to the Wolverhampton Fine Art Exhibition in 1884. Duignan's abilities showed themselves when he was aged only 16, as he gave evidence to R H Horne in the 1840s when he collected evidence on the employment of children for the Royal Commission.

Closely allied with Duignan was the Reverend Alfred Cole, of the Goodall St Chapel, Walsall who was equally prominent in the religious and intellectual life of the town. Alongside Duignan, Cole was a leading light of the Walsall Literary Institute and he also shared John Fullwood's passion for geology.

John Fullwood's etching of the 'Old Gateway at Rushall' near Walsall. Reproduction by permission of Wolverhampton Art Gallery.

John Fullwood attended at least one meeting of the Institute in Walsall even after he had moved to Hastings in Sussex over 200 miles away from Walsall. In a talk given by Edward J. Shaw entitled "The Life and Works of Josiah Wedgwood" in November 1895, at the Goodall St Chapel schoolrooms, John is reported in the *Walsall Advertiser* as giving his views on the difference between "Eastern" pottery and its western copies.

In 1897 John Fullwood provided a cover illustration for the *Goodall Street Chapel Magazine,* the motif described in the *Walsall Advertiser* on 18 September as "a sunflower, decoratively treated, enclosing some lines from the poems of the late Pastor, the Reverend A. A. Cole. The whole effect is a happy blending of the work of the poet and painter."

The Reverend Cole had instigated an evening class teaching elementary art in the Chapel's schoolroom in 1861, the success of which contributed to local pressure for the establishment of what was to become the Walsall Government School of Art in 1869, with its Chairman being W.H. Duignan. The Walsall Science and Art Institute descended from this school and the Honorary Secretary of the Institute was W. Henry Robinson, printer, publisher of the *Walsall Advertiser*, author and scientist.

It is from this circle of associates of W H Duignan and that of Duignan's close friend W Henry Robinson, that the connections in which John Fullwood's art was collected and sold in Walsall can be identified.

Walsall opened a New Art Gallery and Museum on 16 May 1892, which was added to the site of the town's Free Library in Goodall Street. The *Walsall Advertiser* reported on 19th June 1897 that the Walsall Town Clerk "had pleasure in announcing" several Diamond Jubilee gifts had been made to the Art Gallery. E.J. Shaw (JP) had presented a water colour landscape *'Over the Border'* by John Fullwood R.B.A. and other paintings were gifted by Aldermen Bayliss and Holden.

A letter sent to the *Walsall Advertiser*, published on 2 October 1897, pointed out that a local Walsall councillor, Mr Hughes had made an error when he identified the name of the first person to donate works of art to the newly opened Walsall Art Gallery. The author of the letter, only given as 'Pictor', pointed out that person who made the gift of three "beautiful and almost unique works of art" five years ago was actually John Fullwood and Pictor went on to query why these donations were now kept practically out of sight, as well as out of mind.

Pictor added "It shows either a lamentable lack of grace or an almost inconceivable lack of knowledge on the part of our Library Committee of what is beautiful. In any case such unfortunate neglect is scarcely calculated to incite other artists to make similar gifts."

Pictor is a constellation named after its resemblance to Equuleus Pictoris, the painter's easel. This playful combination of art and stargazing perhaps indicated the pseudonym of the Reverend Cole, the priest of Goodall St Chapel.

The *Birmingham Daily Post* of 17 May 1892 had noted that the reading room of the Free Library and Museum contained "some of Mr Fullwood's fine etchings." These etchings had been a "continued source of delight to visitors" according to the *Staffordshire Advertiser* on 21 August 1897 when it commented on the town council's decision to set a fund of £100 annually for the purchase of pictures forming the permanent collection of the new Art Gallery.

However, the process of growing Walsall's civic art collection was painfully slow. As the *Midland Evening News* noted on 12 June 1902 "The process is particularly slow for a place of the size and importance of the borough in gathering the nucleus of a permanent collection of pictures in her Art Gallery."

Although the Council was unwilling to lay too great a burden of creating an art collection upon the ratepayers of Walsall, later that

year another letter, to the *Walsall Advertiser*, noted "To local lovers of art it must always be a matter of great regret that our town is so much behind others in the way of art treasures, and for this state of affairs the Art Gallery Committee are entirely to blame; as a body they know little about pictures."

In May 1902, Edward J Shaw (J.P.) wrote a letter to Walsall Council, asking them "to be so kind as to offer to his Worship the Mayor, as my Coronation Gift to the Art Gallery, a work by John Fullwood R.B.A. It is a painting in oil, considered in one report to be his finest oil painting and is entitled *'The Charcoal Burners'*. Assuring you that it will give me much pleasure to know that my picture has found a home in an institution for which I have always entertained an affection,- Believe me, dear Sir."

By 1902 the permanent collection had numbered just twelve paintings, of which John Fullwood's *'The Charcoal Burners'* was the twelfth. Shaw's letter was reproduced in the *Walsall Advertiser* on 14 June 1902 which recorded the Mayor and Councillors thanking Shaw for his gift of the picture and noting that John Fullwood was "an artist who was not unknown to many of them round that table" and that "as his brother artists considered (the picture) ranked amongst his best", they were doubly thankful to Mr Shaw.

The painting itself was described in the *Walsall Advertiser* as showing "That fellowship of man with nature" as it depicted trunks of beech and oak, "their black branches crossing and re-crossing overhead against a pale and yellow sky." A man is tending a heap of burning wood, "almost enveloped in curling, thick smoke, out of which here and there bright flames break out of the darkness."

Edward John Shaw had already donated one painting by John Fullwood to Walsall Art Gallery; in June 1897 he had gifted *'Over the Border'*, a scene of a graveyard at Shere Church, Sussex, in recognition of Queen Victoria's Diamond Jubilee. A review of this painting at the time stated "The sentiment inspired by the artist's

effort is one which only a true artist can create; that fellowship of man with nature, whatever may be her mood or season."

As the *Walsall Advertiser* noted on 15th February 1908, Shaw had also previously donated three of Fullwood's etchings of old Walsall to the Free Library & Art Gallery Committee. The Mayor's comments surely illustrated who was buying and collecting the art that John Fullwood was producing.

Shaw was a perfect exemplar of the circle in which John Fullwood was moving; he was a Liberal Councillor, a Superintendent of the Sunday School at Goodall St Chapel, an antiquarian and book collector – especially of William Blake - and someone who also reviewed art matters for the *Walsall Advertiser*. The *Walsall Advertiser* was the paper that kept up with John Fullwood's later career.

In August 1902 it reviewed September's edition of the *Art Journal* to which Fullwood had contributed the frontispiece '*An English Pastoral*' in which the reviewer noted "the delicacy of execution, the tender delineation and the brilliancy which pervades the whole plate…. '*An English Pastoral*' is an example of what an etching should be." The reviewer was, however, less complimentary about the accompanying letterpress, which was described as pointless.

An earlier recognition of John Fullwood's popularity with the Walsall bourgeoisie was as early as 24 February 1891 when the *Walsall Advertiser*, in reviewing an exhibition at Birmingham Art Gallery, had highlighted the work of John Fullwood "who stands high in our local appreciation" noting that "many of his natural landscapes….are to be seen on the walls of several of our Walsall homes."

Alongside Fullwood, the reviewer also noted Walter Langley as "one of a group of Art students who commenced their career together at Birmingham, several of whom have worked their way up to fame" and "one of Mr Langley's fellow students was John Fullwood." The author was M.E. Disturnal, bemoaning the lack of

an Art Gallery in Walsall unlike other local towns, although he was not to be disappointed for too long.

Some of the other Walsall homeowners who bought John Fullwood's work can be identified through newspaper adverts for auctions and other records, which identifies some of those collecting his work and the status in which it was held.

On the 20 November 1895 the contents of a seven bedroom residence were auctioned in Walsall, the contents of whose drawing room included "three water colour drawings by John Fullwood R.B.A," according to the *Walsall Advertiser*. On 16 June 1900 the *Walsall Advertiser* noted the auction of the contents of Great Barr Hall, the address of John Scott Esq J.P. The Hall was later used as an asylum, becoming St Margaret's Hospital. Scott was one time President of the Walsall Chamber of Commerce and a Town Clerk of Walsall.

The sale included "a choice collection of valuable water colour drawings by John Fullwood." One of these water colours was '*The River Flock*' which the same paper had noted was owned by Scott in December 1896. Another picture owned by Scott was '*A Kentish Village*', which was described as "full of light and atmosphere."

This painting, according to a review, certainly demonstrated Fullwood's bucolic view of the countryside with its "quaint cottages, the footpath border of tangled weeds and grass, the white road, the village girls and the glimpse into the old fashioned garden, which all bring to our mind recollections of quiet hamlets through which we have passed."

On 14 April 1908 the contents of W. Henry Robinson's house, "The Lindens", in Lichfield Rd Walsall, were auctioned. The auction notice highlighted "rare engravings and etchings" by John Fullwood, together with water colours of his that had been hung in the drawing room.

As the owner of the Walsall Steam Press and the publisher of the *Walsall Advertiser*, Robinson was also the founder of the Walsall Literary Institute, a keen astronomer (elected as a Fellow of the Royal Astronomical Society in 1900) as well as a local historian. He was also an author of (under the nom de plume Maurice Grindon), of novels written in the style then known as "scientific romanticism" and now more popularly identified as science fiction.

John Fullwood had provided two illustrations to one of Maurice Grindon's novels, "Kathleen O'Leavon," published in 1896, which envisioned an Ireland 50 years hence and was possibly influenced by his friendship with W.H. Duignan. W Henry Robinson and W H Duignan were friends, colleagues and even cycling companions, with Robinson using his tricycle to accompany Duignan on many cycling expeditions across the Midlands and further afield.

Fullwood maintained a friendship with the Robinson family for many years. A water colour by him was donated to Walsall Art Gallery in the 1960's by the Rev G. Barker, Robinson's son-in-law who confirmed that it had originally belonged to Lydia Robinson, W Henry's wife, who had then passed it to Margaret Baker, their daughter. Rev Barker wrote "He (Fullwood) was a friend of her mother, and it was done for her."

On the 11th February 1896, John Fullwood wrote to W. Henry Robinson from his address in Slinfold, Sussex:

Dear Mr Robinson,

I am pleased to tell you that Kathleen O'Leavon came to hand quite safely and my wife, who I am sorry to say is ill in bed, was pleased to see it and is looking forward to reading it, and so am I. What a nice looking book it is! My daughter, who has a real weakness in this direction, was quite "gone". She loves the smell and feel of a good book; but she, like myself, has much to do at present with nursing and so on. I shall be happy to know that the volume goes well. Walsall people who would be interested to know, being all homemade

162

and not made in foreign parts even to the lithos which are so frequently done away from home. Thank you very much, and all good luck to it.

With kind regards, also to Mrs Robinson and family, John Fullwood.

He even concludes with a P.S. *"What a nice review; have you sales yet?"*

In an attempt to encourage sales the author (W. Henry Robinson) had also sent a review copy to John Ruskin, whose Secretary responded that whilst "he had read (it) with interest and pleasure: he now no longer is able to give his criticism of books or M.S.S."

Robinson had also sent a copy to Wyke Bayliss, a painter, author, critic and poet who was at the time President of the Royal Society of British Artists, who wrote back "your book reached me this morning and I had to lay aside everything until I had read it."

Wyke Bayliss also made reference to "the kindness you showed me in my visit to Walsall, but I very warmly appreciate your courtesy which added greatly to the journey in a strange land." The friendliness between the two also reflects shared interests, with Wyke Bayliss being a fellow of the Society of Antiquaries. By this time, Wyke Bayliss had already commented favourably on John Fullwood's art work elsewhere, but it is not known whether he was aware of the artist's Walsall links.

The Rev Barker states his father-in-law (Robinson) suffered financially in old age, and certainly the auction of his house and its contents reflected a downsizing of the family's possessions. Robinson's daughter Margaret moved in with her father to provide care for him and to be his "faithful companion in old age" according to Rev Barker. The closeness of their relationship was touched upon in Robinson's obituary where it was noted that they were often seen walking together around Walsall and she was "his

devoted companion in the evening of his life." W Henry Robinson passed away, aged 79, in 1926.

R. H. Holden (J.P.) owned two of Fullwood's paintings '*The Breath of Autumn*' and '*Woodland Melody*'. The family was associated with the Congregational Churches in Rushall, Walsall and on Wednesbury Road, Walsall. R.H. Holden was the son of Edward Thomas Holden, one time MP for and Mayor of Walsall, and whose circle of acquaintances included Walsall Solicitor W.H. Duignan (later another Mayor of Walsall) and Charles Loxton. Loxton was another Solicitor, based in Walsall, who was Town Clerk to Cannock (where Robinson had been born) and was then Clerk to Walsall Magistrates bench.

Edward Holden and Edward John Shaw had been in business together as lamp glass and mirror manufacturers in Walsall until their partnership was dissolved in 1898, and it is possible, though unproven, that they employed James Powell Jones the Wolverhampton antiquarian. It is known that personal sketches by James Powell Jones were pasted into a lamp glass and mirror manufacturer's catalogue (now in the possession of Wolverhampton Archives) although this is catalogued as belonging to George Bradney Mitchell.

The Holdens were leather manufacturers and their house in Great Barr, near Walsall was named "Glenelg", after the Scottish birthplace of Edward Thomas Holden's wife. It was a fine example of a Victorian industrialist's rural retreat and a fit place to hang John Fullwood's art, especially those celebrating nature. The Holdens had long considered themselves patron of the arts in Walsall, both serving on a Committee, alongside W Henry Robinson, bringing an Exhibition of Fine Arts to Walsall in August 1889 to raise funds for the Goodall St. Chapel.

The Treasurer of this Committee, as well as the Chapel itself was William Bayliss and there were other links between W Henry Robinson and William Bayliss. On 14 August 1892 Bayliss wrote

to Robinson "Please accept my best thanks for Masonic books and papers – (for) the establishment of our Royal Arch Chapter, to the highest office of which I was instituted last month."

W Henry Robinson was a member of the St Matthew's Lodge, as was Frank James, another Walsall industrialist, a Councillor and who was later to become a Conservative MP for Walsall. All of these citizens, Robinson, Bayliss, Holden and James, regardless of their differing political outlooks (Conservative vs. Liberal), and religious affiliation, (Church of England vs. Non-conformist) managed to put aside these differences to support the Walsall Literary Institute.

Underlying these affiliations, however, were familial links as William Bayliss was the father-in-law of Edward John Shaw; his daughter Sarah Jane having married Shaw in July 1885. On 8 July 1916, the *Birmingham Daily Post* advertised the auction of the estate of William Bayliss J.P., of Ivy House, Wednesbury Road, Walsall. The house contained "valuable oil paintings" including works by John Fullwood, Alfred Drury and Dante Gabriel Rossetti together with "many choice examples of John Fullwood R.B.A. water colour drawings" and proof-etchings by the same artist.

The auctioneers drew special attention to the sale which "includes some of the finest works of John Fullwood R.B.A." At one time Bayliss owned 'Cottage Homes, near Stratford' which was exhibited at the 1904 Walsall Art Gallery Exhibition. William Bayliss was a Mayor of Walsall and became President of the Walsall Science and Art Institute.

The fundraising activity reinforces another strand that connected John Fullwood to his patrons; that of the non-conformist Church. William Bayliss and Edward T Holden had long established links to the Congregational Church in Walsall. In August 1865 they had raised funds to liquidate the debts of the Bradford St Congregational Church and this reflects that in this time the Church, or Chapel, was more than simply a building.

The community that this church served also participated in the educational classes, the money raising activities and the sense of mutual aid and connectedness that ran through the congregation. The non-conformist Church perhaps reflected less of the inhibited social mobility of the established Church, allowing the son of a newsagent to mix on more equal terms with feted local industrialists.

There is one more connection, of a personal nature. On the population census night of 1891, a visitor stayed with John Fullwood and his family when they were living in Richmond, Surrey. Her name was Dorothy Shaw Bird, aged 6 and had been born in Walsall. She was a contemporary of Maybell Fullwood in age and so was perhaps a school friend. Dorothy's family had lived in Westbourne Road Walsall – the road in which James Powell Jones had lived – and her father was George Bird, who was a school teacher and was later ordained as a Vicar in the Church of England.

The *Walsall Advertiser*, on Saturday 9 October 1909, carried details of an auction for the house contents of William Sanders, also of Walsall; included in this sale was the "well known and valuable collection of pictures" that were "choice, and in many cases exhibited, examples of authenticated works of Walter Langley, John Fullwood (and others)." Sanders was a prominent Walsall industrialist.

On 14 June 1913 the *Walsall Advertiser* recorded the auction of the estate of Joseph Shaw (deceased), which included "valuable pictures, many of which have been exhibited at Birmingham and other Art Galleries (including) water colours by John Fullwood (and others)." A separate entry was made for etchings, of which John Fullwood was the only artist listed.

Joseph Shaw was a glass merchant who owned premises at the top of Park St, Walsall The art department of his store dealt in picture frames as well as oil and water colours and in a sale in May 1894 he

had advertised "20 very fine water colours by John Fullwood R.B.A. and 100 other pictures."

Further afield auctions of house contents also identify sales of John Fullwood's works. On Saturday 27 November 1915 the *Birmingham Daily Post* recorded an auction of 120 oil painting and water colours including works by John Fullwood and Birmingham contemporaries such as T. Baker and W. Oliver, as well as David Cox the elder and even J.M.W. Turner.

On October 11 1918 an auction was held "By direction of Mrs Booth" of the entire contents of her residence. It is not known who she was, or where she had lived but included in the sale were oil paintings and water colours by Walter Langley, Fred Mercer and John Fullwood. In all of these cases, the auction notices also show substantial listings of quality furniture, jewellery and books. The people who bought John Fullwood's paintings had appreciated his art, but in buying them they were also demonstrating their taste and their financial standing in society.

References to John Fullwood's works continued around the period of the Second World War, indicating that his memory was still remembered locally. The estate of the late Sophia Drew of Lichfield Rd Walsall was auctioned in April 1939 and John Fullwood was listed first amongst the artists' works sold.

Later the same year a Mrs Caroline Dickinson, living in London, left '*Looking across South Downs*' to Walsall Art Gallery in her will. A year later five Fullwood etchings, all stated to be of local interest, were auctioned off in Walsall in aid of the Red Cross.

In December 1945 an advert in the *Birmingham Daily Post* for the sale of the contents of a house highlighted John Fullwood's works, as did the *Staffordshire Advertiser* of April 1st 1950 in advertising the contents of the house belonging to Mr G M Whitehouse of Bridgetown Cannock; Whitehouse was strongly linked with the Methodist New Connexion Church.

This pattern of ownership illustrates the evolution of the market for art during the time of Fullwood's emergence as an artist. The traditional art collector prior to the start of the Victorian period had been, stereotypically, someone of the landed classes, the aristocracy who had travelled on the Grand Tour and who bought continental art.

By the 1850's onwards however, the initiative had passed from the aristocracy to the newly enriched middle class; the entrepreneurs, merchants and manufacturers that were a product of the Industrial Revolution, especially in the booming industrial towns of the West Midlands, where the traditional aristocracy retreated to their rural land and the factory owners took prominence. It is not an exaggeration to say that the taste of the Nineteenth century was dictated by the middle classes, just as the aristocracy had dictated the taste of the preceding century.

The regard for Walsall shown by John Fullwood throughout his life was echoed in 2017 when the townsfolk were asked to nominate their favourite artworks from their Art Gallery's permanent collection in order to mark the 125 anniversary of its foundation. The winner in the category of "Nature" was a John Fullwood etching, 'Silver Birch Trees'.

Chapter 12 Inspired By Nature

"Nothing can be beautiful which is not true"

This declaration by John Ruskin, referring to the need to depict nature accurately, draws from the line "'beauty is truth, truth beauty,' – that is all / Ye know on earth, and all ye need to know" by John Keats. Ruskin was the most influential art critic in Britain at this time and directed Victorian taste through his writings and public statements. For him, the prime concern was the landscape, not the people within it. Ruskin identified that "I would rather teach drawing that my pupils may learn to love nature, than teach the looking at nature that they may learn to draw" and John Fullwood's love of nature was evidenced in the inspiration he drew from it and the truthful way he portrayed it.

William Cowper was the poet from whom John Fullwood had drawn inspiration when painting the 'Yardley Oak' and Cowper's lines, from "The Task" written in 1785, would surely have struck a chord with him.

Nature, enchanting nature in whose form,

And liniments divine, I trace a hand,

That errs not, and find raptures still renowned,

Is free to all men – universal prize.

John Fullwood's use of nature for inspiration reflected wider changes in society. Until the middle of the nineteenth century the Victorian patriarch would probably both live and work in the same place. But this was the start of the industrialisation of Britain, which meant that, at least in terms of numbers, urban development was overcoming rural society.

Indeed, John Fullwood was born in the decade that saw the majority of the British population live in an urban rather than rural environment for the first time. He would have seen the growth of the towns and cities as the villages of his childhood merged and become the suburbs of the growing conurbation.

The nature of the newly expanded Victorian bourgeois was to demonstrate their escape from the urban slums that they were creating for their employees by retreating into the emerging suburbs. However they, with their inherited love of the countryside, still clung to the belief that "Man made the town but God made the country" and wanted to purchase landscape pictures and rural scenes to line the drawing room walls in their suburban villas. The Holdens and Bayliss' in Walsall, and the Manders in Tettenhall all chose to live away from the site of their industry. A poem from 1789 celebrated Tettenhall as "a sweet, peaceful place" and one where "Here Hampton's sons in vacant hours repair, Taste rural joys and breathe pure air."

To Ruskin, and many others, nature revealed the wonder and infinite virtue of God's creation; therefore factual integrity was a key component. Ruskin believed that "all truth and beauty are to be obtained by a humble and faithful study of nature, and not by substituting vague forms, bred by imagination on the mists of feeling, in place of definite, substantial reality." John Fullwood's artistic preference for painting nature accurately may have reflected his Congregationalist influences, but also was an opportune fit with the times.

For John Fullwood at least the music of the wind in the tree leaves drowned out the noise of the machinery in the city. That theme would continue to resonate throughout John Fullwood's career and had become apparent from an early stage; his love of nature, the rural idyll and the countryside was the mainspring of his art. Indeed, the 'English Pastoral', the idea that a simple rural existence was the most desirous of lifestyles, inspired one of his greatest works.

The *Hampshire Advertiser*, on 6 August 1902, usefully describes the picture as "typical of the willowy land above and below Evesham." The article continues by stating John Fullwood signed one hundred proofs from this plate, "printed on Japan paper, with copies to be obtained from the publishers."

This etching made the cover of *The Art Journal* issue of 16 August 1902. *The Walsall Advertiser,* describes John Fullwood's cover etching as: "The chief and most worthy contribution to the part (Art Journal) under review, is undoubtedly the beautiful etching by Mr John Fullwood, R.B.A., in itself worth many times over the cost of the complete number. It is entitled 'An English Pastoral' and if testimony to the power of the etching needle is required, we have it here. Delicacy of execution, tender delineation and a brilliancy which pervades the whole plate, combine in such measure as to result in a beautiful specimen of Mr Fullwood's skill. Among the meretricious impressions from copper, now so common, and called 'etchings' only as a courtesy title, 'An English Pastoral' is an example of what an etching should be."

Perhaps his desire for a rural outlook is unsurprising as he lived through a time of increasing industrialisation and he himself chose to move away from a part of the country that was disfigured and scarred by heavy industry and mineral extraction towards rural and suburban peace.

David Cox had a huge influence as a master artist during the nineteenth century and is associated with the Birmingham art scene, and in particular the teachers who taught John Fullwood. David Cox, born in 1783 had his early artistic education in Birmingham. After a short period working in London, he returned to Birmingham to hone his skills and publish several books to help others studying art.

David's first book, '*A Treatise on Landscape Painting and Effect in Water Colours: from the First Rudiments to the Finished Pictures with Examples in Outline, Effect, and Colouring*' (usually referred

to as *A Treatise*), was published in several parts from March 1813 to February 1814.

In 'A Treatise', Cox spent several pages on "General Observations of Landscape Painting" and he spent many years teaching and practising landscape painting throughout his lifetime. Many elements of the practice of art and consequently the love of nature, demonstrated in John Fullwood's later career can be traced back to the step-by-step guide written by Cox.

As Cox wrote in '*A Treatise*', "The best and the surest method of obtaining instructions of works of others is not so much by copying them, as by drawing the same subjects from Nature immediately after a critical examination of them, while they are fresh in the memory." Cox also stated "A greater degree of minuteness, however, ought to be observed in the outline of the fore-ground of a picture, where the features of object assume a more specific appearance,......it will be necessary to make correct drawings from Nature, of weeds, plants, bark of trees, and such objects as usually constitute the foreground of a landscape." All of these lessons were absorbed faithfully by John Fullwood and demonstrated in his works.

Cox featured many scenes of the traditional, rural world. It is unsurprising therefore that the Birmingham art scene of the 1870s was dominated by artists like Henry Vatler, Charles Aston, James Jelly and William Joseph King – all of them georgic painters and dedicated to painting almost anything but Birmingham with its industrial landscape.

Their exhibited paintings often featured the dramatically picturesque landscape of Wales or Scotland which in turn had either a passive or moral content. John Fullwood visited North Wales early in his career ('*On the Ogwen*') and used country churchyards ('*O'er the Border*' – *drawn near to Shere Church in Surrey*) to make his metaphorical points.

Thomas Creswick (1811-69), another Birmingham born artist, often painted pastoral idylls featuring broad expanses of still, reflective water and Ruskin praised him as one of the few artists who "do draw from nature, and try for nature." The parallels with John Fullwood's work along and around the Thames are obvious. The *Times*, in its review of the 'Winter' 1891 Royal Academy Exhibition especially praised Fullwood's "quiet, unaffected landscapes", where he showed the paintings *'Sussex Harvest'* and *'Sunny Vale'*.

John Fullwood was to now move address again, for reasons which remain unclear. He arrived in Hastings in autumn 1893, settling not far from where Edwin Haseler, his old colleague from Wolverhampton, had set up a business. John Fullwood, though had been a visitor to Hastings some time before that.

The *Hastings and St Leonards Observer* recorded Mr and Mrs Fullwood staying at the Alexandra Hotel in September 1889. His cousin Benjamin Fullwood also stayed nearby at the Palace Court Hotel in November and then again the December in same year, not leaving until after Christmas and the New Year. John and Kate Fullwood also stayed at the Palace Hotel for the following New Year.

Benjamin Fullwood was the Treasurer of the Wolverhampton Freehold Land Society, whose motto "county votes for the working man" demonstrated the society's purpose, which was that working class men were to be enfranchised by becoming freeholders. The unstated hope was that these newly enfranchised men would exercise their vote on behalf of the Liberal party in growing its vote. The Wolverhampton Freehold Land Society's President was Charles Pelham Villiers MP, for whom John's cousin Robert Fullwood had acted as the Electoral Agent.

Benjamin Fullwood had also witnessed the order dissolving the partnership between John's Uncle John and Mr Yates which had

transferred the cooperage business to Joseph Fullwood, John's father living in Worcester Street, Wolverhampton.

'Hastings From The Pier' a family painting by John Fullwood.

During 1894 John Fullwood produced a large picture called *'A Song of Autumn'* using his new address of Bank Buildings in Station St, Hastings.

John Fullwood took inspiration from his new location and executed paintings of Hastings for the August 1895 edition of the *Art Journal* which accompanied text giving a historic account of the various parts of the town in an article "Hastings, old and new." The writer describes the history of the castle and the old town and mentions the local golf course before moving on to the slopes of the East Hill, describing the "lovely views" of both the sea and Hastings town. The article describes crossing East Hill towards the village of Fairlight and the nearby romantically named Fairlight Glen, Dripping Well and Lovers' Seat. Fairlight Glen was used by John as the setting and title of his self-published fantastical book.

The couple lived in Hastings until 1896 before they moved to Slinfold, Sussex, but John's art work continued to get good reviews in the local paper in the following years, even after they had moved onto Slinfold and then London.

Perhaps this was due to the favourable impression that John had made on the art critic of the *Hastings and St Leonards Observer* who described meeting John on New Year's Eve 1893 "It has been my good fortune to meet Mr Fullwood within these last few days, and I must say of a more modest gentleman, a man in whom the highest artistic genius and absolute self-unconsciencousness are harmoniously blended, I have never before had speech.....in Mr Fullwood, who took up his residence amongst us less than three months ago, we have a stranger, but in his person we have also been entertaining an artist of high capacity and distinction."

The August 1985 edition of the *Art Journal* also referenced the "the school of nature" as influencing John Fullwood, and mentioned the Selborne Society in this context. The Selborne Society was formed in November 1885 to perpetuate the name and interests of Gilbert White, the naturalist, who had lived in the village of Selborne, Hampshire in the late 1700s. Slinfold, where John Fullwood lived later is a mere thirty or so miles away and he was familiar with the area, painting the River Adur, which rises in Slinfold, amongst other local scenes.

The Selborne Society later joined the Plumage Society, and from this emerged the modern day Royal Society for Protection of Birds (R.S.P.B). It counted John Ruskin, Robert Browning, Richard Jefferies, W H Hudson and Lord Leighton amongst its first members and Alfred Lord Tennyson, the Poet Laureate, had accepted the role of President, which he held until his death in 1892.

The Selborne Society also enjoyed the patronage of Royalty with Princess Christian, the daughter of Queen Victoria, an active member and also a keen water-colourist in her own right.

In another of those coincidences and entanglements which pepper this story, Princess Christian had accompanied her mother when she had visited Wolverhampton to unveil the statue of Prince Albert in 1866. John Fullwood may have been present as he was aged twelve

and contemporary reports state most of the population of the town turned out to see the Queen.

Present day Gilbert White's home, (photo taken by David Fullwood 2015) now a museum, located in the picturesque village of Selborne in Hampshire.

The Selborne Society's stated purpose was the preservation of birds, plants and pleasant places and it ultimately became Britain's first national conservation organisation. Two members of this Society went on to form the National Trust in 1895 in order to preserve these "pleasant places."

John Fullwood was an active member, being elected to the managing Committee in 1892. This love of nature was surely passed down the generations as John's daughter Maybell had a letter published in *Nature Notes* that year describing the feeding habits of swallows in Kew Gardens.

In 1898 John Fullwood designed a membership badge for the Selborne Society. An advertisement in their magazine, *Nature Notes*, stated the badges were tastefully designed in pale blue and silver to reflect the forget-me-not flower, with the Society's

Councillor Badges having a crimson centre. They were subsequently advertised for sale in *Nature Notes* as a broach costing 3s (shillings) and as a pin at 1s 9d (old pennies) and could be ordered via local branches or directly through John Fullwood at his Stanmore Road, Richmond, London address.

John Fullwood's design for the Selborne Society

The organization published the magazine with the explicit objective of it being a connecting link between "unrestricted love of nature and accurate scientific knowledge" a position which perfectly encapsulates two of John Fullwood's passions. In 1903, whilst living in Slinfold, Sussex, he was one of the many who reported to the Royal Metrological Society on the impact of the great dust storm that year in his locality.

In 1898 *Nature Notes* published an article regarding the introduction of "smelt", or juvenile Salmon, to the River Thames at Richmond, London in an attempt to make the river a habitat for salmon once again. John was a keen angler and he retained an interest in the progress of this experiment. On one occasion with enthusiastic if misguided zeal, he caught some juvenile fish and posted them to the London Press as proof that salmon had returned.

Unfortunately the enclosed specimen did not survive the postal delivery in a sufficiently recognisable state, being delivered as a

very smelly mush. Fish, in particular, were one of John's passions. The *'Minnow Catcher'*, one of John's most commercial etchings, was included in an anthology of fishing lore "Thames, from its rise to the Nore" by Walter Armstrong published by Virtue and Co in 1886. A New Year card dated 1900 of his design survives showing a fish- possibly a salmon- leaping from a wooded pool. It was addressed to his neice Vera and her husband Joe, still living in Wolverhampton.

Whilst living in Hastings, Sussex, John Fullwood painted two pebbles in watercolours onto the reverse of two plain postcards. They were of geological samples he had found on the beach. These, alongside 118 other intricately detailed representations of minerals encased in rock on identical postcards, are now held by the Natural History Museum (N.H.M.) in London, having been gifted by the family after the death of his daughter, Maybell Slater.

Indicative of a private passion and clearly not intended for public display, these dated and captioned miniature views give an insight into both John Fullwood's passionate study of nature and geology and of his travels around the United Kingdom.

John Fullwood clearly was well connected with prominent naturalists as a postcard written in 1900 and now in the collection of the N.H.M. demonstrates. The note was addressed to Georges Boulenger, a first-class assistant in the Department of Zoology at the N.H.M. and a noted author whose list of publications and its index of species, covers 77 printed pages. John Fullwood wrote to ask for the current address for another contact they had discussed, having visited Boulenger earlier to show him some his drawings.

John's obituary in the 12 September 1931 *Richmond Times* noted that geology was a passion of his, as it was for many Victorians and Fullwood would collect stones from the beaches around the coasts of Britain as he travelled around the country for both work and leisure.

The article states; "He knew the history of each one. Some he would have to cut open so that he could paint the intricate pattern revealed within. Some of these pictures resemble landscapes in miniature with mountains, rushing streams, and purple skies."

When John Fullwood's Civil List Pension was awarded in 1907, the accompanying Cabinet Office notes referred to John's work as reminiscent of William Blake, and in his study and recording of these stones, he was surely aware of Blake's view of the infinite wonder of the natural world where it was possible "To see a world in a grain of sand, and heaven in a wild flower."

It is not surprising either that one of John Fullwood's closest acquaintances and a patron in Walsall, Edward Shaw, was a noted collector of Blake's works. Perhaps John Ruskin, whose influence on the development of artistic taste and practice in England during the period John Fullwood was studying art cannot be overestimated had this in mind when he championed the importance of "fidelity to nature" and when he specifically described small stones as pearls or "mountains in miniature."

Many Victorian artists studied geology and natural history, and were determined that their art would reflect their knowledge in its accurate depiction of nature. Ruskin's theories of art were deeply rooted in both the scientific and religious ideas of the day as he stated "All great art is praise" and this influenced especially the Pre-Raphaelite Brotherhood's works, with their landscapes fired by a passion for the natural world.

Ruskin truly believed that, "Only truth can produce beauty" and that students should approach nature "in all singleness of heart rejecting nothing, selecting nothing, and scorning nothing."

Yet this advancement in the science of geology caused some consternation to the Victorian mind as increasing scientific certitude regarding fossil records overturned accepted Christian dogma and belief.

As Ruskin himself noted "the clink of the geologist's hammer" chipped away at long held belief. This process can be said to come into being in the 1830s with the publication of Charles Lyell's *Principle's of Geology* in which he stated "on the opinions entertained before the Christian era... the observation of the present course of nature presented too many proofs of alterations continually in progress on the earth to allow philosophers to believe that nature was in a state of rest or that the surface had remained and would continue to remain unaltered."

All of this would have had resonance with the student John Fullwood as he absorbed Ruskin's teaching, the practice and discipline of drawing and encountered new and challenging ideas. All which would, in turn, be reflected back in the paintings, sketches and etchings within which the mature Fullwood depicted nature.

Chapter 13 American Recognition

By the 1890s John Fullwood was a productive and successful etcher. The *Hastings and St Leonards Observer* noted, on 6 July 1895, the issue of a catalogue of his etchings in which "the total of those completed and those in progress tops the hundred." The source of much of this success, however, was not his homeland; it was America.

A biographical sketch of John Fullwood published in July 1907 by the *Birmingham Daily Gazette* noted that "For some time there has been a great demand in America (for his etchings). In fact, the most noted publisher in New York has frequently said that only three etchers work sell in America: Whistler's, Seymour Haden's and John Fullwood's. Some competent judges think that second place should be taken by John Fullwood." The article concluded by noting that "Mr Fullwood stands in the very front rank of etchers. Some of his etchings had a very limited edition and fetched high prices. Some of them called forth the highest praise from so great and stern a critic as John Ruskin."

In Britain, Fullwood's works were distributed by publishers belonging to the Fine Art Trade Guild (as were etchings made by his cousin Albert Henry Fullwood) whereas in America the prestigious dealer Frederick Keppel & Co of East 16th St, Union Square, New York was the principal agent for his American sales. The probable source of the "noted publisher" identifying Fullwood's worth was Frederick Keppel himself. Keppel was an Irishman who had come to America in 1864 and began trading as a bookseller, but from 1868 had started dealing in prints. He became one of the most important print dealers in late 19th century America and was a catalyst in the success of the "Etching Revival" as well as the author of several books and publications on the craft and history of etching.

Keppel was allegedly colour blind and so preferred black & white etchings over paintings. He took his family on vacation to Barbizon in France each year and attended the Paris Salon, where he got to know many of the leading artists exhibiting there. He was also trying to identify new and emerging talent that he could represent in America.

One of Keppel & Co's biggest sellers in the 1890's was James McNeill Whistler. Keppel counted Whistler both as a friend as well as a client; although their relationship cooled later in life when Whistler perceived Keppel to have taken sides in his dispute with Seymour Haden, who was Whistler's brother-in-law. Keppel was unable to effect reconciliation between them and after Whistler's death he published a small pamphlet of his letters to the pair, entitled *The Gentle Art of Resenting Injuries,* a rejoinder to Whistler's more notorious book, *The Gentle Art of Making Enemies.*

Whistler's most famous enmity was with John Ruskin, who he sued for libel when Ruskin criticised his work. John Fullwood's view of the dispute is unknown but surely his temperament would incline to Ruskin's spirituality rather than Whistler's "Art for art's sake" abandonment of religion, morality or history.

Keppel had clearly spotted Fullwood's emerging talent during his trip to Paris in 1883 but the friendship was to endure for many years. A proof etching still exists on which Fullwood, having commented on some alterations, addressed his "Dear, kind Friend, Fredk. Keppel, 21 May 1903." Frederick Keppel died in 1912, although the business was continued by his son.

Keppel's attachment to black and white art is reflected in a poem he wrote in the 1880's, dedicated to another New York gallery owner, called "Among my prints".

I sit among my folio's all,

My friends in black and white,

And silent speakers wise, as fair,

Surround me as I write.

With pride the favourite prints I see,

That my poor walls adorn,

Symmetric *Line* and *Etchings* free,

And royal *Proofs* first born.

Keppel & Co was selling Fullwood's work as early as 1884, the year that Hellier sued Fullwood for not supplying any more etchings for the book 'Remnants of old Wolverhampton'. A review in the *Buffalo Commercial* newspaper in New York State that year highlights two etchings by John Fullwood, '*A Devonshire Hayfield*' and '*The Belated Traveller*' in an exhibition by Keppel & Co hosted by a local dealer. Keppel & Co still advertised these for sale in their 1897 catalogue and noted that they had been exhibited at the Paris Salon, as well as the Royal Academy exhibitions in London.

Keppel & Co's approach to realising the value of their artists was highlighted in the introduction to their Illustrated Catalogue: "Our aim always has been to issue works which appeal rather to people of real culture than to the larger and less critical public. In consequence we issue very limited editions of these works, and in many cases we take the further precaution of destroying the copper plates so as to prevent the possibility of subsequent printing from them, thus insuring the rarity and permanent value of the original edition."

The practice of issuing etchings in limited editions had developed from the late nineteenth century. The limitation of the number of quality impressions taken from each original had previously been limited by the technology; it was generally considered that no more than three or five hundred good quality prints could be taken off a copper plate.

After the development of lithography and especially of steel facing metal plates from the mid nineteenth century, it became possible to pull off many thousands of prints without a noticeable loss of quality. Because of these technological developments print sellers such as Keppel marketed limited edition prints, creating an appearance of scarcity and individuality for what was essentially a multiple-impression art form.

Another review of John Fullwood's work in America, in the *Brooklyn Daily Eagle* of 8 November 1885, described an exhibition of etchings at the Keppel Gallery in New York: "John Fullwood is an English Etcher who makes landscapes...but who makes every etching a picture. Frederick Keppel has just acquired some of his plates and has them on exhibition. 'A Gypsy Camp' is the subject of his last work. The lights are crisp and the shadows strong, and the plate has a solidity and evenness that is due in part to the fact that it has never been retouched but was made at a single sitting."

That John's work was becoming more widely known in America is shown by the same newspaper's review of the September 1886 copy of the *Art Journal*. This was a London publication and Fullwood's '*Minnow Catcher*' was the frontispiece of this edition. The American reviewer enthused over it, contrasting the work's looser style with the usual British rigidity and precision of form that this magazine featured. John Fullwood's work, it stated, "is like catching British art in its shirt sleeves, to find so easy a performance there." This more relaxed approach was especially noted in the depiction of "the sheep on the opposite bank of the stream where the young angler has cast his line (which) are very rudely done."

This early favourable press comment generated sales, some to prominent art collectors such as Mary Morgan. She was the daughter of an industrialist and whose cousin was the financier J P Morgan. As such she could collect the best works of art and so did: her collection included examples of work by Constable, Millet, Delacroix and Corot, amongst others. It also included seven etchings by Fullwood, including 'A Devonshire Hay Field', presumably bought from Keppel & Co. After her death in 1886 her estate was auctioned and realised more than a million dollars.

The *Brooklyn Daily Eagle's* reviewer clearly kept an eye on the appearances of Fullwood's work at Keppel's gallery. An unnamed work by John Fullwood was described as "a singularly large and strong drawing" in the November 1892 edition. It went on "the drawing is in sepia and represents an evening effect. The foliage is especially massive and the result of the manful treatment of the subject is almost grandiose." The same paper obviously felt that the 1896 biographical article about John Fullwood in the *Art Journal* would be of interest to American readers, as it noted it in its review of the magazine.

Further afield *The Chicago Daily Tribune* of 13 August 1893 noted that Keppel & Co had published a new plate, '*Twickenham Elms*' by John Fullwood which was "a charming landscape motive treated with delicacy and sentiment." Keppel's catalogue, notes that "The etchings of this rising young English painter are specially recommended for framing. They are bold, strong, painter-like and thoroughly original", and it included '*Twickenham Elms*' as a signed artist proof on vellum at $7.50 along with three other etchings it notes "were etched from nature in 1893" (the phrase "signed artists proofs" distinguished the original prints from subsequent reproductions).

Another Keppel exhibition that year was reviewed by the *Brooklyn Daily Eagle* which noted "clear and brilliant works" by John Fullwood. Again, in December 1902 the same paper highlighted the release of two more etchings through Keppel '*A Houseboat near*

Windsor' and '*A Road by the Trent*' which it described as "typical of the English landscape and agreeably composed."

Frederick Keppel died in 1912 and perhaps the energetic marketing of Fullwood's work subsequently lapsed. By January 1916 the *Brooklyn Daily Eagle* merely carried an advert for etchings by Fullwood, although one which described him as someone who "stands in the front rank of contemporary landscape-etchers." His declining popularity is reflected when, on 31 October 1927, the same newspaper carried an advert describing his work as by one of the "contemporary English Artists of note" and that his works were still exhibited for sale, but this time in the Loeser Gallery and that they were "modestly priced."

The sale of Fullwood's work to "people of real culture", as Keppel's catalogue noted, had peaked through the last years of the nineteenth century. This was the "Gilded Age" and Keppel's phrase was shorthand for the new financial elite. Mary Morgan is a case in point and his success in selling Fullwood can be tracked in later auction sales. In 1905 Keppel & Co sold the collection of the "well known collector" Monsignor Doaune which it described as "a judicial collection of engravings and etchings of the right sort", and which included eight etchings by John Fullwood.

An auction of the estate of the Baltimore banker David T Buzby was held in Madison Square Gardens, New York, in 1906 and Fullwood's 1893 engraving '*Twickenham Elms*' was amongst those sold. Another auction, that of the collection of the society photographer Frederick Gutekinst in 1917, contained "valuable proof etchings" by John Fullwood, as did in 1918 the estate of W C Craigie, Assistant Trust Officer of The Provident Life and Trust, Philadelphia. These last two sales were handled by the auctioneers Storn Henkels, who noted these catalogues as containing "Ancient and modern etchings by the most noted masters of the art" and listed Durer, Rembrandt, Corot, Daubigny and Whistler alongside Fullwood. S.V. Henkels was a leading authority on prints and rare books as well as an auctioneer, bookseller and cataloguer.

The importance of Fullwood's works in these collections should not be exaggerated: they formed a very small part of the whole and they kept the company of considerably more recognised artists. Indeed, their inclusion probably reflects more of the keen marketing of Keppel than of their intrinsic worth. Nevertheless, what is important is the fact that Fullwood was considered collectable by the elite and worthy of inclusion in their collections.

The American market also offered another opportunity for Fullwood to profit from providing illustrations for books, both of British publications sold in the USA but also of books produced by American publishers for their home market. Several reviews of London publications in American newspapers referred specifically to illustrations by John Fullwood, indicating that his work was sufficiently well known in America to attract readers of those papers.

The New York Times, in Sept 1894, merely listed that it had received a copy of 'The New Forest', by C.J. Cornish, to which Fullwood supplied illustrations but the following year it gave a full review to 'The Isle of Wight' by the same author, and noted the contributions of John Fullwood and especially his etching 'Freshwater Gate', which provided the books frontispiece.

The New-York Tribune had given a much more fulsome review of 'Fairlight Glen' on 26 February 1896. The same newspaper, in August 1912, also noted the publication of 'The Village Homes of England', with illustrations by Fullwood, amongst others with the reviewer identifying "charming examples of ancient English architecture."

The Philadelphia based publisher J.B. Lippincott and Company which, at the turn of the twentieth century was one of the largest and best known publishers in the world, published a series of illustrated works in 1888. Included in this series was "The Message of Love" originally published by Griffin, Farrran and Co. in London, and which was illustrated with twenty four of Fullwood's

landscapes. Lippincott's publicity stated that the series was "illustrated by English artists of repute." The following year "Easter Bells" with Illustrations by Fullwood was published in America, with a review in the "Book News."

John Fullwood's work achieved far greater cultural penetration in North America when it was subsequently licensed for commercial use. There are examples of Christmas cards and perfumery adverts produced in the depression era 1920's that used his bucolic images to reflect an earlier, and more simpler time. Cheap coloured lithograph editions of his popular works were sold through retailers such as Jordan Marsh, the largest regional chain of department stores in New England.

Yet the American market was also to deal a blow to John Fullwood's artistic, if not financial concerns, as the *Birmingham Mail* reported in his 1931 obituary that "some years ago a number of his best etchings went down with a boat bound for America and, these being artists proofs, and the plates in accordance with custom having been destroyed, the prints became rare and the price went up."

Examples of John Fullwood's work can still be found, although not currently displayed, in American galleries; the Harvard Art Museum, the Currier Gallery in New Hampshire, the National Gallery of Art in Washington and the San Francisco Art Museum all contain examples of his etchings. The New York Public Library has the engraving 'English Pines' on display (No 112 in Keppel's catalogue) as part of the Miriam and Ira Wallach bequest.

Chapter 14
John Fullwood in London

"Where the silver Thames first rural grows"

Cowper was not the only poet from whom John Fullwood derived inspiration. John used the poem 'An Ode to Autumn' by James Thomson, as the source for three etchings, reflecting on the line "When Autumn's yellow lustre gilds the world."

The same poem sequence, in 'Summer', also provides the line quoted above, identifying that point on the Thames where the poet considers the rural nature of the river parts from that element within the city. For Thomson this was at Richmond, then a town in Surrey, before it subsequently became absorbed into Greater London.

Thomson was a Scottish-born poet resident for many years in Richmond, a place which John Fullwood made his adopted home town in his later years, although he lived in a number of Thames-side locations as his economic circumstances changed through time.

Given his predilection for nature, it was perhaps fitting that John chose this location to live in. The twelve mile stretch of the Thames between Hampton, Twickenham, Richmond, Kew and Chiswick had been identified since the 18th century by writers such as Addison and Pope as that Arcadian stretch of the river where man and nature lived in harmony. In describing it so, these writers had sought inspiration from the classical, pastoral, poets of ancient Greece and Rome, and indeed John Fullwood was to entitle one of his best known etchings 'An English Pastoral'.

In July 1896, the *Portfolio* magazine contained a monograph on Richmond-on-Thames written by Richard Garnett, Keeper of Books at the British Museum. This was later published as a standalone book for which John Fullwood produced his etching 'Richmond Hill' as the frontispiece.

Garnett and John Fullwood both used Thomson's poem 'Summer' in association with their works of art. Garnett liked the Richmond area because it was patronised by the monarchy and aristocracy as 'splendid' locations for their grand houses but by now their popularlity was in a sad decline. Garnett had noticed the expansion of towns and cities as well as the improvement in transport links. He gave these reasons for the decline and used the phrase "rus in urbe".

Richmond Hill itself, as Garnett recalls, is where "nature has here adorned the generally level banks of the stream with a summate felicity which could not have been surpassed if the site had been the choice, and the hill the creation, of the most accomplished human creation." Indeed this view remains protected by an Act of Parliament and John Fullwood's delicate etching catches the mood of Garnett's description, with the view of Richmond Palace in the background.

This etching, *Richmond Hill*' along with another '*The Thames at Twickenham*', which represents the stretch of the river between the Embankment and Richmond Bridge itself were purchased by Richmond Council to hang in their newly built Town Hall and Library in 1897. In the latter etching Fullwood subtly altered the relationship between the Church and Eel Pie Island to suit the composition and enhance the feeling of peace.

As well as the natural attractions of this area of the River Thames, and the fact that the extending tentacles of the railway network afforded easy access into central London, there are two other, albeit tangential, connections to Wolverhampton which may have influenced his choice.

John Fullwood had first moved to Surrey by May 1885, after returning to England from Paris. His new address was 15 Apsley Villas, Twickenham, which were built in 1845 on land previously belonging to the estate of Twickenham House, a grand house built

at the beginning of the 18th century and subsequently demolished in 1888.

The extension of the railway network had extended the reach of those who wished to have easy access to London but live in a more rural location and many such estates were being broken up to provide building land. Another residence located in the garden of Twickenham House, known as Diamond House, was built sometime in the 1760s and demolished in 1887. Doctor Hugh Diamond leased this property from the 1850s and ran it as an asylum, mainly for female patients. Dr Diamond was a member of the Society of Antiquaries and held regular weekly gatherings in his garden. One of the regular attendees was George Wallis, and Wallis' daughter Rosa painted Diamond Villa shortly before its demolition. It is known that George Wallis kept a close link to his home town of Wolverhampton and the correspondence in local newspapers had certainly brought John Fullwood's name to Wallis' attention. Perhaps Wallis recommended the area?

Another, admittedly unproven, connection was that the Member of Parliament for Wolverhampton, Charles Pelham Villiers, for whom John's cousin Robert Fullwood was a committed activist and party worker, kept a house in Parkshot, Richmond. Given the difference in social standing between the two a friendship is unlikely.

However Benjamin Fullwood, another cousin and one with whom John Fullwood was close, worked closely with Villiers on the Board of the Wolverhampton Freehold Land Society. If Benjamin had effected an introduction to Villiers then the support of such a prominent local figure would have been very helpful to an artist seeking to establish himself in London.

John Fullwood, with his wife Kate and ten year old daughter Maybell, had moved again by 1890, after returning from living in Hastings, to Coomb House, Stanmore Road, Kew. This area had also been developed as the railway had reached the village of Kew, making Kew Gardens a popular day out for many Londoners.

The existing farmland was replaced by large suburban villas intended to house the metropolitan middle classes and they soon filled up with bank managers, solicitors and company directors. Comb House does not appear in local records for 1889, indicating that perhaps the Fullwood's moved into a newly built property. Unfortunately the house itself did not survive the Second World War bombing and post war redevelopment but enough of the Victorian neighbourhood survives to indicate that it would have been a substantial property, and one whose occupancy indicated that John Fullwood had become a successful and established professional artist.

We know that John first visited this area of the Thames well before 1890. Indeed, Richmond Free Library's report for 1881, the year that it was opened, shows that John Fullwood had donated a landscape etching as a gift. His first recorded etching of Richmond itself is an etching of the town reviewed in the *Leeds Times* of 16 July 1887. On describing the etching, the reviewer considered the plate "powerful; also poetic" although "a little wanting in the chiaroscuro", comparing him to De Wint and Richard Wilson.

John was also to paint '*Richmond Bridge*', displayed at the 1888 Royal Academy exhibition. He had soon completed enough material from Richmond and the surrounding area in order to mount an exhibition devoted solely to it, although not held in Richmond itself but back where his reputation was strongest, at Edwin Chamberlain's gallery in Birmingham.

Comprising both water colours and etchings, an advert in the *Walsall Advertiser* of December 1890 invited readers to attend "An exhibition of water-colour drawings of Richmond, Twickenham, Kew, and neighbourhoods, By John Fullwood RBA, will be held at Burlington Chambers, New Street Birmingham on and after next Tuesday December 2., Admission on presentation of card." One of these cards, inviting James Powell Jones and friends to this exhibition, survives in Wolverhampton Archives today.

All told, John Fullwood had produced more than fifty water colours plus several etchings of Richmond, Twickenham, Kew and the surrounding area. The review of this exhibition in the *Birmingham Daily Post* was positive, almost effusive. The reviewer wrote it is "impossible to walk through the galleries without being impressed with that by no means common quality – of distinctiveness."

The excellence of the work "proclaims the individuality of the artist" and whereas talented men of any art school may display similar technique in technical perfection and sense of colour, these works on display "could have come from no one else." The reviewer particularly highlighted the "remarkable felicity with which the artist (Fullwood) has saturated his drawings with light: now bright and palpitating, now softly glowing in broadly – diffused masses, but always light."

One painting '*Landing Stage, Messom's*' captures a scene "where the light penetrates the soft hazy atmosphere and the thin vesture of the spring trees, now warming into colour with the swelling buds, and glancing from the keels of the boats just undergoing their 'spring cleaning'.

As John's reputation grew his peers recognised his talents: John Fullwood was elected a member of the Royal Society of British Artists on 27 October 1890. Whilst living at Coomb House, Stanmore Road, Kew between 1890 and 1894 he exhibited a further four times at the Royal Academy.

John and his wife were becoming well known in the locality as an entry in the diary column of the *Thames Valley Times* on 19 February 1890 gives a flavour of the circles in which they moved; "A note from Mrs Fullwood asking us to tea. Vi and I spent a delightful hour in Mr Fullwood's studio, looking at his pictures and hearing his description of the lovely views he has seen. A big Cornish landscape in water colours positively glowed with sunlight, and some of the Surrey sketches were exquisite in tone. Vi was charmed with a sweet little head modelled in relief by Mr Fullwood

on a bit of slate with terra-cotta wax. I always revel in a studio and would love to be an artist."

But John's social prominence also attracted attention of another, unwelcome, sort. The *East & South Devon Advertiser* of 18 April 1891 records that a local conman, impersonating a Roman Catholic clergyman, visited John Fullwood to ask for a subscription to a home for destitute women. John Fullwood refused, the man was subsequently arrested and his various aliases discovered before he was sentenced to three months hard labour.

The following year the *Richmond and Twickenham Times* described John as "That wide awake artist, John Fullwood" in recounting another potential scam where he was invited to become a member, for a substantial subscription fee, of an impressive sounding but fraudulent artistic institution. John recovered his money and the local press covered his warnings to other gullible residents.

The same paper, on 16 April 1892 reviewed the review of the R.B.S.A. 'Spring Exhibition' as carried in the *Birmingham Daily Post,* drawing attention to John Fullwood's work, indicating some level of prominence in Richmond as well as Birmingham. The London critic 'sniffily' noted that the "Birmingham notice is what, across the silver streak" they call "tall". However, it went on, "but it is scarcely overcharged, the drawings being of the best that Mr Fullwood has ever produced."

Moving nearer to London hadn't diminished John's reputation in the Midlands, either. The *Birmingham Daily Post* of 9 April 1891 noted that "Promises have already been received from the following artists to contribute pictures to be hung in the convalescent or other rooms in the new General Hospital." The article then went on to list prominent local artists, such as Walter Langley, William Wainwright, Oliver Baker, Charles Morgan alongside John Fullwood, many of whom were alumni of the Birmingham School of Landscape Art under Edward Watson.

The *Walsall Advertiser* was a regular source of John Fullwood's progress, reporting on 5 January 1895 that he had "just finished a very remarkable etching '*A Song for Autumn*' measuring 30 inches by 20 inches." The article goes on to remind readers of what it considers are the fine examples of John's etchings at the Walsall Free Library and Birmingham Corporation Art Gallery, and especially of 'Remnants of Old Wolverhampton' of which "there are only a few copies of a rare work in the possession of the cultured few in Walsall, in which some years ago he illustrated a great many of the old landmarks of Walsall and Wolverhampton with the etcher's needle." The author of the article points out to those who remember, and perhaps bought this work of John's, that they saw "the rich promise of a glory yet to come."

The fact that the *Walsall Advertiser* continually kept local readers up to date with John Fullwood's career is also evidenced on the 2 March 1895 when it noted that "A few weeks ago we warmly recommended to the notice of our readers a new and beautiful etching by Mr John Fullwood who is well known to many of our subscribers. That what we said is in harmony with the opinions of those most competent to judge is shown by the following interesting note, which we take from the Hastings Times. – Mr John Fullwood's latest etching, 'A Song of Autumn' concerning which Mr Ruskin wrote a few weeks ago in terms of unqualified praise, has attracted considerable attention in art circles…I was reading the other day, in an American paper, an article on "Etchers" by the famous Dr S.H. Douane, in which he describes Mr Fullwood as one of the few great etchers of the day."

In common with the majority of Fullwood's etchings '*A Song for Autumn*' had only a limited number of prints but the etching was treated in an unusual and novel way by John Fullwood. Only forty impressions were taken from the copper plate and after this the plate was broken into forty pieces with each of those pieces becoming the property of each purchaser of a proof. This meant due to its limited production, each proof practically carried the value of the original.

Throughout the 1890s newspapers both in the Midlands and nationwide were reporting John Fullwood as having a considerable national and international reputation as a landscape artist, as his output and status grew. The *Times of London*, in April 1890, reported on the exhibition of watercolours in the Dudley Art Gallery, housed in the Egyptian Hall, Piccadilly, London, noting that "an exhibition containing too many indifferent works mingle here too freely with what is meritorious" but highlighting "several of Mr John Fullwood's fresh and very effective contributions."

This art gallery, named for its patron the Earl of Dudley, was a challenger to the older Water Colour Society's exhibitions, generally given over to more daring and aesthetic works. The *London Daily News* noted that "several breezy drawings of hills, meadows and other landscape features providing opportunities for touches of rich and strong colour by John Fullwood, a new member."

The Egyptian Hall had been financed by the Earl of Dudley to house his valuable collection of pictures, and the room thus gave its name to the Dudley Art Society who used the room for its own exhibitions by members. It grew to a membership in excess of 150 including many well-known artists and whose council members included the prominent art critic and writer John Ruskin.

Around this time he was exhibiting at several regional art galleries; *The Bristol Mercury* of 25 April 1892 notes, towards the end of a lengthy article, his painting '*The Vale of Shere*' at the Bristol Fine Arts Academy exhibition, and *The Derby Mercury* recorded his '*The Thames, at Walton*' being shown at the Derby Gallery show on 9 October 1895, although the reviewer did not include him in the list of "well known artists" represented there.

In 1904 he exhibited at Walsall Art Gallery where the reviewer, Edward Shaw, was effusive in noting that the painting '*Cottage Homes near Stratford*' (which was owned by William Bayliss) was "a dream in lemon and gold and green of an English village at

eventide." Shaw considered that Fullwood was "one of the most poetical of English landscape painters" and described a series of small landscapes by Fullwood, including '*An afterglow, over a valley in Wales*' as containing "pale silvery and springtime glimpses along meandering rivers; purple landscapes flecked with orange and red and distant mountains of russet brown." In the same year he exhibited at the Sussex society of artists in Chichester where he showed '*The ferryman's daughter*', '*Canterbury Vale*' and '*The Ferryman's Cabin*'.

In the same year John Fullwood also exhibited paintings in his home town of Wolverhampton. In September the Art Gallery held "an exhibition of work executed by modern artists" who "reside in Wolverhampton and district." This modernist choice was justified in the local paper as "picture lovers living and working in the throes of the twentieth century do not, for the most part, care to send their exhibited." John Fullwood's residential non-qualification was not identified.

John also exhibited at the 'Winter' R.B.S.A. exhibition where the *Bristol Times & Mirror* of 2nd November noted "Mr John Fullwood has a cleverly painted piece of a country village, called 'Cottage Houses in Shakespeare's Country, near Stratford'."

The *Art Journal* was published by Virtue & Co with whom John Fullwood had a long and profitable relationship. In 1892 John had illustrated an article in the paper by G.A. Storey on 'An Unknown Glen'. The September 1895 edition was reviewed in the *Hampshire Telegraph* which noted that "Rye and Winchelsea come in this month for Mr John Fullwood's sympathetic description and delicate representation."

John Fullwood provided two illustrations for Maurice Grindon's book 'Kathleen O'Leovan' in 1896 and was published by W. Henry Robinson's Steam Printing works in Walsall (Maurice Grindon was the nom-de-plume of W Henry Robinson). John also contributed to *The Studio*, in whose 'Spring 1912' edition he supplied drawings

for 'The Village Homes of England' in support of text written by Sydney Jones.

John Fullwood's move to London also enabled his black and white work to prosper. In November 1891 the *London Mercury* carried an advert for Griffith, Faran and Co, entitled "Story Books for the Young" which included one entitled *'Twice Four',* for which John Fullwood contributed black and white illustrations. This company was to provide him with repeated commissions, including illustrating religious books such as *'The Message of Love'* and *'Easter Bells',* as well as books for children.

In 1892 John illustrated *'Selections from Tennyson'* for the same publisher with full page illustrations of streams and woodland which "arc in commendable harmony with the text" according to the *Richmond and Twickenham Times.*

Another of John's more prominent employers was the book publishing house of Cassell & Company, which held a regular sequence of exhibitions highlighting the original illustrations that had appeared in their publications. Their 13th annual exhibition was held in the Hall of the Cutlers' Company, Warwick Lane, in the City of London in May 1895.

The exhibition was reviewed in *The Times* and the *Westminster Budget* newspapers which both noted the contribution of John Fullwood's landscapes to the display. The *Stamford Mercury* published an article about the revival of lithography written by Mr M.H. Spielmann on 16 April 1897, and he illustrated it by referring to works produced by 'prominent' artists.

As an example Spielmann referred to "a pleasant paper called 'The Wanderings of the Tamar' written by Annie Groser Hurd which is accompanied (illustrated) by some clever landscape work by John Fullwood R.B.A." The April 1897 edition of the *'Magazine of Art'* published by Cassell & Co, carries an extract from 'The Wanderings of the Tamar' text and included six water colour paintings produced by John Fullwood.

Five of those six water colours of the Tamar valley painted by John Fullwood and used in Annie Groser Hurd's book, were also included in another book called 'The Rivers of Great Britain', and published by Cassell & Co, for which Fullwood contributed several works including 'Shrewsbury Castle', 'Between English and Welsh Bridges', 'Tavistock New Bridge', 'The First House on the Severn: Blaenhafren', all with engravings and printing by Andre & Sleigh.

In many ways, John Fullwood's work for Cassells proved a natural fit. John Cassell was a prominent supporter of the Temperance movement, and an evangelical, nonconformist who believed strongly in the self-education of the working man; all traits found throughout John Fullwood's extended family.

Cassell had founded his eponymous publishing house as a way of publishing pamphlets to publicise his temperance ideals. Soon after that he had started a newspaper, the *'Working Man's Friend',* but soon began the production of cheap, illustrated magazines and educational books, from which he was to make his fortune. He recognised that it was the illustrations that sold the works, and from then on illustrations became the principle feature of his periodicals and one of the biggest sellers of which was the *'Magazine of Art'*.

This paper became more than just a record of the current art scene, as it reviewed, criticised and analysed artistic endeavours, and eventually expanded to include original text and verse. The contributors to this paper included John Ruskin as well as Sir George Wallis and Sir Wyke Bayliss. The fact that Lord Wolverhampton, Sir Henry Fowler (the first non-conformist to hold a post in the Cabinet), was Chairman of Cassell & Co for ten years from 1891, is likely to have helped John Fullwood in his career in illustration.

John Fullwood also continued with his etching work for other publishers. John C. Nimmo published a complete (48 volumes) edition of Sir Walter Scott's Waverley novels (1892-94) with John illustrating *The Red Gauntlet* along with the artist James Orrock.

John also contributed work to Seeley & Company, especially illustrating the books of the author Charles John Cornish. Although Charles Cornish was an Assistant Classical Master at St Paul's School in London, he was also an accomplished naturalist, writing studies of the New Forest and the Isle of Wight, for which John Fullwood provided many etchings. Cornish was a noted authority on natural history and country life and was a regular contributor to *The Spectator* and *Country Life,* and wrote a natural history of the Thames Valley. Cornish and John Fullwood made an ideal fit for text and illustration.

In 1900 *'Riverside Churches'* was published by W.R. Howell & Co, Bedford Row Gallery London WC1. It which contained fifteen original etchings of Thames Valley churches by John Fullwood in a limited edition of two hundred, each signed in pencil and on plate on cream laid paper. The churches that were illustrated followed the progress of the Thames from Kew through, Brentford, Isleworth, Richmond, Petersham, Twickenham, Teddington, Kingston, Thames Ditton, Hampton, West Molesey, Sunbury, Walton on Thames, Shepperton to Chertsey in Surrey. John Fullwood lived in some of these Parishes, and was familiar with the Thames throughout its journey.

John Fullwood also contributed a dozen colour plates to 'The Country Homes of England' published in 1912.

Chapter 15 Fairlight Glen

"While Mr Fullwood lives, Blake cannot be said to be dead"

In 1896, two of John Fullwood's paintings were chosen by Sir Edward Poynter, the President of the Royal Academy of Arts, to be exhibited amongst the representatives of British Art in the St Louis exhibition at the Brussels International Exposition. This exhibition was a statement of intent by the British Art establishment, and funded by the British Government at a cost of £5,000. It proved successful: the following year, between May and November 1897, almost 8 million people visited the exhibition grounds. The British Fine Art Section was, as reported in the *Morning Post* of 12 June 1897, to "consist of one of the finest collections of British pictures ever sent out of the country." One of John Fullwood's paintings displayed in Brussels was '*Autumn Glow*', which was later owned by William Bayliss J.P. of Walsall.

Sir Edward Poynter had been elected President of the Royal Academy following the death of Sir John Millais in 1896. He was the brother-in-law of the Pre-Raphaelite genius Edward Burne-Jones, but also had connections with Wolverhampton, and therefore John Fullwood, through Poynter's wife Agnes McDonald. Agnes was the daughter of the Reverend George McDonald who had preached at Darlington Street Methodist Church, Wolverhampton in the 1860's, at a time when many of the extended Fullwood family would have attended services there. Henry Fowler, later Lord Wolverhampton, was another who worshipped there at this time.

Agnes was artistic and when the family moved to Birmingham she befriended many of the "Birmingham Art Scene" artists. Her sister Georgina married Edward Burne-Jones and Agnes married Edward Poynter in 1866. Her other sisters included Louise, who was the mother of future Prime Minister Stanley Baldwin and Alice, the mother of Rudyard Kipling. A large classical scene, 'The Champion

Swimmer', by Sir Edward Poynter still forms part of the permanent collection at Wolverhampton Art Gallery.

John Fullwood's success as an artist had linked him to many of the influential shapers of Victorian art and this period perhaps represented the high point of John's artistic reputation and financial standing, yet may also have contained the seeds of his decline.

In 1892 John Fullwood wrote, illustrated and published the culmination of his career to date; a book, entitled *'Fairlight Glen'*. This encompassed his established pictorial landscape work together with illustrations of fantastical figures and his own prose and poetry, incorporating fact and fantasy.

The book 'Fairlight Glen' can be seen both in the context of the Victorian folklore revival which had collected local tales, songs and rural traditions and brought them to the wider public, and also the genre of 'faerie paintings'.

The tale is built up from John Fullwood's knowledge of antiquarian matters in locations he was familiar with, which he uses to support a folkloric fantasy, encompassing lovers torn apart by religious strife and connected by mystical symbolism. The volume was aimed at a discerning market of art collectors, being produced in a limited

edition of 250 signed copies, by Waterlow & Sons, and costing the princely sum of 42 shillings.

The real Fairlight Glen is a wooded area lying about two miles east of Hastings and one and a half miles west of the small village of Fairlight Cove on the East Sussex coast. This was a place that he said he visited often when he lived in Hastings.

A columnist writing in the 30 December 1893 edition of the *Hastings and St Leonards Observer* described meeting the author; "And this word artist I would use in a twofold sense, for as one turns over leaf after leaf of *'Fairlight Glen'*, astonishment at the beauty of the illustrations is only exceeded by admiration for the chaste, poetic language in which the story is told. Not many artists are able to write up the productions of their pencil, brush and needle......while Mr Fullwood lives, Blake cannot be said to be dead....I can do no more, therefore, than to draw attention to one illustration entitled *'Transporting Melody'*, and to say of it that this exquisite, fanciful production that is intrinsically worth all and more the fifty shillings charged for the whole rich pictorial mine." The paper summed up with "The book shall be a valuable acquisition to any library."

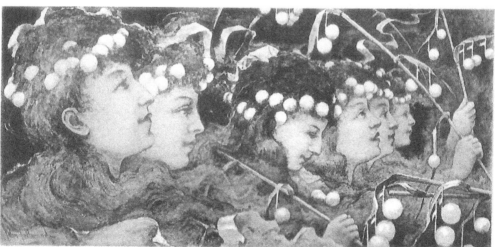

'Transporting Melody' an illustration owned by Paul Fullwood and included in the book 'Fairlight Glen' written, drawn and published by John Fullwood.

'Fairlight Glen' is written from the perspective of an un-named first person. Yet the narratorial voice betrays many of the interests and preoccupations of John Fullwood and an examination of the text offers an insight into his world.

It tells the story of a visitor to an old, illiterate lady in a tumbledown cottage. The narrator says "as an antiquery, I could not leave without noticing" an ancient family bible, which the old lady tells him had belonged to the last descendant of a local family. He buys it from her and, upon returning home he dissects the thick leather bindings to reveal a "Hand of Glory" – a good luck charm – and writings concerning mysterious events set in the 'Fairlight Glen' relating to two Elizabethan lovers forced apart by religious strife.

Locations that John Fullwood was familiar with are easily identified in the book. The narrator states his residence as Loaton, where presumably Fullwood was referencing Laughton in East Sussex. Other locations used are Hastings and Winchelsea, and the narrator also references Caldmore Hall in Walsall, which John etched and published in his book 'Remnants of Old Wolverhampton' as the 'White Hart Inn', and landscapes in North Wales, where he sketched as a member of the Birmingham School of Landscape Art.

Caldmore Hall was originally a gentlemen's residence dating from Tudor times which later became a public house called the White Hart Inn. During Victorian renovations a mummified child's arm was discovered bricked up in a chimney. This became known as the Hand of Glory, and was considered a charm to ward off evil. As someone who considered himself an antiquary, John Fullwood would have been well aware of this event and how it became local folklore (the arm is still in the possession of Walsall Art Gallery and Museum, but not on public display). The Hand of Glory in the book is a mole's paw and the narrator describes how, when living in Sussex, a countryman friend provided one for him.

Alongside the fictional characters of the sculptor Claud Raymond and his lover Evaline, John Fullwood also introduced the historical character of the protestant martyr Joan Bocher. The town of Den Brielle in the Netherlands is the setting of Claude's exile. Whether John Fullwood knew Den Brielle personally or simply chose it because of its significance in the history of the establishment of the protestant faith in the Netherlands during Elizabethan times is unknown. John Fullwood's choice of the name Evaline for his heroine may also be significant given the family story outlined at the end of chapter 4.

The cause of Claud Raymond's exile is explained as his refusal to accept the concept of the Trinity. The narrator states that Raymond looks to the East, referencing the religious schism between the Eastern, Orthodox Church and Roman Catholic Church. Whether this reflects John's own religious understanding or is simply a historical plot device is unclear.

Many of the clues that Raymond leaves behind, and which are interpreted by the narrator, are inscribed on the "Gnomen" rock, in the shape of mysterious symbols. A Gnomen is the part of the sundial that casts a shadow – from the greek, literally "one that knows."

'White Hart Inn' at Walsall', also known as Caldmore Hall, is an etching by John Fullwood. Etching owned by David Fullwood. In 'Remnants' the scene is set in winter. In 'Fairlight Glen' the same scene is depicted in summer.

The narrator compliments Claud Raymond on the quality of his work "I am delighted with the artist's fidelity in his studies from nature." This work is observed in a lavishly carved bedstead which the narrator sees at a friend's house. This bedstead had been bought by another antiquary and gifted to the friend who, according to the narrator, lived in a grand hall not far from Caldmore Hall in the unnamed Midlands town. Perhaps these two unnamed friends represent W.H. Duignan and W. Henry Robinson. Duignan was living in Rushall Hall, a couple of miles from Caldmore at the time.

'Fairlight Glen' is lavishly illustrated with John Fullwood's distinctive landscape style but also contains evocative drawings of female figures in a highly stylised form, especially in *'Transporting Melody',* and *'The Refrain'* where the nymphs play musical instruments. These are unlike any of his other works. This

stylisation was explained by John Fullwood in his 1896 interview, "Nature is always singing a lullaby to me, and so I endeavour to make my compositions musical." In this he reflects John Ruskin's view that "colours can be compared to the ordered sounds of music."

It was reviewed in the *Sunday Mirror* on the 22 October 1892, whose critic noted "A story of tradition and folklore, told and depicted by an Elizabethan artist and now re-told by John Fullwood." Sir Wyke Bayliss, President of the Royal Society of British Artists said "it is so throughout the book, a book of magic and culture."

The *Birmingham Daily Post*, of 27 December 1892 described the book as "opulently enriched" and that the volume was "a veritable triumph" with thirty full-page plates comprising landscapes and studies of quaint interiors, but the reviewer especially noted the illustrations where Fullwood gave rein to his imagination, peopling the glens and glades, and the moors and caves, with strange fantastic forms such as gnomes, spectral horses and sprites. This reviewer was less convinced of its literary rather than artistic merit, describing the text as "too inchoate and discursive to interest the general reader."

The *Magazine of Art*, in December 1892 considered the book "full of artistic charm and imagination" and described it "as a medieval fairy tale, now bright, now weird, always ingenious, and often striking in its poetical conception." Again, the reviewer was less impressed with the story, stating "we will not say that the text maintains an equally high point, but it is interesting and possesses such characteristics of grace and originality that makes it stand out, in its strong individuality, from any other book of the year." The review goes on to highlight the illustrations with the effect of "the running of the water, in the form of musical notes, along a stream, their liquid gliding and 'transport', gives the artist the opportunity of designing a number of drawings as fanciful as they are charming and dainty, and as ingenious as they are quaint and sometimes

poetically thoughtful." This theme was picked up by the *Lowestoft Standard* "The illustrations are replete with poetical feeling" and the *Norwich Argus* considered the book to be "The gift of the season."

John Fullwood's prose certainly evokes other worldliness. He describes the invoking of the faerie spirits as "from where the spirits come and make the glen their sanctuary, where the road is narrow and winding and deep, where trees lock their branches, and make the glen at nightfall dim and obscure, the water falls like running notes on a lyre."

As well as prose John Fullwood deploys poetry to build the atmosphere. He writes;

> Eternally and eternally,
>
> The rhythmic swell, embracing, unites,
>
> The far off shore, and on the bosom,
>
> Of the ever-flowing wave is born,
>
> The vigorous germ of distant life;
>
> And continents and lone isles are near.

'Fairlight Glen' was also reviewed on 26 February 1893 by the *New York Tribune*. The critic noted that England was passing through a fairy tale revival at this time and so the story was built on "a folklorist foundation, but the thing which gives the author a place apart is that he has heightened the effect of the text with charmingly original illustrations in ink and wash. Mr Fullwood publishes the book himself so that is plain he is a devoted acquisition to the ranks of English workers in the field of fairy lore, leaving nothing undone in the course of his labours."

The book contained 30 full page process plates, ten block illustrations and over twenty designs as initials, tailpieces etc. It was

bound in a specially dyed calf-skin with an appropriate design in gold for the cover. It was, as the reviewer noted, "*a production du lusse.*" The *Gentleman's Gazette* concurred, noting that "the *edition deluxe* promises to make the mouths of bibliophile's water."

Fairlight Glen was also reviewed in *The Art Journal* (Vol 55). The critic felt that the author's words, given to the character of the sculptor Claud Raymond, "I am delineator, and sculptor. These are my designs; I give them birth and they have my soul" perfectly summed up John Fullwood's own approach to art.

In his use of "strange fantastic forms such as gnomes, spectral horses and sprites", John Fullwood was drawing on a well established tradition of 'faerie paintings'. This genre predates the Victorian age, but went through a significant mid-nineteenth century revival, hugely influenced by the works of William Blake with whom Fullwood and his circle were completely familiar. In this genre there is typically a proliferation of details, with perfectly formed nature in the background contrasting with imagined forms such as sprites and gnomes. Where the human form is shown it is often female, and of a child like nature.

Many contemporary artists portrayed "Faeries" in large scale works, from those who are still associated with it, such as Dadd, and those who are not, such as Landseer. Closer to home, his colleague and friend Walter Jenkins Morgan, President of the Birmingham Art Circle, and fellow illustrator for Cassell & Co, completed a number of examples (e.g. The Fairy Ring; Fairy Revels) which now hang at Birmingham Art Gallery, so there was a local appreciation and market for the genre. John Fullwood's use of this genre does seem to be restricted to this book, with no large scale forms being apparent in his recorded works.

Perhaps his timing was wrong. 'Fairlight Glen' was published after the high water mark of the genre, and was possibly considered old-fashioned by the time it was on sale.

John Fullwood's widow Kate donated a copy of the book (148/250) to Wolverhampton Art Gallery after her husband's death in 1931. One other of the original purchasers is known: W Henry Robinson's copy was sold off as part of his attempts to raise money for his business. He advertised it for less than he had paid for it.

Chapter 16
Connections With Australia

"The ties that bind"

In 1895, and looking back over the previous two decades, the *Birmingham Daily Post* estimated that between 4,000 and 6,000 Birmingham citizens had emigrated to the British Empire in each of those years. If that is true, and taking Birmingham's population as numbering about 400,000, then that represents a movement of around 1% of the population each year, It was not surprising then, as the paper stated with some pride, that it had posted many thousands of copies of its weekly edition abroad in order that these Birmingham émigrés could be kept up-to-date with the affairs of the city they had left behind.

The motives for emigration may have varied but equally, support was available from a variety of sources. The Australian colonies advertised for workers with specific trades and organisations were set up in Britain to facilitate the movement of colonists.

After leaving Wolverhampton to live with his brother William in Birmingham, John Fullwood may have read the weekly *Birmingham Journal,* along with many other Birmingham papers which published articles reflecting news from the Empire. The Birmingham Y.M.C.A., in whose building John Fullwood attended his art classes, held regular discussions about the Empire and through its organising committee, facilitated emigration across the colonies as part of its mission to export "civilisation." Prior to that, the Wesleyan Chapel in Darlington Street Wolverhampton also had, from its earliest days, established a fund for supporting foreign missions and reports from these were circulated to the congregation at the time that the Fullwood's attended the Chapel.

This international circulation of information reflects the continued exchange, curving back and forth between Britain and its colonies

such as Australia that influenced many 'Brummies' to try their luck abroad. Indeed, siblings of both John Fullwood and his wife Kate were to emigrate to Australia before the turn of the twentieth century. Kate's younger brother Albert Edward Rooker left Birmingham for Queensland, where his family prospered. Sadly there is no surviving correspondence between Albert and Kate.

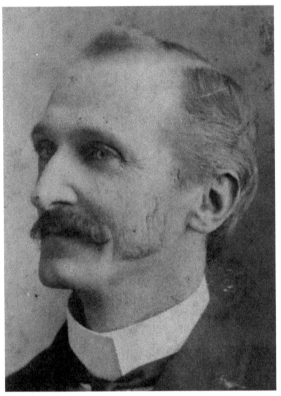

A portrait of Henry Fullwood provided here with the permission of Anne Robertson a descendant of Henry Fullwood's family. Henry's family tree is shown at Appendix E.

John Fullwood's elder brother Henry, was still living in Wolverhampton when John moved to join their brother William in Birmingham, but he was to try his luck in Australia shortly thereafter.

Thanks to family records and letters kept by Anne Robertson, an exchange of letters has been preserved in Australia between Henry Fullwood and Walter Fullwood, Henry's second cousin. (See Appendix F showing the progenitor link between, Henry, John and Walter Fullwood). These letters highlight the connections and resultant misconnections between both extended branches of the Fullwood family in Australia.

Walter Fullwood had arrived in Sydney in 1890 and found work with the Railways Department of the New South Wales Government. After reading the Government Gazette in 1899, Walter noticed that a Henry Fullwood had just registered his patent

for erecting wire fencing. Walter wrote to him on 13 July 1899 enquiring as to whether "being of the same name…we are in any way related" and gave brief details of his own family in Wolverhampton and Birmingham.

Henry replied 18 July 1899 giving details of his father, aunts, uncles and cousins including his brother John Fullwood described as "an artist of the distinction of the R.B.A. (Royal Society of British Artists) living in Sussex England" and stated that "he too had made acquaintance with other Fullwood's in Australia with a view to contacting relatives and added that he had talked to a man who told him there was a Fullwood, an artist, in Sydney." Although Henry Fullwood didn't realise this at the time, he was referring to Albert Henry Fullwood.

Henry Fullwood also mentioned in his letter to Walter a reference to his brother Joseph who lived in Oak Street Wolverhampton. Joseph was regularly receiving letters in error meant for another Fullwood living in the same neighbourhood, who happened to be an old man. (A personal note from the co-author David Fullwood of this life story; this reference by Henry to "an old gentleman" is likely to be his two times great grandfather James Fullwood (born October 1832) who was living in the area at Merridale Street and then at 115 Oak Street, Wolverhampton in 1911.) As a footnote; James was born just two months after his father had passed away in August 1832 from Cholera caught during the outbreak in Bilston, Staffordshire.

In Walter's reply back to Henry, in the remaining final letter of this sequence, Walter states "your brother John, the artist, is some years older than my brother Albert (who at the period mentioned was rather shy) and both attended the Y.M.C.A. in Needless Alley, Birmingham but they never became acquainted, probably owing to said shyness. I had several of your brother's water colours when in England and one of his etchings, but sold them when leaving."

The correspondence closed with neither cousin understanding the real relationship that existed between them. In later life Albert Henry Fullwood was to become a great social figure in the group of expatriate Australian artists in Edwardian London, living a bohemian life to the full; his supposed shyness was certainly overcome by then.

We know John Fullwood also kept in touch with his brother Henry and his extended Australian family. In 1907 he sent a copy of '*The Minnow Catcher*' and an etching of the Thames with a hand written note, "Yearly Greetings, Sunbury-on-Thames" to his brother. We also have a record that in April 1922 John posted four artist's proof etchings of one of his works inscribed "To Edgar and Mabel". This was to Henry's son Edgar Fullwood and his wife Edith Mabel (nee Delves).

This union of the two families in Australia, the Fullwood's and Delves, recognises a curious connection between all three branches of the family and the village of Slinfold, Sussex, England. Edith Mabel's father, John Delves, had lived in the village of Slinfold with his parents before moving to Australia, and this was the same village that John Fullwood had lived in for 6 years between 1898 and 1904.

Edgar's son Alan Edgar Fullwood later wrote up his family history and wrote, "John Delves was born in Canon Street, London in 1855, before his parents Thomas Walter Delves (a tobacconist) and Elizabeth Delves, nee Joell moved to Slinfold in Sussex." From there, in 1856, the Delves family emigrated to Collingwood, Australia, with John Delves aged only one year old.

John Delves, by then a plumber, married Mary Ann Marshall on 14 October 1875 at the age of 21, and his daughter Edith was born the following year. Edith Delves married Edgar Fullwood in 1902, in Carlton, a suburb of Melbourne. By 1913 they had three children and Edgar moved his young family to a new house he had built in another suburb, Mont Albert. They named this house "Slinfold"

after the village where his father-in-law had lived fifty years prior and his uncle only a decade previously.

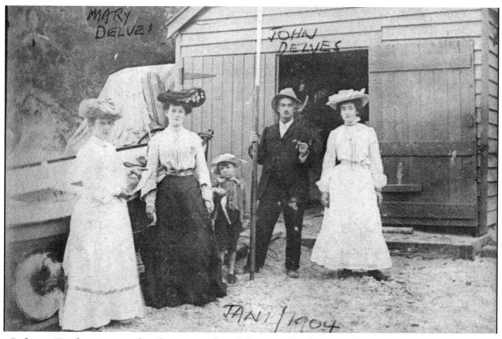

John Delves with his wife Mary Delves (nee Marshall) and daughter's, one of which is Edith Delves (born 1876) who married Edgar Fullwood (born 1875) in 1902 at Melborne, Australia.

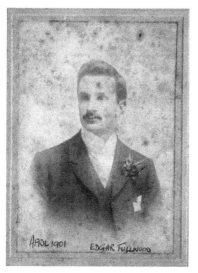

Above, on the left Edgar Fullwood and on the right Edith Mabel Delves. Photographs provided by Anne Robertson.

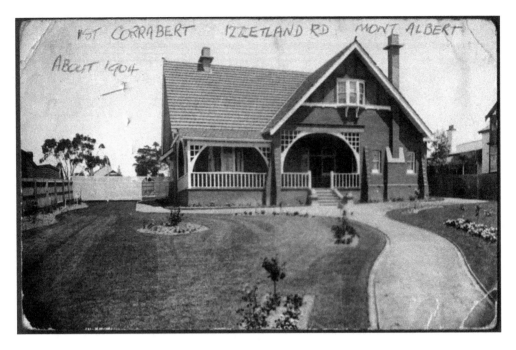

"Slinfold" Mont Albert, Melbourne

The British Empire, including the Australian colonies, was the main export market for goods made in Birmingham and the Black Country. Goods as disparate as door knobs, nails, chains, hinges, tools and cooking equipment, as well as jewellery, were manufactured in and around Birmingham and despatched overseas.

The booming Australian economy had seemed to offer financial riches during the 1880s when "Marvellous Melbourne" was the third richest city of the Empire, and wire netting was a vital necessity enabling the expansion of Australian agriculture. To emphasise the connectivity of an imperial world, Birmingham Wire Gauge was the most commonly used system of specifying wire diameters in the 19th and early 20th centuries in both Britain and Australia.

In what may be a connection or maybe just a coincidence, John Fullwood's elder brother Henry, who had emigrated Australia in 1879, had registered several patents in Sydney including one to improve the erection of wire fencing. The combination of familial connections, evangelical memories and business opportunities may

216

have influenced John Fullwood to invest in a financial venture in Australia with six other partners. This project, 'The Australian Wire Netting Company Ltd', was registered at Companies House in London on 6 February 1893 with a share capital of £20,000, equivalent to more than £1,750,000 in contemporary values (2017). This sum was confirmed in a legal notice placed in the *Adelaide Advertiser* on the 14 February 1893.

The company's object was "The carrying on in the City of London, in the colonies of New South Wales and Victoria, on or at such other place or places as the company may decide, the business of iron wire manufactures, wire netting manufactures, galvanisers and finishers of Iron and Wire…"

Sadly and inevitably, bust followed boom and this, allied with a banking crash in New South Wales, tipped the Australian economy into a depression which lasted until the outbreak of World War One. Had Henry's enthusiasm for the new life in Australia persuaded his younger brother to invest more than he could afford in this new venture?

In any case, as a letter to Companies House dated only a few months later on June 4 1894 from the Secretary of the business stated: -

> "Sir, The Australian Wire Netting Co. Ltd. never came into real existence, and is now defunct. We intended working it but find it can be done better in another way.
>
> Yours very truly
>
> H. B. Tucker, Colonial Mercantile Agency Co Ltd."

Henry Besley Tucker was one of the six other investors of the company, who each owned one equal share in the company. Assuming that each shareholder invested the same amount of money, this would represent a personal stake in the company of nearly £3,000 each. The company must have appeared a reasonable

prospect, as it had been trading for a number of years and had substantial rented offices in the City, near Monument station in central London.

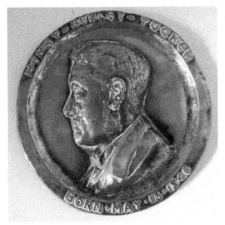

John Fullwood produced the above copper medallion showing the portrait of Henry Besley Tucker. This could be the "sweet little head" referred to in the text towards the middle section of chapter 14.

It seems unlikely that John Fullwood was the instigator of this scheme, more likely that it was proposed to him by others more used to financial risk. How much he personally invested, and whether he recouped any of his money when the company did not come into existence, is not documented. By the end of the following year the *London Gazette* recorded that the Colonial Mercantile Agency had been struck off the Companies Register and dissolved.

Tucker was living next door to John Fullwood in Stanmore Road, Kew, at the time the company was incorporated. As well as a neighbour he may well have been a personal friend; certainly he was someone with whom John Fullwood spent time as he created a copper medallion, about five and a half inches diameter, showing the head of Tucker, inscribed with his date of birth. This is the only known example of this type of work in Fullwood's oeuvre. The Medallion carries the inscription J Fullwood R.B.A. which dates it post 1891.

John Fullwood's art work in Australia was recognized, sold and collected, although he was not as prominent an artist in Australia as his second cousin, Albert Henry Fullwood. Two of John's water-colours, '*Shere Church*' (Surrey England), near the town of Guildford and the village of 'Slinfold', and '*In the Meadows*', were amongst thirty or so English paintings displayed in the Colonial Gallery in Tasmania according to the 8 Jan 1895 edition of the Hobart *Mercury*.

The next year *The Age*, of Melbourne reported a sale "upwards of 70 oil paintings and water colours by English, foreign and Australian artists will be offered for sale at the fine art gallery of Messrs Gemmell, Tucker and Co. on Collins Street.........the water colours include other pictures signed by J. de Groot, John Varley and John Fullwood."

The *Sydney Morning Herald*, in April 1917, carried an advert for the sale of the contents of a property, noting that it contained several etchings, oil paintings and water-colours by "the celebrated English Artist John Fullwood RBA."

The *Melbourne Argus* of 9 December 1925 also records an auction of a collection of paintings which includes those of John Fullwood, although his name does not appear high in the list.

Albert Henry Fullwood, who had emigrated to Australia in the 1880s, returned to England in 1901 and established himself as a successful artist in Edwardian London. The familiar name must have caused some confusion back in Australia when John Fullwood was mistakenly listed in the "*Queensland Daily Mercury*" of 1 May 1909, instead of his second cousin, amongst other Australian artists such as Longstaff, Mackennal, Lambert, Coates and Streeton who were exhibiting at the 'Spring 1909' show at the Royal Academy.

Chapter 17 The Royal Academy, & The Final Years

Between 1898 and 1904 John Fullwood moved out of London and lived in the village of Slinfold near Horsham, in Sussex. His home address was given as 'The Studio, Meadowside, Park Street' where he lived with his wife Kate and daughter Maybell. *Photograph below taken by David Fullwood of Slinfold Church.*

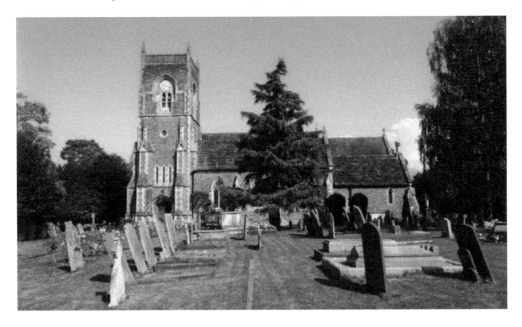

St Peters Church, Slinfold, West Sussex

It is easy to imagine John being content here as he was living in the beautiful South Downs, an area he clearly loved, surrounding by bountiful nature, secure in his career, enveloped in the love of his family. Yet, in the twilight of the Victorian age, and with continued success seeming assured, the seeds of a worrying future had been sown.

When the new century dawned John's daughter Maybell was 19 years old. She decided to be christened in St Bartholomew's the Parish Church of Edgbaston, Birmingham in August 1900, despite

the family living in Slinfold at the time; St Bartholomew being the Parish of her birth. Perhaps her desire to join the established church indicated the families increased social standing. The move from nonconformity to Anglicanism was not unknown amongst the aspirational middle class as the common phrase "The carriage only stops for one generation at the chapel door" reflected.

John Fullwood at this time also committed to the Church of England. Perhaps closer to his heart was the comment of a fellow non-conformist who asserted that the principal reason why prosperous middle-class men and women gave up their public worship was "the allure of the country, river or sport, either for the sake of health, pleasure or both." Slinfold did have a non-conformist chapel within its boundaries, so John Fullwood could have continued his established religious preference if he had so wished.

Whilst it cannot be said with any certainty when John Fullwood changed his allegiance from non-conformity to the Church of England, during the time John Fullwood lived in Slinfold he was active in the life of the village and a prominent member of the congregation at the Parish Church, St Peter's. *Photograph of Slinfold village street taken by David Fullwood.*

Slinfold Village, Sussex

The *West Sussex County Times* of 26 January 1901 reports on a wedding at which Maybell Fullwood was a bridesmaid and where the reception was at John's house, "Meadowside". The groom was a John Churchman, a local auctioneer and the bride a widow whose address was given as Twickenham, perhaps indicating the connection between her and the Fullwood's. As was the custom the paper lists the presents given to the happy couple. Amongst the gifts were silver cutlery, ebony backed hairbrushes, a brass dinner gong; all indicating the social milieu that the Fullwood's were mixing in. John Fullwood, as was his wont, gave the newlyweds one of his etchings.

The following year the same paper reported on a presentation at the village hall on the occasion of the Curate of St Peters being promoted to his own Parish. John Fullwood was prominent in the list of guests amongst the likes of the local gentry. The Parish's gift was of a writing desk and sum of cash, but the Curate also received an illuminated address of the event comprising twelve pages containing the names of donors and a record of his achievements. This "handsomely produced" leather bound volume was illustrated with sketches of the village and church and was compiled and produced by John Fullwood.

Another presentation was reported in the same paper, a few months later. This was occasioned by the promotion of the Rector of Slinfold to becoming a Cannon at Chichester Cathedral. Those present included two Colonels who were prominent local landowners, a JP and many others, including the new Mrs Churchman. John Fullwood had, according to the report, organised a collection for the Rector that resulted in a desk and set of silver candles, together with a presentation album in which he had produced drawings of each church in the rural Deanery. This was two years after he had produced his 'Riverside Churches' album, so he was familiar with this work.

If John Fullwood's social position now seemed secure, so did his commercial standing. His continued to receive commissions to illustrate books and his sales of prints in North America provided regular revenue. At the same time he continued to exhibit oils and watercolours at a number of prestigious venues in the UK. From his address in Slinfold he continued his success at the Royal Academy of Arts (R.A.) exhibiting three black and white etchings at the 1900 R.A. 'Summer Exhibition'. They were: 'On the Thames above Staines', 'On the banks of the Colne' and 'On the downs, near Portsmouth'.

At least eighteen of John Fullwood's paintings were hung at the R.A. at Burlington House, Piccadilly, London between 1883 and 1915, including eight consecutive years after his first entry. As early as 1884 John gave the name of James Bourlet as his London agent. James Bourlet advertised that he had appointments to Queen Victoria, the Prince of Wales and the Archbishop of Canterbury. More especially he was a picture frame manufacturer, packer and conveyancer of fine arts and exhibition agent for the Royal Academy.

The *Surrey Comet* of 15 May 1886 reviewed that year's 'Summer R.A. Exhibition'. John Fullwood exhibited '*The Swallows Haunt*', giving Apsley Villas in Twickenham as his residence, the first recorded London address in his R.A. history. Unfortunately, it was not considered highly by the reviewer who considered it a "well drawn waterscape, but the reeds hang together badly." His reputation was to grow from this inauspicious beginning during the time he lived at Twickenham, from where he exhibited five times at the R.A.

The summer exhibition of the R.A. was a highlight of the Victorian social calendar and with all paintings for sale, was especially lucrative event for the artist. John Fullwood's chosen genre of landscapes, appealed to the popular mood of the day. An analysis of paintings submitted between 1896 and 1914 showed that of the

121,000 pictures presented to the R.A., only 19,000 were hung but, of these, nearly a third were landscapes.

A postcard from John Fullwood to Edward Poynter still exists with John Fullwood querying the hanging of his exhibits at the R.A. Average attendances at Burlington House during this period were huge, with around 350,000 visiting each year and being selected to hang "on the line" at the R.A. could make or break an artist's reputation.

Many of his works from this period were to feature the Thames, and riverside scenes between the west London suburbs towards Reading became typically associated with him. The Thames boating scene had become prominent in the 1890s, popularized by the success of 'Three Men in a Boat', written by the Walsall born author Jerome K Jerome, published in 1889.

Boating scenes set between Oxford and Windsor sold well at the Royal Academy, perhaps as a contrast with the wintry landscapes that had predominated earlier exhibitions. An article in the *Art Journal* in 1883 and 1884 had presaged this development, although whether John was influenced by this is unclear.

Another interesting item was brought to the attention of the authors by the American owner of the picture above. Although the owner doesn't have a name for the landscape, it is fairly typical of the output from John Fullwood's Sussex period but the most interesting feature is the child's head in the lower margin. Could this sketch be of Maybell Gaunt Fullwood?

The successful paintings were chosen by the Council of the R.A. exclusively composed of members of the R.A. and a flavour of the frustration felt by the many unsuccessful artists was expressed in the satirical poem "A rap at the R.A." written in 1875 by John Soden.

"A rap at the R.A." by John Soden.

The toil of months, experiences of years,

Before the dreaded Council now appears,

It's left their view almost as soon in it,

They down them at the rate of three a minute,

Scarce time for even faults to be detected,

The cross is chalked; it's flung aside, rejected.

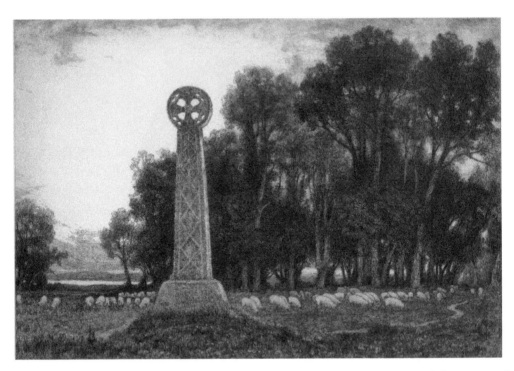

John Fullwood's etching of St Augustine's Cross owned by David Fullwood.

John Fullwood's final R.A. entries were in 1912 with 'St Augustine's Cross', 'Pegwell Bay', 'Thanet' and in 1915 with a view of Kingston-on-Thames. John gave his address as Clonmel, Seymour Rd, Hampton Hill, London.

Membership of the Council of the R.A., the Academicians, was limited to fifty living artists, and invitations were only issued to become new members upon the death or retirement of an existing member. This restriction together with the fact that the only 'open' exhibitions in London were at the Royal Academy and the British Institute, led to the formation of 'The Society of British Artists in 1823'.

A group had met to consider their status and decided to create a body to improve the lot of fellow artists. Their manifesto stated; "This organisation was not formed to rival existing societies but that every member was to be at liberty to assist and support any other society."

By 1876 the Society still only numbered fifty or so members. However it was to receive a boost when James McNeill Whistler joined the group. Within a short time he became President and succeeded in raising the profile of the Society to such an extent that in Queen Victoria's Golden Jubilee Year of 1887 it was granted the prefix 'Royal'.

The Royal Society of British Artists (R.B.A.) held their exhibitions at their gallery in Suffolk Street, London. John Fullwood first exhibited here in 1888/9, showing '*When Pines do not complain*', and giving his address as Apsley Villa, Twickenham.

John was elected a member in summer 1891 when he exhibited '*The Breath of Autumn*' from his address as Coomb House, Stanmore Rd with an asking price of £30. This painting, and associated Richmond etchings, formed the basis of his exhibition at Edwin Chamberlain's gallery in Birmingham that same year. The following year John exhibited '*A Repose of slanting rays*' at the R.B.A., asking £105. John Fullwood received membership of the R.B.A. in 1891 and proudly inscribed the initials R.B.A. on his works from that date. He exhibited '*Loch Lomond*' in the 'Winter' 1904 show and continued exhibiting until 1910, asking between £17 to £25 for each of his works.

John Fullwood left Slinfold in Sussex around 1904 to settle again into the Richmond area of London. Perhaps the financial implications of the failure of his Australian investment, together with cost of self-publishing *'Fairlight Glen'* had taken its toll on both his financial and mental well-being.

John Fullwood was awarded a 'Civil List' pension of £75 per annum from 1906, "in consideration" as the award noted, "of his attainments as a painter and an etcher, of his impaired health, and straitened circumstances." The condition for receipt of these payments was simply 'Proof of Life'.

These pensions were awarded under the Civil List Act of 1837 and paid by the Treasury upon the recommendation by peers and colleagues "to such persons only as have just claims on the royal beneficence or who by their personal services to the Crown, or by the performance of duties to the public, or by their useful discoveries in science and attainments in literature and the arts, have merited the gracious consideration of their sovereign and the gratitude of their country."

The Cabinet Office papers which record the decision to make the award, notes that John Fullwood had written and illustrated *"Fairlight Glen*, reminding one of Blake." Was that commendation from Sir Wyke Bayliss, an eminent critic, President of the R.B.S.A. and someone who had reviewed the book so positively when it was first published, or from the artist Alfred East, whose Presidency succeeded Bayliss the following year, or even from the renowned portraitist John Singer Sargent? All of these, alongside others, were recorded as in support of the award.

The reason that the award was made, however, is laid out in the phrase "his imagination has overbalanced his intellect" as it stated that he had been in an asylum, and was destitute. Many papers commented on the award but not on the nature of his illness although the *Wolverhampton Chronicle*, in July 1907 did state that he had suffered from unspecified ill-health in the previous year.

The trustees of the award were listed as Alfred Drury and Charles Adshead Loxton. Alfred Drury was a member of the Royal Academy and also President of the R.B.S.A. 1915-24. Alfred was a noted sculptor whose figures of female allegorical figures had strong features with hair short or tied back, with slightly smiling faces and whose clothing is emphasised. There are often flowers, greenery and garlands incorporated into the design in an organic and floral fashion. John Fullwood's figures of the spirits in 'Fairlight Glen' contain many of these elements, so was John influenced by Drury?

Charles Adshead Loxton was a Solicitor originally from Cannock but whose practice was in Walsall, where he was Clerk to the Magistrates Court. Although younger, he mixed in many of the same circles in Walsall that John Fullwood had been involved with. He was also a keen astronomer who, picking up the baton left by W Henry Robinson, was to re-found the Walsall Astronomical Society. Loxton was also a collector of Fullwood's work and had loaned two of his paintings to Wolverhampton Art Gallery's 1905 'Winter' exhibition.

John Fullwood's changed circumstances are signalled by the change of his housing during this period. The grand detached house in Richmond, Comb House, was replaced by a modest semi-detached property in Twickenham. Yet Fullwood continued to work. John exhibited a number of monotypes – a type of printmaking where the image is transferred from the surface area onto a sheet of paper – at an exhibition in the New Gallery, Regent Street in 1908. This was held under the auspices of the International Society of Sculptors, Painters and Gravers, the founder and first President of which was James McNeill Whistler. He contributed to an exhibition at the Pastel Society in June 1910.

The Times art critic gave a generally disparaging review of the exhibition but did note that John Fullwood had contributed works of "cheerful studies of nature." His work had been stocked by the dealer Thomas Richardson who specialised in modern art at his

premises in Piccadilly. When Richardson's stock was auctioned at Christies, also that year, three of Fullwood's work was sold; a pair entitled '*A Valley in the Mendip Hills*' raised £4, 4s, and '*Near Pulborough*' raised £3, 13s.

The year after his pension was awarded, John's daughter Maybell married Alaric Gye Slater, a bank clerk, in St Mary's Church, Sunbury-on-Thames where the family were living at the time. She was 27, and perhaps she waited until her father's future was settled before securing her own happiness. Maybell's future husband Alaric Slater had also been baptised into the Congregational Church when he was a child.

Maybell and Alaric had no children. In the immediate pre-war years they lived with Maybell's cousin Thomas in Letchworth, Hertfordshire before moving back to Twickenham, near to John and Kate, before finally moving to Middlesex.

A lady who contacted the authors recounted an anecdote concerning the later years of the widowed Kate Fullwood and her daughter and son-in-law. As a child in the 1940's this lady frequently visited her grandmother, who lived next door to the Maybell and Alaric Slater in 12 Westhall Road, Kew. *Westhall Road (photograph above)*.

The Slater's, according to this lady, appeared very proper and indeed seemed quite Victorian. Mrs Slater wore long dresses and with her husband, cared for a very, very old lady who was bedridden upstairs. She would be sent up to visit the old lady and

referred to her as 'Mrs Holly' which she now believes was a nickname. It was probably Kate Fullwood that she was visiting, who died in 1949, aged 91. As a 'thank you' for visiting the family, Maybell Fullwood gave the lady an etching of John Fullwood's, showing the Thames at Hampton, which is still in her possession.

As well as his art and interest in nature, John Fullwood found time to pursue his other interests: He became a member of the Twickenham Literary & Scientific Society in his later years when living in Twickenham and served on its committee in the last years of his life. John clearly liked being a member of societies; he had been elected to the management committee of the Richmond Athenaeum – a debating society - in 1891 before resigning when he moved to Hastings three years later.

Despite his setbacks John Fullwood was still considered to be an artist of repute in his sixties. Princess Marie Louise commissioned the architect Sir Edwin Lutyens to build a dolls house for Queen Mary, the wife of King George V between 1921 and 1924. Princess Marie Louise's mother was Princess Christian, who had been a patron of the Selborne Society at the time John Fullwood served on its committee.

Princess Marie Louise used her connections in the arts to fill it with thousands of objects made by leading designers, craftsmen and artists. Perhaps it was through her mother's connections that she invited John Fullwood to contribute two miniature paintings entitled, 'The Hunting Season - The Meet', and 'Autumn Afterglow, Shepperton-on-Thames'.

The *Richmond Times* report of the time however noted only one picture, "having been invited to contribute a miniature picture to the Kings Library, Mr John Fullwood F.S.A. of Hampton Hill has forwarded a local subject painted in water colours entitled 'Autumn Afterglow', a picture that has given considerable pleasure though measuring only 1½ inches by 1 inch." It was a typical Fullwood composition of a landscape with a small boat on the river, trees and

a yellow glow in the sky. Queen Mary's dolls house is now kept at Windsor Castle.

John Fullwood died at his home, 19 Tennyson Avenue, Twickenham on 9 September, 1931, at the age of 76. He had been in poor health since suffering from a bout of influenza the previous March and although seemingly recovered, another bout of illness had seen him take to his bed, where he had been nursed at home by his wife Kate.

John's funeral was held at Holy Trinity Church in Twickenham and he was interred at Twickenham Cemetery. His widow Kate, daughter Maybell and son in law Alaric were accompanied by other members of the Slater family at the funeral. Representing the Fullwood side were his nephew Albert and niece Sara, children of his brother Stephen, who had travelled down from their home in Sheffield.

Also present was John Scott, one of his long standing patrons and friends originally from Walsall, but now living in Surrey and Oliver Drury, the son of one of the executors of John's Civil List pension, Alfred Drury R.A. The other executor, Charles Loxton, had sent flowers. John Fullwood died intestate and his estate was valued at £1395 gross but only £376 net, with letters of administration granted to his widow.

Kate survived John's death, living for a further four years in Twickenham before moving nearer her daughter in Middlesex. She died, aged 90, in 1949. Maybell Fullwood died in 1964 and her husband Alaric the following year.

Appendices

Appendix A
- John Fullwood's Obituary

Mr. John Fullwood, F.R.S.A., R.B.A., F.S.A., of Twickenham, formerly of Wolverhampton and of Birmingham, for many years living at Newlyn, Cornwall, who died on September 6th, aged 76, intestate, left estate of the gross value of £1,395, with net personalty £376. Mr. Fullwood was an artist, whose etchings, particularly of Thames Valley subjects, were greatly admired. Mr. Fullwood was one of the pioneers of the Newlyn art colony.

Extract from a newspaper article in 1931 confirming John Fullwood's obituary.

Appendix B
- Chronology of John Fullwood

Date	Age	Event
1854		Born at 68 Worcester St Wolverhampton.
1861	7	Address: 68 Worcester St Wolverhampton.
1871	16	Address: 55 George St West, Hockley, Birmingham.
		Occupation: Chaser and Embosser.
1875	21	3rd Grade Prize awarded at Birmingham Municipal School of Art in Artisan and Modelling class.
1876	22	Exhibited at Spring RBSA: The Old Sheds. Kings Heath + Bridge, near Yardley.
		Autumn: Bewdley-on-Severn + Near Wenlock.
		Address: Grafton Place, Ellen St, Hockley, Birmingham.
1877	23	Exhibited RBSA: 'On the Ogwen' and 'Near Aber' both North Wales.
		Married: Kate Rooker.
1878	24	Exhibited RBSA: Compton Pool, evening & Sherwood Forest
1879	25	Exhibited RBSA Spring: Sketch of the Forest & Sherwood
		Clarendon Arts Fellowship formed.
		Birmingham Arts Circle formed.
		Partnership with Arthur Frederick Hellier formed.
		Daughter Lillian Fullwood born.
		Brother Henry emigrates to Australia.
1880	26	Exhibited at RBSA Spring:
		"Thine arms have left thee; winds have rent them off" – Cowper.
		First instalment of 'Remnants of Old Wolverhampton' published.
1881	27	Business Address: Grosvenor Chambers, 11 Broad St Corner, Birmingham.
		(Professional artist's chambers) Teacher at Grosvenor Chambers.
		Home Address: 195 Lea Bank Rd, Edgbaston, Birmingham (census).
		Occupation: Artist.

Death of Lillian Fullwood.

Birth of Maybell Gaunt Fullwood.

1882 28 Address: c/o Mr Chamberlain, 19 Temple Row, Birmingham.

Exhibited RBSA: 'Penzance'.

Exhibited: Birmingham Arts Circle: 'Once with the fleet'.

Exhibited easel Club: 'Marazion Marshes' & 'An old building, St Ives' & 'An old street, St Ives'.

1883 29 Address: Tal Carney, Paul, Penzance.

Exhibited at RA: Haymakers Returning.

1883 29 Exhibited at Art Circle, Summer; 'When the trees are bare'.

Exhibited at Art Circle, Winter, 'From Labour returning'.

Address: 13 Rue du Montparnasse, Paris.

Exhibited at RBSA: "etchings illustrating points of local interest".

1884 30 Address: 13 Rue du Montparnasse, Paris.

Exhibited at RA: 'Hush of Night'.

Bound volume of 'Remnants of Old Wolverhampton' published by Virtue & Co.

Etchings donated to Wolverhampton Art Gallery for South Staffs Industrial and Fine Arts Exhibition.

Brother William Fullwood emigrates to Australia.

1885 31 Address: Apsley Villas, Twickenham.

Exhibited at RA: 'Sighting Aspens'.

Exhibited at Keppels Gallery New York: 'A Gypsy Camp'.

1886 32 Exhibited at RA: 'The Swallows haunt' & 'The Gypsy Camp'.

Joined Easel Club, Birmingham.

Exhibited at Easel Club: 'The Minnow catcher' (subsequently printed in the Art Journal).

Exhibited Spring RBSA:

Connected with the English School of Art at Newlyn, Cornwall and one of the first artists to settle there. While there JF produces a 'What the morning revealed'.

Arthur Hellier dissolves partnership, sues John Fullwood.

1887 33 Exhibited at RA: 'To meet the Fleet'.

Address: 15 Apsley Villas, The Green Twickenham.

1888	34	Exhibited at RA: 'On the Heath' & 'Richmond Bridge'.
		Exhibited at Easel Club: 'End of a winter's day'.
1888	34	Address: 15 Apsley Villas.The Green Twickenham.
1889	35	Address: 4a Bank Buildings, Hastings.
		Exhibited at RA: 'Woodland Melody'.
		Exhibited at Easel Club, 'Silver Aspen'.
1890	36	Elected member of the Royal Society of British Artists.
		Address: Coomb House, Stanmore Rd, Kew.
		Exhibited at RA: 'Repose of Slanting Rays' & 'The Grove'.
1891	37	Exhibited at Art Circle, Summer: 'Softened whisper' & 'Vespers of the gloaming'.
1892	38	Published: Fairlight Glenn.
		Moved to Hastings.
1893	39	Exhibited at RA: Richmond Bridge.
		Exhibited at Keppells Gallery NY: 'Twickenham Elms' & 'A Devonshire Hayfield' &
		'The belated traveller'.
		Invested in The Australian Wire Netting Company.
		JF produces a frontispiece piece etching of the 'Barnhurst' for the book "A History of Tettenhall" by James P Jones.
1894	40	Exhibited at RA: 'Twickenham Common' & 'A Thames backwater'.
		Exhibited at Art Circle, Summer: 'A peep of the sea from the south downs' and
		'The banks of the Colne, Lower Thames Valley'
		JF penned a poem to accompany his new picture 'Twilight'.
		Australian Wire Netting Company wound up.
1895	41	Newspaper Hastings & St Leonards Observer report JF is living in Hastings.
1896	42	Hastings & St Leonard's Observer reports JF is now living in Horsham (Slinfold).
		JF produces two illustrations and a chapter for a book 'Kathleen O'Leovan' by Maurice Grindon (aka W. H. Robinson) printed in Walsall and London.
1897	43	Represented England at Brussels World Fair: 'Autumn Glow'.

		Exhibited RBSA: 'Cottage houses in Shakespeare's Country'.
1898	44	Address: The Studio, Meadowside, Park St, Slinfold, Sussex.
		Exhibited at RA: 'A Vale of Kent, Near Canterbury'.
1900	46	JF is still living in Slinfold in October 1900.
		Exhibited at RA: 'On the Thames above Staines'; & 'On the banks of the Colne' & 'On the downs, near Portsmouth'.
		Published; Riverside Churches (15 etchings of Thames side churches).
1901	47	Address: Halliford Road, Sunbury-on-Thames.
1904	50	Exhibited at RA: 'A Sussex valley at sun down'.
1907	53	Awarded civil list pension (back dated from 1906).
1908	54	Maybell Fullwood marries Alaraic Gye Slater.
1909	55	Address: Halliford Road, Sunbury-on-Thames.
1912	58	Address: Acacia, High St (London Rd) Twickenham.
1915	61	Address: Clonmel, 10 Seymour Rd, Hampton Hill.
1929	75	Address: 19 Tennyson Avenue Twickenham.
1930		
1931	76	Died September 9th.
		Address: 19 Tennyson Avenue Twickenham.

Appendix C - Bibliography

Walter Langley; Pioneer of the Newlyn Art Colony, Samson & Company, Penlee, 1997.

Victorian Painting, Lionel Lambourne, Phaidon press Ltd, 1999.

Painting at the Edge – British Coastal Art Colonies 1880-1931 Sansom & Company 2005.

The Art Journal, December 1896 pp 369-373.

A Review of the RBSA 1821-1999 J Barrie Hall, 2002.

The History of the RBSA, Joseph Hill & William Midgley, The Society and Cornish Bros.

Les Peintiers Britanniques dans le Salons Parisiens des origins a 1939, Beatrice Crespon-Halotier, Repotaire Dijon, 2003.

British Landscape Painting – Charles Hemming 1989 Victor Gollancz Ltd.

Landscapes; the Artists vision Peter Howard Routledge 1991.

Varnished Leaves; A Biography of the Mander family of Wolverhampton 1750-1950, Charles Mander, The Owlpress 2014.

Great Victorian Engravings – Hilary Guise Astragal books London 1980.

Victorian Narrative Paintings Raymond Lister Museum Press Ltd 1966.

English Papier-mache, It's origins, development and decline George Dickinson The Courier Press, London 1925.

The Mezzotint, Carol Wax, Thames & Hudson, London 1990.

All around the Wrekin (2nd edition 1860), Walter White.

Walks in the Black Country, Elihu Burrit, The Roundwood Press (Publishers) Ltd, Kineton 1976.

The Making of Victorian Birmingham, Victor Skipp.

Industrial Development of Birmingham and the Black Country 1860-1927, G C Allen, London, 1929.

The Jewellery and Gilt Toy Trades, J S Wright, in The Resources, Products and Industrial History of Birmingham and the Midland Hardware District, London 1866.

The Black Country Elites – the exercise of authority in an industrial area 1830-1900 by Richard H Trainor Clarendon Press Oxford 1993.

Borough Politics: A study of the Wolverhampton Town Council 1888-1964.

"For want of Due Regulations: Public Health and Housing in Walsall 1800-1914" (Walsall Chronicle, 1984).

Opening Doors in the Heartlands – A History of the University of Wolverhampton, Mike Haynes and Lib Martin , 2013.

A History of Tettenhall, D A Johnson and N J Tringham, being an extract from the Victoria County History of Staffordshire Vol XXI

Appendix D
- John Fullwood's Family Tree

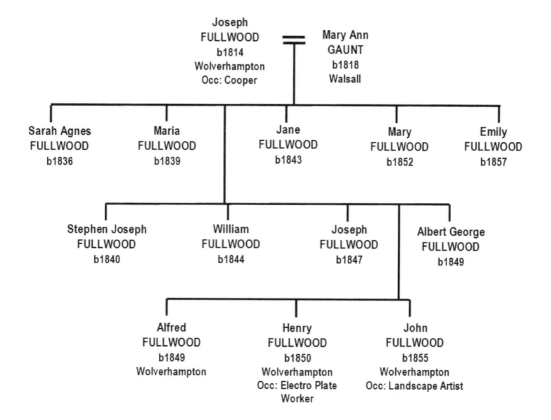

Joseph FULLWOOD b1814 Wolverhampton Occ: Cooper
Mary Ann GAUNT b1818 Walsall

Sarah Agnes FULLWOOD b1836

Maria FULLWOOD b1839

Jane FULLWOOD b1843

Mary FULLWOOD b1852

Emily FULLWOOD b1857

Stephen Joseph FULLWOOD b1840

William FULLWOOD b1844

Joseph FULLWOOD b1847

Albert George FULLWOOD b1849

Alfred FULLWOOD b1849 Wolverhampton

Henry FULLWOOD b1850 Wolverhampton Occ: Electro Plate Worker

John FULLWOOD b1855 Wolverhampton Occ: Landscape Artist

Appendix E
- Henry Fullwood's Family Tree

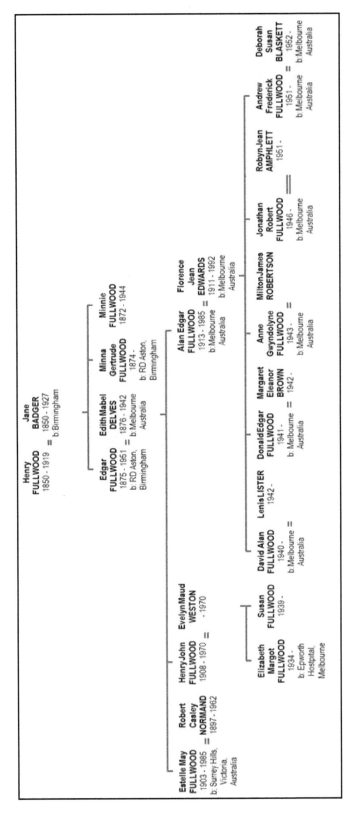

Appendix F – Anglo Australian Connection

Josiah Fullwood b.1706 = Sarah Gibbons

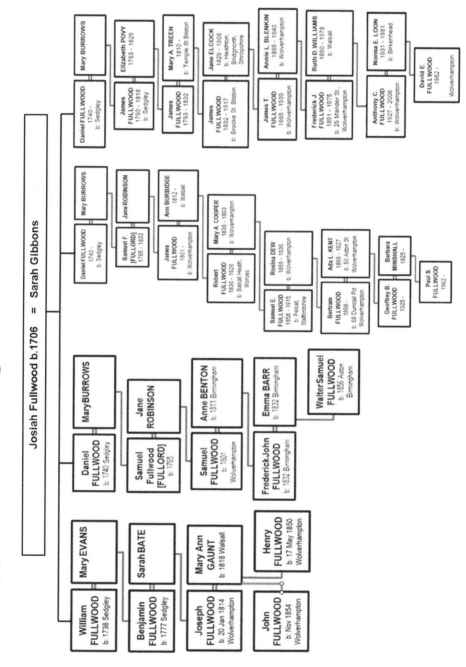

Appendix G List of Etchings in 'Remants of Old Wolverhampton'

Remnants of Old Wolverhampton & Its Environs.

Arthur Hellier and John Fullwood intended to publish this work serially, as a part-work with four etchings in each quarterly edition intended to run to 25 editions. Thus the complete works would have entailed 100 etchings. In the event only a number of these editions were published before the partnership broke down. Subsequently Arthur Hellier issued a book of 48 of the etchings entitled Remnants of Old Wolverhampton and its environs Volume One. A subsequent book, entitled Volume two, was also published but contained only a number of the etchings in Volume One plus a further two etchings. Volume Two did not contain the illustrative text accompanying the etchings that had appeared in the part work and volume one. These books were presumably Hellier's way of recouping some of the expenses from the failed partnership.

Listed below is all the known etchings by John Fullwood identified from Volume One and Two of 'Remnants of Old Wolverhampton and its Environs'.

1. Wolverhampton Collegiate Church (St. Peter's).
2. The Deanery.
3. Wheelers Fold.
4. Boscobel.
5. Tettenhall Church.
6. Court, Victoria Street.
7. Old houses in Lichfield Street.
8. Old Houses, Walsall.
9. Essington Mill.
10. Horsefair.
11. Old House, Victoria Street.
12. Old Building, Bilston.
13. Ancient Pillar, St Peter's Church.
14. Shop, Lichfield Street.
15. Old Building, North Street.
16. Albrighton Church.
17. Dunstall Hall.
18. Cat yard, Berry Street.
19. Old House, High Street (Dudley St.).
20. White Hart, Caldmore.
21. Old Hall, Wolverhampton.
22. Shop, Old Lichfield Street.
23. Molineux House.

24. Shop, Victoria Street.
25. Penn Church.
26. Old Building, Salop Street.
27. Bridge, Old Coach Road, Tettenhall.
28. Old Buildings (Town End Bank) Walsall.
29. Moseley Old Hall (named in error - etching is of Northycoat Farm).
30. Berry Street, general view.
31. The Fountain Inn.
32. Codsall.
33. Old Lichfield Street.
34. The Old Hill, Tettenhall.
35. Windmill near Sedgley.
36. Churchyard Cross, Pattingham.
37. Tong Castle.
38. Old Gateway, Rushall.
39. Birthplace of Edward Bird R.A. (Berry Street)
40. The Greyhound Inn, Bilston.
41. Old House in Dudley Street.
42. Old Coach Road, Tettenhall.
43. Tower of Codsall Church.
44. Thatched House, Albrighton.
45. Old Houses, Little Lichfield Street. (duplicate of number 7.)
46. Brewood Church.
47. The Shrewsbury Arms, Albrighton.
48. Tettenhall Churchyard.

The following etchings are not listed in either of the two volumes of 'Remnants'.

49. Horsefair
50. Old Lichfield Street
51. Hudson's Shop, Lichfield Street.

Request for Information

If anyone has any information about John Fullwood or his family then please contact David Fullwood and Paul Fullwood using the following email addresses:-

david.fullwood@btinternet.com
paulfullwood.pf1@gmail.com

Please note we are unable to provide valuations for John Fullwood's art work.

Lightning Source UK Ltd.
Milton Keynes UK
UKHW050237130319
338978UK00004B/29/P